The Femme Fatale

The Femme Fatale

Erotic Icon

by

Virginia M. Allen

The Whitston Publishing Company
Troy, New York
1983

Copyright 1983
Virginia M. Allen

Library of Congress Catalog Card Number 82-62834

ISBN 0-87875-267-6

Printed in the United States of America

TABLE OF CONTENTS

PREFACE

The femme fatale caught my attention some time ago during studies concentrated on of images of women in the visual arts. She became the subject of my Ph.D. thesis, now revised and expanded into the present book. My research led me to a series of conclusions that are presented here: that the original source of the femme fatale, as we now understand the term, is the dark half of the dualistic concept of the Eternal Feminine—the Mary/Eve dichotomy; that the evil force of this form was so intensified by artists and writers during the middle decades of the nineteenth century as to become a new image; that the image was so often repeated as to become a stereotype by the beginning of the twentieth century.

Among the bits of evidence that led me to these conclusions is the term itself. Initially I was puzzled to find that while the phrase "femme fatale" has entered the language, it was not common in the nineteenth century—if it existed at all. I have not yet found it used in the nineteenth century in its present form. It has only recently been included in English language dictionaries: The *Random House Dictionary* in 1966, the *American Heritage Dictionary* in 1969, and finally, that arbiter of the Anglo-Saxon tongue, the *Oxford English Dictionary,* in its 1972 Supplement—in each case for the first time. As evidence of early usage, the editors of this last-named volume cite a letter written, fittingly—since he stood in so much awe of self-assertive women—by G. B. Shaw in 1912.

The burden of all definitions is the same: the femme fatale is a woman who lures men into danger, destruction, even death by means of her overwhelmingly seductive charms. The application of the term to a variety of images of women, literary and visual, has steadily accelerated during the recent decades of the twentieth century. Gardner's *Art Through the Ages* is a case in point. The term does not appear in the 1936, 1948, and 1959

editions of this basic art history text. In the revised and ex-
panded 1970 and 1975 editions, however, extensive discussion
is devoted to Delacroix's *Medea* (1838)—a picture not men-
tioned in earlier editions—who is described at length as a femme
fatale. In other words, the phrase "femme fatale" has appeared
since 1900, while many of the images to which authors refer
when they use it appeared before 1900. The nineteenth century
invented the image; the twentieth century its label. It is now
being applied retroactively to nearly any image of a seductive
woman, even those who are not noticeably evil.

As far as the early use of the phrase is concerned, while
Shaw may not have invented the term when he used it in 1912,
it was certainly novel at the time. It may have been coined in
the popular journalism of his field: theater and theatrical reviews.
The fact that the term is French does not necessarily mean that
the French invented the phrase. It illustrates more than any-
thing else the profound Anglo-Saxon conviction that sexy—
erotically dangerous—women are usually French, and as a corol-
lary, most French women are sexy.

Insofar as "high art" is concerned, the femme fatale no
longer appears much at all, let alone with the almost daily fre-
quency of her *fin de siecle* manifestations. But she has entered
film, advertising, and popular mythology. Given the ubiquitous
nature of the imagery, there has been relatively little study of its
historical emergence. The single extensive study is the chapter
entitled "La Belle Dame sans Merci" in *The Romantic Agony* by
Mario Praz. His is an encyclopedic survey of what seems to be
nearly every possible sample of the "Fatal Woman" (nowhere
does he use the French form of the phrase) found in European
literature from the end of the eighteenth through the early
years of the twentieth century. The study serves as an invaluable
resource, a model for every writer on the subject.

Professor Praz published the first edition of his book in
1933, and it undoubtedly broke new ground. He was probably
the first to give a name and chronological description to what
can only be called an erotic icon. Apart from his work, very
little has been published about the femme fatale. General studies
of the period exist, such as John Milner's *Symbolists and De-
cadents,* Edward Lucie-Smith's *Symbolist Art,* and Philippe

Julian's *Dreamers of Decadence.* In the first two of these, the term femme fatale appears, but is not defined. Julian does not even use the term, though his subject is similar and he uses many of the same illustrations. Rather he uses the term "chimera," taking the word from the title of Gustave Moreau's large painting, left unfinished by the artist when he died.

The term has crept into history and criticism in the fields of literature and art history, in other words, with very little examination of the icon as such. In particular, there has been little study of the visual iconography as a tradition. Only a few articles have appeared—those by Alexandra Comini and Martha Kingsbury in the anthology *Woman as Sex Object* (1972), edited by Thomas B. Hess and Linda Nochlin; others by Jan Thompson and Dora Janson in art periodicals a year earlier. Ms. Kingsbury's distinction of a set of physical characteristics in a select group of images as a "particular configuration" of the femme fatale is a useful and early venture into examination of a visual iconographic tradition.

None of the publications I have found, however, allude to earlier forms which might comprise the ancestry of the femme fatale. Nor do they penetrate very far into the murky and hazardous territory of speculation about the social and historical forces that might have produced both the phenomenon and its extraordinary popularity. This is true also of the most recent publication on the subject, that of Patrick Bade, entitled *Femme Fatale: Images of Evil and Fascinating Women* (1979). The work is one which the author emulates Professor Praz in presenting a descriptive survey of a large number of images, in this case drawn from the visual rather than the literary arts. He suggested, as I did earlier in my dissertation, that one social factor underlying the birth of the femme fatale was the threat to men inherent in the rise of feminism. His text offers suggestion rather than evidence, however, since his primary purpose in the book is limited to the presentation of visual material.

More recently I have become convinced that the connection between feminism and the femme fatale is at once broader and more specific than the political threat she posed to the established social order. Artists and poets created femmes fatales in their work as an expression of what they saw in women who

were beginning to declare their sexual as well as political free-
dom. For the issues raised by such art were, a century ago, near-
ly identical to the issues that exist today between the sexes:
fear and desire experienced by men confronted with women
who demand the right to control their own desires, their bodies,
their reproductive tracts—women who, in other words, deny the
right of men to control female sexuality.

The historical development of the iconography which grew
out of that fear forms the basis of this book. At the risk of being
almost too tidy, I have organized the historical material in cate-
gories of prototype, archetype (using the word in its ordinary
rather than Jungian sense), and stereotype. The opening chapter
offers a detailed description of what is meant by the term:
femme fatale; and some evidence as to the time period in which
the icon came to maturity. The following two chapters are con-
cerned with the work of writers and artists whose products are
prototypes: forms ancestral to the femme fatale. The central
chapters of the book focus on the work of six writers and paint-
ers whose work was significant to the emergence of the full-
blown femme fatale. These are Theophilé Gautier (1811-1872),
Charles Baudelaire (1821-1867), Gustave Moreau (1826-1899) in
France, and Dante Gabriel Rossetti (1828-1882), Algeron Swin-
burne (1837-1909), and Edward Burne-Jones (1833-1898) in
England. Of these, Gautier, Baudelaire and Rossetti might be
called the "first" generation; Swinburne, Burne-Jones and
Moreau the "second." The selection is based on the impact these
men had on their contemporaries and juniors, and on the content
of their body of work. Not only did they create femmes fatales;
they created *more* of them than others around them.

Working on the basis of prototypes from shared sources,
these men established a "type" for the femme fatale, which in
its turn became a prototype for others. After the establishment
of the type, the femme fatale was repeated so often as to become
a cliche. In my conclusions I endeavor to illustrate how this
happened, as well as the social context which made it possible.

ACKNOWLEDGMENTS

I wish to thank the original members of my dissertation committee: Professors Herbert W. Mason, Samuel Y. Edgerton, Anthony Leeds, and Daniel McCall, for their encouragement and assistance. My manifold thanks go also to the staffs of a variety of libraries, in particular the Boston Athenaeum, The British Library, and above all Mr. Ben Hopkins and Mr. Charles Churchill of the library of the Massachusetts College of Art. Their assistance has helped to make both my research and my teaching there a pleasure. Much appreciation is due to the National Endowment for the Humanities, whose award to me of a Summer Stipend in 1980 allowed me to find much additional material for this study. In addition I am enormously grateful to my colleagues and my students, all of whom have heard me on this subject with great patience and fortitude, and last but far from least, to my long suffering family. Many thanks are owing to the museums who have kindly allowed me to reproduce works in their collections, cited in the List of Illustrations. I wish also to thank the following for permission to use previously published material.:

The Oxford University Press for permission to quote from Mario Praz, *The Romantic Agony* [1933] 2nd ed., revised (1951), copyright renewed, 1970; from Virginia Surtees, *The Paintings and Drawings of Dante Gabriel Rossetti 1828-1882,* A Catalogue Raisonne (Oxford: The Clarendon Press, 1971); and from *The Letters of Dante Gabriel Rossetti,* edited by Oswald Doughty and John R. Wahl, 4 vols. (Oxford: The Clarendon Press, 1965).

The Pennsylvania State University Press, University Park, Pennsylvania, for permission to quote from F. E. and Lois Boe Hyslop, eds. and trans., *Baudelaire as Literary Critics: Selected Essays,* copyright 1965.

Office du Livre Fribourg for permission to quote from Pierre Mathieu, *Gustave Moreau,* trans. James Emmons (Boston: New York Graphic Society, 1965), copyright: Office du Livre Fribourg.

The Society of Authors on behalf of the Shaw Estate for permission to quote from George Bernard Shaw, "Letter to Arthur Bingham Walkley," in the Preface to *Man and Superman*, included in *Nine Plays* (New York: Dodd Mead & Company, 1948).

The Ohio University Press, Athens, Ohio, for permission to quote from *The Rossetti-Leyland Letters*, edited by F. L. Fennell, Jr. (Ohio University Press, 1978).

Routledge and Kegan Paul, Ltd., for permission to quote from Eudo C. Mason, *The Mind of Henry Fuseli* (London: Routledge & Kegan Paul, 1951).

The Nonesuch Library for permission to quote from Theophilé Gautier's *Mademoiselle de Maupin*, with an Introduction by Jaques Barzun (London: Nonesuch Press, 1944).

The Greenwood Press for permission to quote from Lewis Galantiere, trans. and ed., *The Concourt Journals* [Doubleday, copyright by Lewis Galantiere, 1937] New York: The Greenwood Press, 1968.

The Phaidon Press, Ltd., for permission to quote from Charles Baudelaire, *Art In Paris 1845-1862*, trans. and ed. by Jonathon Mayne (London: Phaidon Press, 1965).

Dover Publications, New York, for permission to quote from J. K. Huysmans *A Rebours* [Against The Grain], translated with an introduction by Havelock Ellis (New York: Dover Books, 1969), first published in 1882.

Harper and Row for permission to quote from Dorothy Sayers, *Strong Poison*, copyright 1930, Dorothy Sayers, renewed 1958 (New York: Avon Books, 1967), republished by arrangement with Harper and Row.

The Humanities Press, Inc., Atlantic Highlands, New Jersey, for permission to quote Eino Railo, *The Haunted Castle* [first published with Routledge and Kegan Paul, 1927], New York: Humanities Press, 1973.

New Directions Publishing Corporation for permission to quote from Charels Baudelaire, *Flowers of Evil,* edited by Marthiel and Jackson Mathews, rev. ed., 1963, copyright 1855, 1962, by the New Directions Publishing Corporation.

The Editors and Publishers, The National Psychological Association for Psychoanalysis, New York, for permission to quote passages from Fritz Wittels' "The Lilith Neurosis," *The Psychoanalytic Review,* vol. 19, no. 3, 1932.

LIST OF ILLUSTRATIONS

1. Gustave Moreau (1826-1898). *Salome,* 1876. Oil on Canvas, 56-5/8 x 41-1/16 in. Courtesy of the Armand Hammer Foundation, Los Angeles, California.

2. Dante Gabriel Rossetti (1828-1882). *Mrs. William Morris,* 1865. Charcoal on white paper, 16-1/2 x 13-5/8 in. Courtesy of the Fogg Art Museum, Harvard University, Cambridge, Massachusetts.

3. Edvard Munch (1863-1944). *Madonna,* 1894-1895. Oil on Canvas, 91 x 70.5 cm. Courtesy of the Nasionalgalleriet, Olso, Norway.

4. Edvard Munch. *The Vampire,* 1895/1902. Colored Lithograph and Woodcut, 338 x 552 mm. Courtesy of the Munch-Museet, Oslo, Norway.

5. Dante Gabriel Rossetti. *Astarte Syriaca,* 1877. Oil, 72 x 42 in. Courtesy of the City Art Gallery, Manchester, England.

6. Raphael. *The Three Graces,* c. 1500. Oil. Musees Conde, Chantilly. Photo: Courtesy Lauros-Giraudon.

7. Albrecht Dürer. *The Four Witches,* 1497. Engraving, 7-3/8 x 5-1/8 in. From *The Complete Engravings, Etchings & Drypoints of Albrecht Durer,* ed. Walter L. Strauss, 1973, Dover Publications, New York. Photo: Courtesy Dover Publications.

8. Guido Reni (Bolognese). *Salome with the Head of John the Baptist,* c. 2638. Oil on Canvas, 97-3/4 x 68 in. Courtesy of The Art Institute of Chicago.

and Art Gallery, Birmingham, England.

20. Dante Gabriel Rossetti. *Miss Siddall with Strand of Hair in her Mouth,* c. 1853. Study in pencil for *The Return of Tibullus to Delia,* 8-1/2 x 7-3/8 in. Courtesy of the Fitzwilliam Museum, Cambridge, England.

21. Dante Gabriel Rossetti. *La Belle Dame sans Merci,* 1855. Pencil, pen and ink wash drawing. Courtesy of the British Museum, London.

22. Titian. *Lady at her Toilette,* c. 1515. Oil. Louvre Museum, Paris. Reproduction courtesy of the Musees Nationaux.

23. Dante Gabriel Rossetti. *St. Cecilia,* 1856-1857. Pen and brown ink, study for the Moxon edition of Tennysons *Poems.* Published by permission of the Birmingham Museum and Art Gallery, Birmingham, England.

24. Henry Fuseli. *Young Man Kissing a Young Woman at a Spinet,* 1819. Black crayon drawing, 24.7 x 20 cm. Courtesy of the Kunsthaus, Zurich.

25. Dante Gabriel Rossetti. *Sir Lancelot and the San Grael,* c. 1856-1857. Watercolor, 26-3/4 x 40-3/4 in. Study for the Oxford Union Murals. Courtesy of the Ashmolean Museum, Oxford, England.

26. Dante Gabriel Rossetti. *La Bocca Baciata.* Oil on panel, 12-3/4 x 10-11/16 in. Courtesy of the Museum of Fine Arts, Boston. Gift of James Lawrence.

27. Dante Gabriel Rossetti. *Aurelia (Fazio's Mistress),* 1863. Oil, 17 x 15 in. Courtesy of the Tate Gallery, London.

28. Dante Gabriel Rossetti. *Lady Lilith,* 1868. Oil on Canvas, 38-1/2 x 33-1/2 in. Courtesy of the Delaware Art Museum, Samuel and Mary R. Bancroft Collection.

29. Dante Gabriel Rossetti. *Sibylla Palmifera,* 1866-1870. Oil, 37 x 32-1/2 in. Courtesy of the Walker Art Gallery, Liverpool, England.

CHAPTER I

INTRODUCTION

The femme fatale is usually described as an image that became popular during the closing decades of the nineteenth century, characteristic of the art and literature of the Aesthestes, Decadents, and Symbolists; one whose visual traits entered the design style of Art Nouveau. As commonly depicted, she is Siren, Circe, Salome, Cleopatra: seducer and destroyer of men. Her appearances and labels are so varied that they automatically evoke curiosity. What, besides beauty and seductiveness, do these images have in common?

Details of the femme fatale's disastrous attractions come most often not from literature on the one hand, or visual images on the other, but from their symbiosis, as in J. K. Huysmans' novel *A Rebours* (1884). Here is the protagonist, Des Esseintes, describing Moreau's painting of Salome dancing before Herod (fig. 1):

> No longer was she only the dancing girl who extorts a cry of lust and concupiscence from an old man by the lascivious contortions of her body; who breaks the will, masters the mind of a King by the spectacle of her quivering bosoms, heaving belly and tossing thighs; she was now revealed in a sense as the symbolic incarnation of world-old vice, the goddess of immortal Hysteria, the Curse of Beauty supreme above all other beauties by the cataleptic spasm that stirs her flesh and steels her muscles—a monstrous Beast of the Apocalypse, indifferent, irresponsible, insensible, poisoning, like Helen of Troy of the old Classic Fables, all who come near her, all who see her, all who touch her.[1]

John Milner described this unparalled literary moment as Huysmans' "seizure" of an image representing new heights of lust and evil, a figure of paramount importance to the arts of

the *fin de siecle*.[2] To seductive beauty and danger, this interpretation adds eroticism heightened to lust, tainted with corruption and perversion. Philippe Julian prefers Swinburne to Moreau as creator of these images, singling him out as the supreme interpreter of "pitiless womanhood." Swinburne, he informs us, is masochist "slave" to "empresses" of corruption.[3] Such an empress might be found in a drawing by Dante Gabriel Rossetti, entitled *Mrs. William Morris*, dated 1865 (fig. 2). It shows a woman's head in profile, with unbound hair falling in sculptured waves to her shoulders. Her equally sculptured lips are full and pouting, and she gazes out from beneath heavy eyelids with an air of somber mystery.

Martha Kingsbury's "particular configuration" of the femme fatale in the visual arts at the end of the nineteenth century includes frontal presentation, erect posture ("signifying a threatening power"), lowered eyelids, sometimes a partially opened mouth, thrown-back head, and long flowing hair.[4] One might add full sculptured lips, smouldering gaze, and a color range dependent on low values, intense hues, and frequent use of hot colors, to this list. A famous and typical instance of the icon thus described is Edward Munch's *Madonna*, first painted in 1893, later repeated in woodcuts (fig. 3). Fused in a single image, these characteristics form an orgasmic vision; if you will, an erotic swoon.

Ms. Kingsbury commented that many of the works she selected as portraying the femme fatale emphasize, as in Munch's work, precisely that moment of abandonment in the sex act—a loss of self-awareness following the conscious seduction of the male. The *petite morte* of the orgasm exhibited in Munch's painting, moreover, shows her, according to this author, in the grip of a Shavian Life Force, and expresses the idea that a woman's erotic power can destroy her as well as her male victims.[5]

If so, she is driven, like Salome as described by Des Esseintes, as though whipped on by an inexorable compulsion completely outside herself. However, there is a dimension to the meaning of the femme fatale suggesting that even though she might die, she will not be obliterated. She will rise to claim another victim, perhaps as one of the living dead, a vampire. Walter Pater's famous eulogy

of Leonardo's *La Gioconda* describes her thus:

> She is older than the rocks among which she sits; like the vampire she has been dead many times, and learned all the secrets of the grave.[6]

Mario Praz singled out this passage as one of the most famous descriptions of the femme fatale. To vampirism, erotic force, and beauty, he added oriental exoticism as part of the lady's character. Gautier's Cleopatra, Flaubert's Salammbô, are both, for him, examples of exotic femmes fatales. So too is Prosper Mérimée's Carmen, a gypsy. Whatever the setting of the femme fatale, she reflects substantial distance from ordinary experience, ordinary women. For the French, as above, she was frequently oriental; for many others, she was an amalgam of ancient classic and later central European folklore, as in Lamia, Siren, vampire.

Romantic Englishmen also drew on these sources, but for them, even when a femme fatale was not clearly intended, a dangerous woman was often automatically understood to be at least partly French. Becky Sharp is a prime example. In 1848, shortly after publication of *Vanity Fair,* a reviewer wrote that Thackeray had "disarmed" criticism of Becky "by making her mother a French woman. . . . The construction of this clever little monster is diabolically French," he continued, since an English woman would be far less subtle, her seductive advances much easier to resist if she was like Becky, without "heart and conscience." France, he concluded, "is the land for the real Syren, with a woman's face and dragon claws."[7]

Whatever the reviewer's opinion of *Vanity Fair,* his comments offer an important insight into the meaning of the femme fatale. Becky, self-willed and self-determined, wholly unlike her lady-like contemporaries, was seen to possess neither heart nor conscience, as well as being a siren—a favorite label, later, for femmes fatales. Was she a "Syren" and heartless *because* she was self-determined? The connection between female independence and ambition, on the one hand, and fatality on the other, is highly suggestive.

Something of the same attitude surrounded Lola Montez,

the famous nineteenth century dancer/courtesan. A news article of May 20, 1847, described her as staying "with the King" in Munich. She had retreated there from Paris, apparently, after some problems caused during her stage appearances by "leaving off portions of her costume." "All succumb to her;" in spite of scandal and flight, claimed the writer, "pride, obstinacy, passion, talent and beauty make her one of those women *who are just what they want to be.*"[8] Lola Montez, in other words, not only beautiful but self-willed, may have served as a living prototype for at least some of the attributes of femmes fatales in art and poetry.

Neither Becky Sharp nor Lola Montez is or was a full-blown femme fatale, but the characters of both help to illuminate the concept. The adjectives so far collected include beautiful, erotic, seductive, destructive, exotic. To these we may add self-determined and independent. In addition, throughout the examples runs the theme of an indifferent and chilling remoteness from human feeling. These two women, literary and living, are both still well within the dimensions of wickedness understood as human. The femme fatale is less human. She is immortal, queen, goddess, and therefore separated from ordinary men—and women—by a vast gulf. She is not only amorous and lovely, but indulges her sexuality without concern for her lover of the moment, entranced, like Salome seen through the eyes of Des Esseintes.

To this list of adjectives must be added the word "barren." Over and over again, especially in the poetry of Baudelaire and Swinburne, the words "sterile" and "barren" occur. The femme fatale, no matter how amorous, does not conceive. Sin alone may feed at her luscious breast. She was construed as the woman who controlled her own sexuality, who seduced men and drained them of their "vital powers," in an exercise of eroticism that had no issue. She was—and is—the diametric opposite of the "good" woman who passively accepted impregnation, motherhood, domesticity, the control and domination of her sexuality by men.

The visual iconography in which this body of meaning was incorporated includes several striking elements. One is the repeated imagery of long flowing hair. In addition to his *Madonna*,

Munch produced seductive vampires in both etching and wood-cut, in which the lethal lady's hair swirls down and surrounds her lover's exposed and vulnerable neck (fig. 4).

Even earlier, a cascading veil of hair adorned nearly every lady Rossetti painted. Philippe Julian expressed the opinion that Rossetti and the Pre-Raphaelites, together with Moreau, are responsible for creating novel forms of beauty: vampires, sirens, drowned Ophelias.[9] Edward Lucie-Smith's position is more precise; he stated unequivocally that Rossetti's *Astarte Syriaca,* completed in 1877 (fig. 5), represented in its day an entirely new idea of Woman as Fatal, one of central importance to the later French Symbolists.[10]

The work does indeed exhibit a type of beauty that has become the hallmark of the artist's style, as well as, for some, of the femme fatale. The heavy-lidded gaze, pallor, long full throat, luxurious hair, recur constantly in individual works in which erotic challenge and danger are so intermingled as to become a unified whole. The meaning is further amplified by the picture space in which the femme fatale is usually placed. Her various images have in common a departure from the academic tradition of natural light and three-dimensional perspective of nineteenth century painting. Nearly all of Rossetti's painted women inhabit a space that is shallow and ambiguous, almost filled by the female figure, who is surrounded by richly decorated surfaces. The packed interiors of his paintings create a closeness of atmosphere that approaches suffocation. Munch's *Madonna* floates in a turbulent void, in which the repetition of rhythmic line produces a sense of constant movement and tension, the elimination of any point of stability or rest. In Moreau's *Salome* paintings the architecture tightly encloses the space, filled with glittering surfaces comprised of jewels, fabrics, and carved ornament. Together with the other-worldly illumination, these combine to form an airless compartment in which the inhabitants are immobilized as in a tomb. They are indeed erotic icons, frozen outside of time, langourous or monumental or both, reflecting the desires and fantasies of the men who made them.

Morevoer, they stand in sharp contrast to an almost equally popular Victorian image of woman inhabiting plays, novels,

poems, and the visual arts: namely, virtuous, compassionate womanhood, ranging from the sweet innocence of maidenhood to long-suffering, nourishing maternity. As Mary and Eve stand in opposition, so also do *The Angel in the House,* that popular Victorian image,[11] and terrible Astarte. Each pair represents the ancient dual concept of the Eternal Feminine.

In the Christian tradition, however, Eve is weak rather than willfully evil, a fallen woman more than a fatal one. The transition from Fallen Woman to Fatal Woman marks the convergence of several themes, literary and visual, that merge into a new monumental form.

It might be argued that no such transition as from fallen to fatal woman took place during the mid-nineteenth century. Is the femme fatale new or old? Since many of the names, such as Astarte, Salome, Cleopatra, given to the femme fatale by her creators a century ago, are drawn from ancient myth and legend, has she not existed perennially, in some form, from antiquity? On the other hand, given the exotic, even bizarre eroticism of some late nineteenth century images of women, has the sin of Eve been altered and intensified to produce an immensely exaggerated implication of evil?

Mario Praz came close to contradicting himself on this question. "Baudelaire and Flaubert," he wrote, "are like the two faces of a herm planted firmly in the middle of the century, marking the division between the period of the Fatal Man and the Fatal Woman, between the period of Delacroix and that of Moreau."[12] The reversal took place, he stated, because the Fatal Man: Lord Byron, Faust, direct descendants and imitators of the Marquis de Sade, reversed roles with the women who were objects of their desires and became masochist, thus the prey of the Fatal Woman. She, on the other hand, to Professor Praz, is not a new form at all. "There have always existed Fatal Woman in Mythology and literature," he declared, "since mythology and literature are reflections of real life, and real life has always provided more or less complete examples of arrogant and cruel female characters." These "simply become more numerous in times in which the springs of inspiration were troubled."[13]

If the form was indeed new in the time of Flaubert, the

postulation of a conversion of an entire generation of artists and writers from sadism to masochism is nonetheless a tautology: it happened because it happened. If, contrariwise, Fatal Women have always existed, what "troubled" the "springs of inspiration" in such a way as to increase their numbers so sharply? After all, literature and mythology have also provided "more or less complete examples of arrogant and cruel" *male* characters, but these have not achieved the popular dimensions of the femme fatale.

Support for the opinion that the form is not new, but simply a variation on an ancient theme, comes from the frequent use of the word "archetype" in connection with her appearances. In the field of cinema, for instance, the female characters created by Truffault in various films are labelled *belle dame sans merci,* and femme fatale, and also archetypal, all in the short space of one sentence.[14] The psychologist Karen Horney might also have agreed that such images of woman in literary and visual works have existed perennially because they embody for men what she has called the "Dread of Woman." In an essay of that title first published in 1932, she pointed out that men have produced expressive images of conflict, violent fear combined with violent desire, with great frequency since antiquity. They would appear to echo a feeling rooted in all men's emotional response to "certain biological facts."[15] Those biological facts are menstruation, pregnancy, childbirth and lactation; the anatomy and physiology of being female.

Horney's concept is one in which the person who is wholly "other" than oneself is understood to be threatening to the point of terror. For men, Woman would seem to be such an "other." She maintained that this largely unacknowledged dread of women in men produces their need to conquer the woman—to objectify her as "thing" to be dominated and possessed, since only through domination can one conquer the fear. The efforts of men to express their dread and longing have resulted in an endless parade of images in which the "eternal feminine" is reduced to two variations on a female theme: the mother on the one hand, the sex object on the other.

Two "pop" psychologists appear to concur with Horney's position. In *Beyond the Male Sex Myth* (1977), Pietropinto and

Simenauer devoted substantial space to the discussion of the male "prostitute-Madonna" complex.[16] Defined psychiatrically, the complex is one in which the afflicted man has difficulty in performing sexually with a "good" woman, with symptoms ranging from apathy to impotence. The authors believe that the complex has always been very common, but is now beginning to disappear, no doubt as a result of the sexual revolution.

The Eve/Mary dichotomy aptly reveals the contrast of types. Tertullian, oft-quoted, fulminated during the Patristic era against Eve as the Devil's Gateway, and aided in the establishment of Lust as the Original Sin, deadliest of all the Seven Deadly Sins. On the one hand, as Daughters of Eve, all women are guilty of inciting lust in the hearts of men. Apart from the fact that his is a classic case of what is often called "blaming the victim," he was far from alone in his opinion among theologians, then or now. Mary, on the other hand, is Queen and Mother, forever chaste, forever virtuous, forever subservient to the Divine Will. She is utterly untainted by sexuality or seductiveness, and full of nourishing love.

The visual arts have illustrated the dichotomy since antiquity. Hellenistic Greek Aphrodites, forever unclothed, stand in contrast to idols of Demeter, always clothed, abundantly represented in the world's great art collections. The contrast quite possibly illustrates ancient and lasting fears and prejudices. Prior to the late classic period, Athenian art is notable for the dearth of female nudes in monumental art. A few nudes did occur in the art of other cities, especially Sparta, where women exercised nude as did the men, and were thus available as "models." Female nudes in high art in Athens became popular only after the time of Alexander, and are sometimes attributed to the growth of Orientalized cults of Aphrodite. Demeter and Persephone, so far as I know, were not portrayed nude. The fact that they were always clothed may reflect the ancient Greek belief that to look upon the Goddess undraped was to incur her instant vengeance.

Both Demeter and Aphrodite, in any event, have their counterparts, if not their descendents, in contemporary nudes in galleries and musuems, and modern Marys over the altars of today's churches. The products of the arts have reinforced the

psychological and theological separation of women into two stock types in polar opposition: Mary/Eve, Snow-White/Rose-Red, Saint/Witch, nun/succubus; all these abound.

A series of images demonstrates the growing weight of evil attached over time, especially in the Christian tradition, to the female as sex object. First, a Pompeiian fresco, in which diminutive female nudes pose with flowers as the Three Graces, attributes of Venus; the same subject, quoted by Raphael, with more opulent bodies, whose flowers have become Golden Apples, either those of the Hesperides—or perhaps of Eve (fig. 6); finally, in the hands of Dürer, becoming four witches (fig. 7). Concrete images as well as the theological and literary abstractions of the west record the conflict described by Horney quite clearly.

Jung might have identified such images as expressions of the male anima. In his theoretical system, these are individual manifestations of an archetypal form from the collective unconscious. His follower Erich Neumann discussed such forms at length in *The Great Mother.* Neumann described ego-consciousness as symbolized by the "male hero," the unconscious as a whole with the "archetypal feminine," in the world's mythological cycles. In his analysis, the archetypal feminine has two charcters: positive and negative; and when negative, is felt as the devouring unconscious: the female Monster.[17] There is a strong analogy here to what Praz has called the "cannabalistic" aspect of the femme fatale: she who "devours in the morning the lovers who have spent the night with her."[18] The "deadly" anima, embodied as Circe, Spinx, or the wicked princess who kills her unsuccessful suitor, are among further elaborations of the Negative Feminine, which constantly confronts the Hero with the necessity to conquer or be killed.

All of the ancient goddesses of the Mediterranean and Near East represented, for Neumann, different aspects of the primordial Great Mother. The re-use of their names by artists and poets in the nineteenth century lends credence to the possibility that the femme fatale is not new at all, but a variation on an ancient and eternal theme. Aphrodite, Venus, Even, Lilith, Astarte, all appear in nineteenth century art. So also do historical and legendary mortals: Salome, Cleopatra, Semiramis, Messalina, even Judith, who slew Holofernes. One of the more entertaining

adaptations of names from antiquity belongs to the forensic psychiatrist Krafft-Ebing. In his discussion of "chronic nymphomania" he gave the name "Messalina" to any woman he diagnosed as driven from promiscuity to prostitution by her sexual pathology.[19]

Conversely, a number of arguments can be marshalled against the position that the femme fatale is ancient. First is the argument of sheer numbers. Even the most casual and impressionistic survey of the visual artifacts, let alone the literature, of late nineteenth century Europe confirms the notion that there was an inundation of images now labelled femmes fatales. Second is the alteration and intensification of the imagery itself. The erotic art of preceding centuries: the nudes of Titian in the sixteenth, Rubens in the seventeenth, Watteau and Boucher in the eighteenth—offers the viewer endless numbers of images that are sex objects. They are not, however, fatal. In western art, only Eve in the Garden, proffering Adam the Apple, occasionally exhibits the combination of sensuality and danger that suggests the femme fatale.

Neither Dürer's Witches nor even Eve in her many manifestations before the nineteenth century incorporate the entire gamut of elements included in the poetic and visual iconography of the femme fatale by the century's end. There is a clear shift in attitude and emphasis in erotic art between the eighteenth and nineteenth centuries. For instance, the boudoir nudes of Boucher, among others, are not only not fatal, but usually extremely vulnerable. Lying on tumbled couches, languid and exposed, they are at once alluring to the voyeur and utterly helpless. Their postures may invite, but they do not smoulder.

A long list of comparisons of such paintings to later ones might be made, each of which would verify the addition of new iconographic elements to traditional subject matter, exaggerating eroticism and the atmosphere of hazardous sensuality. However, one example of successive versions of Salome should suffice. In the Baroque painter Guido Reni's *Salome with the Head of John the Baptist* a richly clad Salome draped in satin, girlish and pink-cheeked, calmly holds St. John's severed head by the hair (fig. 8). Her posture is based on classical prototypes and her face is expressionless. She seems almost to be contemplating a new

fashion in millinery. In Moreau's *Apparition* a bejewelled, partially nude Salome, gazing somberly out from under her eyebrows, extends a searching hand toward the floating head of the Saint (fig. 9). Finally, in Aubrey Beardsley's illustration (1893) for Wilde's play; an ecstatic, gloating Salome floats in the air, grasping the severed head in both hands (fig. 10).

The charged emotional content of this last-named work has few, if any, counterparts in earlier art. Defining the femme fatale as an archetypal image (in the Jungian sense) may explain *some* of the male psychology underlying the production of such images, but it does not explain the alteration and intensification of feeling underlying *these* images. Nor does traditional analysis based on the history of style fully explain the emphatic blood-lust implied in these works. Neither does the re-use of the names of ancient goddesses for the femme fatale, in itself, imply the reflection of an archetype. The artistic practice of naming a new image of woman "Astarte" or "Salome" most probably resulted from the conventional nineteenth century academic practice in the West of using prototypes "from the antique." The general antiquarian and medievalizing passion of Romantics everywhere created a century-long climate in which the search for remote, exotic, novel images became natural, if not mandatory.

In any event, nineteenth century depictions of goddesses and other figures usually do not reflect their characters as understood in antiquity. The believer in antiquity undoubtedly approached the deities with the reverence and awe a believer brings to church or temple today. The poet and artist of post-Enlightenment Europe saw, and probably still sees, these figures as symbols, even fictions, not living realities.

The acceleration of archaeological activity may equally have inspired the nineteenth century selection of names from antiquity. The Mediterranean, Egypt, the Near East, were all locations of intense activity. Following Napoleon's expedition to Egypt, large numbers of artifacts flooded Europe. The first exhibition of Assyrian sculpture was held in the Louvre in 1847, and at nearly the same time, the *Illustrated London News* began a series of articles describing the arrival of Assyrian antiquities at the British Museum.[20] Austen Henry Layard published his

Ninevah and Its Remains in 1848 and received an enthusiastic and lengthy review in the *Quarterly Review* early in 1849. The reviewer's excitement over the discovery of concrete evidence supporting the historic reality of ancient legend is palpable. He cited the stories of Herodotus and Diodorus Siculus in order to reach the conclusion that mythical Semiramis had indeed once lived. "We see no reason to doubt," he wrote:

> a priori . . . that Semiramis may have built the primeval Babylon. . . . She may even have furnished a precedent for that lawless and prodigal plan of indulging her own passions without endangering her power, which acquired for a late Imperial female the name of a northern Semiramis.[21]

The "late imperial female" was no doubt Catherine The Great, notorious for her bizarre sexual appetite. Semiramis caught Dante Gabriel Rossetti's attention, appearing briefly in his poem *The Burden of Ninevah* which he evidently wrote around 1850, though it was not published until 1856 in *The Oxford and Cambridge Magazine.*[22] The poet alluded to his source of inspiration in his own poem: its first stanza describes the arrival of a "winged beast" at the British Museum, and he footnoted his poem with a reference to Layard's publication.[23]

G. B. Shaw gave voice to an awareness of sharp alteration in the imagery of the arts during the late nineteenth century. In his "Letter to Arthur Bingham Walkley," in the Preface to *Man and Superman* (1901-1903) he commented that in the time between Goethe and Byron on the one hand, and Ibsen, on the other, "Don Juan had changed his sex and become Doña Juana, breaking out of the Doll's House and asserting herself as an individual, instead of a mere item in a moral pageant."[24] Once again, female self-assertion implies instant sexual threat.

Whatever else Shaw might have meant to convey, he in fact expressed a clear perception of a concept of Woman only recently formulated at the end of the nineteenth century in all the arts. That is, the *iconography* of the femme fatale, both verbal and visual, was new, and conveyed an idea of woman that was more erotic and more evil than in earlier art. Out of the ancient and traditional contrast of Demeter/Aphrodite, Mary/Eve, emerged a new image: one in which the evil pole was enormously

intensified, and the poles themselves were pushed apart to their furthest limits. Her image acquired a series of personality traits that altered and exaggerated her character from mere sin to positive and devouring evil. The gradual accumulation of those traits is my next concern.

NOTES

[1] J. K. Huysmans, *Against the Grain* (A Rebours), introduction by Havelock Ellis (New York: Dover Publications, 1969), p. 53.

[2] John Milner, *Symbolists and Decadents* (London and New York: Studio Vista/Dutton Pictureback, 1971), p. 38.

[3] Philippe Julian, *Dreamers of Decadence* (New York: Praeger Books, 1971), p. 106.

[4] Martha Kingsbury, "The Femme Fatale and Her Sisters," *Woman as Sex Object* (New York: Art News Annual, Newsweek, 1972), p. 183.

[5] *Ibid.*, p. 205.

[6] Walter Pater, *The Renaissance: Studies in Art and Poetry* (London: Macmillan, Second edition, revised, 1877), p. 135.

[7] Unsigned Article, "Vanity Fair by William Makepeace Thackery," *Quarterly Review* 84 (December 1848-March 1849), p. 160.

[8] Unsigned Article, "Notice of Event," *Illustrated London News*, March 20, 1847, Vol. 12, p. 180. Italics mine.

[9] Julian, p. 45.

[10] Edward Lucie-Smith, *Symbolist Art* (New York: Praeger, 1972), p. 43.

[11] A poem by Coventry Patmore, cited by William Rossetti in *Some Reminiscences* (New York: Charles Scribner & Sons, 1906), 2 volumes, vol. 1, p. 83.

[12] Mario Praz, *The Romantic Agony*, translated by Angus Davidson (Oxford University Press, 1970), p. 152.

[13] *Ibid.*, p. 189f.

[14] Marsha Kinder and Beverle Houston, "Truffault's Gorgeous Killers," *Film Quarterly* 17, no. 8 (Winter 1973-1974), p. 2.

[15] Karen Horney, *Feminine Psychology*, edited and introduction by Harold Kelman (New York: W. W. Norton & Company, 1967), p. 134.

[16] Anthony Pietropinto, M.D., and Jacqueline Simenauer, *Beyond the Male Sex Myth* (New York: New York Times Books, 1977), p. 22ff.

[17] Ernst Neumann, *The Great Mother*, Bollingen Series XLVII, translated by Ralph Manheim (New Jersey: Princeton University Press, 1963), Ch. 3, especially pp. 28, 35.

[18] Praz, p. 204.

[19] Richard von Krafft-Ebing, *Psychopathia Sexualis* (New York: G. P. Putnam's Sons, 1965), pp. 502-503.

[20] Articles begin January 30, 1847, in *Illustrated London News.*

[21] Unsigned Article, "*Ninevah and Its Remains* by Austen Henry Layard," *Quarterly Review* 84, no. 168 (December 1848-March 1849), p. 139.

[22] William M. Rossetti, *Dante Gabriel Rossetti—His Family Letters with a Memoir*, 2 vols. (London: Ellis and Elvey, 1895), vol. 1, p. 197.

[23] Dante Gabriel Rossetti, *The Collected Works of Dante Gabriel Rossetti* (Boston: Roberts Brothers, 1887), edited by William M. Rossetti, in two volumes. Vol. 1, p. 266f.

[24] George Bernard Shaw, *Nine Plays*, with prefaces and notes (New York: Dodd Mead & Company, 1948), p. 491.

CHAPTER 2

THE MACHTWEIB

The Countess Adelheid, an early invention anticipating the full-blown femme fatale, appeared in 1773 in an early publication by the young Goethe. This was a revised and shortened version of a play written some months earlier in more elaborate form, entitled *Götz von Berlichingen.* The story, set in late medieval Germany, revolves around the conflict between the feudal system and the growing centralized power of town, Imperial Crown, and cathedral. The following year the play went into production in both Berlin and Hamburg as a flashing and thunderous drama; even, possibly, melodrama, since it included orchestra, real horses, and real gunpowder.[1]

As the curtain rises, we find the central character of the play, the Baron Götz, involved in a feud with the citizens of Nuremburg and the Bishop of Bamberg. The Emperor Maximilian had proscribed private baronical wars in 1495, and was repeatedly defied by the historical Baron Götz, whose biography was the basis for Goethe's play. Political plot, counterplot, and civil war lead inexorably to the conclusion, with the death of the outlawed Götz, mortally wounded in battle. His last words are "Himmliche Luft! Freiheit!—Freiheit!"[2] Götz, in true *Sturm und Drang* fashion, symbolized for the author and his audience an era of idealized medieval freedom and virtue that were for Goethe specifically and characteristically "German." Sir Walter Scott, the first English translator of the play, described Götz more aptly as "in reality a zealous champion of the privileges of free knights. . ."—not freedom in general.[3]

Devious and ambitious, the Countess Adelheid is responsible for his downfall. In the first version of the play, not published until after the author's death in 1832, her stage role was far more extensive than in the revised version that was actually produced.

Even in a greatly reduced part, however, the Countess plays a pivotal role in the plot, and as devastatingly beautiful, seductive and destructive. Her driving ambition for power creates the motive force of the drama.

As the word was frequently defined in the eighteenth century, she is above all a virago: Superwoman, Amazon, or, in the German, "Machtweib": "woman of power."[4] She dominates nearly all the men who encounter her, compelling emotions that range from dread to nearly unendurable lust. Weislingen, a powerful nobleman, the friend and companion of Götz's youth, becomes one of her earliest victims. Estranged from Götz, he appears in the early scenes of the play, attached to the Imperial party, opposed to baronial privilege. Soon, however, he renews his friendship with Götz and betroths himself to Götz's sister, Maria, creating new ties of feudal loyalty and brotherhood, and shifting his allegiance to the baronial party. Adelheid, determined to rise to wealth, power, and Imperial favor, undertakes to persuade him to forsake Götz, and to return to allegiance with Bishop and Emperor.

To do so, she uses the classic techniques of seduction and coquetry, dangling and then snatching back the bait. In one particular scene, Weislingen begs Adelheid for a smile, and she retorts: I should smile, and you my enemy?[5] She makes clear to him that to win her regard, Weislingen must shift his loyalties. Utterly smitten, Weislingen turns traitor once more, deserting Götz,—and of course Maria, his betrothed—for the Imperial forces supported by Adelheid. Thus the ultimate destruction of Götz is insured, since the military forces arrayed against him at this point are overwhelming.

During the course of the play, Adelheid's appearances are relatively few, but are crucial to the procession of events. She not only seduces Weislingen (and marries him) but also his page, Franz, and attracts the roving amorous eye of Charles, son of Maximilian and heir to the Imperial crown.

Weislingen calls Adelheid "Zauberin!" Sorceress! (Sir Walter Scott renders this as "Enchantress!")[6] The force of Adelheid's personality and compelling beauty is reinforced by the contrast between her and Weislingen's original betrothed,

sister to the hero. Maria is gentle, sweet, and wholly devoted to her menfolk. Early in the play, the page Franz draws the contrast:

> "Maria is beautiful and amiable. In her eyes is compassion and sympathy—But in thine, Adela, is life—fire—spirit! Would to—I am a fool—Such has one glance made me.[7]

Leben! Feuer! Mut! Franz is made "ein Narr" by a single glancing flash of Adelheid's eyes.[8] One might speculate that the very traits which make Maria lovable—her gentleness and loyal docility (one imagines doe-like eyes and cow-like simplicity) evoked the desire for a more exciting woman in the men around her. In any event the passive Madonna and the sinful Eve live here in new and flamboyant garb.

The kinship of Adelheid and Lady Macbeth is readily recognizable. Indeed, the public announcements of the first stage production stated that the play had been written in a Shakespearean mode.[9] But in Shakespeare's play, Lady Macbeth, inciting Macbeth to murder, does not use the bait of her person and her love overtly, as does Adelheid. She challenges Macbeth's manhood politically rather than erotically, implying that he is weak, "too full o' the milk of human kindness" to commit the deed that would bring him power and greatness. She presents herself as more courageous, stronger—

> ". . . hie thee thither,
> That I may pour my spirits in thine ear,
> And chastise with the valor of my tongue
> All that impedes thee from the golden
> round[10]

Macbeth falls into evil not through lust for the woman, but by competitive striving for power: to control, to rule, to wear the golden round—the crown.

Lady Macbeth is not, at any rate in Shakespeare's text, a prototype for the femme fatale. She is not erotic. But she may have provided at least one model for Goethe's Adelheid, who does not appear in the original story of the life of Götz that Goethe used for his plot. Nor does Weislingen.[11] These are

characters invented by the author to create dramatic structure and motivation for the events of the play.

At the time he wrote the drama, Goethe had become the friend and disciple of Johann Gottfried Herder. This scholar has historically received credit for the interest of an entire generation of young German students in the study of Shakespeare, medieval German legend, native "Gothic" folklore and folksong. For young Goethe, under Herder's influence, not only Gothic architecture and folklore, but any great poetry or drama—especially Shakespeare's—were above all "Germanic."[1 2]

Thomas Mann also likened Goethe's youthful product to Shakespeare's work, first quoting a poem from the same period, and then comparing it to the play:

> How new, how bold, how marvelously free, how melodic and picturesque! How the rush of its rhythm blew the powder from the rationalistic wigs! The dramatic tale of *Götz von Berlichingen* had the same effect, that stage hit in the style of Shakespeare with its teeming tableaus of German antiquity. Frederick the Great called it formless nonsense and rejected it, but throughout the German lands it evoked joy over its cordial affront to musty poetic rules. . . .[13]

Goethe himself considered Macbeth important to his literary development. However, while Adelheid may be an eroticized Lady Macbeth, there is no contrasting character in Shakespeare's play analogous to the simple and sweet Maria, to act as counterpoint and highlight the ferocity of the "Machtweib." It is a commonplace of literary analysis that Goethe derived the character of Maria from that of Friedericke Brion, the girl whom he loved and then deserted in the months immediately preceding the writing of his play. He loved her passionately, but loved his freedom more. His wavering between the two perhaps produced the psychological conflict suffered by Weislingen, who is often said to resemble Goethe himself, torn between the sweet, simple Maria (Friedericke) and loyalty on the one hand, and opposing desires on the other.

Perhaps so. But if Goethe portrayed something of himself in Weislingen, his Friedericke in Maria, drew Götz from a medi-

eval biography, several other characters from his friends, the structure of the drama from Shakespeare and, possibly, the political ambition of Adelheid from Lady Macbeth, there is still no named source for the destructive eroticism of Adelheid. Was she an expression of his own fears and desires directed toward actual women? Many of his biographers would have us believe that she is. He fled from many women. Thomas Mann said "his wooing was aimless, his loyalty perfidious, and his love a means to an end, a necessity to his work." He was a "roving genius who lay at their [women's] feet for a time [but] was unwilling to accept the consequences to his life and liberty of his gallant adventures." (He also said that Goethe's love affairs used to be part of the "required education" of German youth—"one had to be able to enumerate them like those of Zeus.")[14]

According to this school of thought, Adelheid may be a personification of what he himself may have feared most: a woman so compelling that she might dominate him, corrupt or destroy his work, deprive him of emotional independence and personal liberty.

Goethe has also been described as afraid of sexual love, afflicted with a neurotic fear of marriage.[15] Certainly he provided would-be posthumous analysts with considerable grist for their mills. Weislingen's explosive "Zauberin!" carries terror and lust fused together, the two intense and contradictory emotions embedded later in the imagery of the femme fatale.

Goethe wrote of his fascination with the Machtweib—virago —years later in his autobiography, describing the revision of the first version of the play:

> . . . I had not deviated much at the beginning and the first acts could suitably pass for what they were intended to be. In the following acts, however, and especially toward the end, I was unconsciously carried along by a wonderful passion. While trying to describe Adelheid as amiable, I had fallen in love with her myself, —my pen was involuntarily devoted to her alone. . . .[16]

He bowed, in the end, to the necessity of creating dramatic unity in the play, and "greatly condensed" the role of Adelheid—as well as the love scenes in which she figured.

He wrote several times also of the enchantment of the "fetters" of erotic love. In a letter to an unknown recipient in 1771, he wrote:

> We hear it said that it [love] makes courageous—by no means! So soon as our heart is tender, it is weak. When it is beating so warmly against the breast, and the throat is as it were tied tightly, and one strives to press the tears from one's eyes, and feels an incomprehensible joy as they begin to flow, then we are so weak that we are fettered by chains of flowers, not because they have become strong through any magic charm, but because we tremble lest we should tear them asunder.

He goes on:

> Tell my Franzchen that I am still ever hers. I am very fond of her, and was often angry with myself because she tortured me so little; when one is in love one *wishes* to be in fetters.[17]

But when the fetters of which he speaks were present, he was at pains to find a way to break them—

> She with magic net enfolds me,
> That defies my utmost skill;
> Lovely, wanton maid, she holds me,
> Holds me fast against my will,
> In her magic ring who finds him
> After all her ways must mind him,
> Ah, how great the change to me!
> Love when wilt thou set me free?[18]

Possibly Goethe was expressing deep-seated neurotic conflicts over women, love, marriage. Equally possibly he merely gave new and far more than usually eloquent expression to the traditional sentiments of young men in love. A more direct source than his personal psychology—which is in the long run less important than the echoing impact of his work—for the characters, and the polar opposition of Maria and Adelheid, is the ancient dual concept of the Eternal Feminine. In these two women Goethe constructed a newly emphasized version of Mary/Eve. Adelheid and Maria, contrasted, provide the legendary confrontation of seductive evil and victimized innocent sweetness.

Goethe reiterated the theme in his *Faust, Part I,* providing an image that caught the rapt attention of later poets. On Walpurgisnacht, Mephistopheles and Faust climb the Brocken, the legend-haunted peak in the Harz Mountains, to join an orgiastic witches' sabbat. As they join the festival, an extraordinarily beautiful woman appears fleetingly in the distance. Faust asks: who is that? Mephistopheles replies:

> Mark her well! That's Lilith.

> Faust: Who?
> Mephistopheles: Adam's first wife.
> Of her rich locks beware!
> That charm in which she's paralled by few;
> When in its toils a youth she does ensnare,
> He will not soon escape, I promise you.[19]

Goethe had recourse to Jewish legend for this fleeting apparition. Lilith, it is said, was Adam's wife before Eve, but deserted him, and became queen of the demons, consorting with her subjects by the shores of the Red Sea. Faust's vision of her quickly fades, and a dance begins, Faust entering the dance with a beautiful young witch. He tells her of a dream in which two apples in a lovely tree charmed him so that he climbed after them. The witch replies:

> Apples still fondly ye desire,
> From Paradise it hath been so.
> Feelings of joy my breast inspire,
> That such too in my garden grow.[20]

Faust, it would seem, is Adam, and about to fall once more. The witch shares with Lilith the cold sensuality that produces not human joy, but demons. The scene, coming as it does after the seduction of Marguerite, is described as the "lowest point" for Faust—a "descent into hell," and one of the climactic moments of the plot.[21]

But Faust leaves the dance, and has another vision, this time of "Gretchen," (Marguerite) pale, moving slowly as if shackled, with "the eyes of a fresh corpse" and a "single blood-red line" around her throat—as though it had been cut. Again Mephisto-

pheles warns him—

> Let it be—pass on—
> No good can come of it—it is not well
> To meet it—it is an enchanted phantom,
> A lifeless idol; with its numbing look,
> It freezes up the blood of a man; and they
> Who meet its ghastly stare are turned to stone,
> Like those who saw Medusa.[22]

In successive visions, in other words, Faust encounters, first, the chilling enigma of Lilith, who will entrap him if he succumbs to her erotic power—climbs after the apples?—and then, his sweet Gretchen, whom he has already victimized, and who is clearly damned. The young witch—and perhaps Lilith—offering apples, echo Eve's contribution to the downfall of Adam; Gretchen, the vision of Fallen Woman. But the image of Gretchen gleaming through the darkness and flames of Walpurgisnacht is after all not the compliant lover Faust has known, but an evil spirit, who "looks to everyone like his first love."[23] She is Medusa, warns Mephistopheles, with the power to turn men to stone even after death.

Gretchen seems to combine here the traits of helpless victim on the one hand with destructive avenger on the other. Was the author creating Gretchen's Doppelgänger? Or was he suggesting that any woman could combine the polar opposites of good and evil? Certainly he intensifed the sin of Eve to demonic proportions. Lilith, in particular, is demonic. Not only is she night-demon, but also bride of Satan, stealer and destroyer of infants.[24]

Goethe also contributed to the vampirism of select versions of the femme fatale. In his epic poem *The Bride of Corinth* (1797) he related the tale of a young man who arrives in Corinth for his wedding, only to find his bride recently dead. In the night, as he sleeps, however, she comes to him as a revenant, drawn by her undying love. After they make love, he dies, since she has become a vampire. For this poem, Goethe undoubtedly drew on the vampire legends becoming current in Germany, imported from eastern Europe during the eighteenth century, possibly on other sources as well.

In its turn, Goethe's work became a major source of images for later Romantics. *Faust, Ein Fragment* was published in 1790; *Faust, Part I,* in its finished form, was first published in 1808.[25] Translations followed rapidly, and the play became a deep well of inspiration for writers and painters all over Europe.

More than almost anyone else, he precipitated the creation of a climate in which successive artists and poets were attracted to Woman as Destiny—a destiny that was more often than not disastrous. The closing lines of *Faust, Part II,* sung by the Chorus Mysticus, underline the idea:

> The Eternal-Feminine
> Draws us onward.[26]

In the character of Helen, in the second part of his drama, Goethe wanted to illustrate the beatific force of Love, the Mater Gloriosa, who acted as guide for Faust as Beatrice did for Dante, in the closing scenes of apotheosis and transition from mortal to eternal. But throughout his play one is constantly aware of the hazards besetting the follower of the "Eternal Feminine"—the constant potential for encountering either great good or great evil. Above all, one is aware of the Eternal Feminine as a figure bordering on the Omnipotent.

Goethe may have invented the phrase: The Eternal Feminine, or, if not, given the idea its earliest literary shape. In the multifarious nineteenth century editions of Faust, it is variously printed: Das Ewigweibliche; Das Ewig-weibliche; Das Ewig Weibliche. English translations are equally variable: The Eternal in Woman; The Eternally Womanly; The Eternal Feminine. While it is possible that the phrase existed before Goethe wrote his play, the variations in original and translation suggest that he either coined the phrase or that it was sufficiently rare not to have acquired a standard form before the publication of *Faust.*

Goethe's Eternal Feminine expressed an idea that began to permeate the work of painters as well as poets. Chief among the painters was Henry Fuseli, who cherished much of Goethe's work, in particular *Götz von Berlichingen.* Fuseli received a copy of it when he was studying in Rome, sent to him in a batch of new books in 1774 by his friend Lavater. It was still in his

possession at his death.[27]

While Goethe and Fuseli never met, it is clear that they had considerable admiration for each other's work. They evidently corresponded through Lavater. Goethe greatly admired Fuseli's drawings, and is recorded as early as 1775 as requesting Lavater to acquire some for him.[28] Around that time he may himself have done a drawing of three witches that is a copy of one of Fuseli's.[29] Shortly after Fuseli passed through Zurich on his return to England in 1779, Goethe was there, and bought as many of Fuseli's drawings as he could locate.[30]

Rather than having direct influence one upon the other, it appears that the two men found each other's work rewarding because they shared an attitude towards life expressed with intensity in the art of *Sturm und Drang.* Fuseli had been some time in Germany in his youth; like Goethe he had fallen under the spell of Shakespeare, Homer, Ossian, seen through Germanic eyes. Though he is less well-known today than his contemporaries in the visual arts, he was a power in his lifetime. Born Johann Heinrich Füssli in Zurich in 1741, he was educated for the Protestant ministry, but became instead a translator and writer. He came from a literary, intellectual, religious background in which he had been encouraged to master all the languages and philosophical ideas available to him. He learned not only Greek and Latin, but also Hebrew—and was fluent in French, Italian, and English, as well as his native German tongue. Like the Stürmer and Dränger, he was an early admirer of Rousseau.

He met Sir Joshua Reynolds, first President of the newly-formed British Royal Academy, in London in 1767, and, encouraged by him to espouse the visual arts as a career, went to Rome to study for nearly nine years. On leaving Rome he returned to London where he lived for the rest of his life, becoming A.R.A. in 1788, an R.A. in 1790, Professor of Painting at the Academy in 1800, and Keeper of the Academy in 1804.

The painting that made Fuseli famous, and helped to smooth his path into the Royal Academy, was exhibited in 1782, shortly after he arrived to live permanently in London. Entitled *The Nightmare,* it depicts a young woman lying supine on a

couch, in a posture of abandon, almost as though she had been flung there by a giant hand. On her chest sits a grinning, muscular goblin; behind her, the head of a wild-eyed horse looms out of the darkness (fig. 11).

This is an early manifestation of the erotic swoon that has been described above as an essential part of the iconography of the femme fatale. Not only was the first set of engravings from this painting a sell-out edition, but other publishers requested replicas of the work from the artist. Of the two most famous versions, the first now hangs in Detroit; the other is in the Goethe Museum in Frankfurt. The engravings after the painting were largely responsible for Fuseli's rapid rise to fame. The track of their influence is visible in paintings, drawings, prints and cartoons right across Europe for the next fifty years.[31]

Now, the lady in this painting is obviously a victim, not a seducer, and is therefore hardly fatal. But she does display traits later symbolic of lethal femininity: her fainting face, the humid atmosphere, the flowing hair. If the painting is turned sideways —if the figure is turned to the vertical, so to speak—she takes on a remarkable similarity to Munch's later Madonna (fig. 3). The upraised arm, the dying swoon, the cascade of hair, suggest that one of Munch's sources, if not this painting, may at least have been one he shared with Fuseli, or that stemmed from Fuseli's famous achievement.

The sources of *The Nightmare* are complex in the extreme, consisting as they do of a combination of antique sculpture, folklore—at least as much Germanic as it is classic—and quasi-scientific ideas about the nature of dreams. Nicholas Powell, Fuseli scholar and author of a monograph on this painting, identified one source for the reclining figure, as, if not the ubiquitous reclining or sleeping Maenad of antique sculpture, a monumental reclining Aphrodite, which he reproduces, in the Vatican Museum.[32] Maenads as well as Aphrodites exist, of course, in numerous samples in Rome, where Fuseli lived so long. However, so far as I know, no one has suggested that another source might be one that Fuseli, like any visitor to Rome, not only could but probably would see: Bernini's sculpture of the *Ecstasy of St. Theresa* (1652), still in place in the Church of Santa Maria della Vittoria, where it was installed when it was new. The near-

ly closed, uprolled eyes, the slightly parted lips, and complete abandon of the body in Fuseli's work bear rather more resemblance to Bernini's saint, fainting in a rapture that is clearly physical, than to a work of classic repose.

Whatever the sources, the erotic connotations of the young lady's posture in Fuseli's painting are unmistakable. Even total strangers to the visual arts are instantly aware that she has been, or is being, ravished, in dream if not reality.

The question is, does the assault take place in the girl's dream or in the dream of the painter who created her? On the reverse of the canvas is a portrait of a young woman, a three-quarter figure portrayed frontally (fig. 12). If a suggestion of Adelheid-like virago exists in the work, it is in this figure. While the composition on the front of the canvas is organized horizontally, this figure stands upright. She measures over four feet from hip to crown of her head, and is indeed a superwoman: monumental and compelling. She stares at the viewer sidelong, her head turned slightly to the right, her right shoulder slightly forward, seeming to offer the viewer a bold sexual challenge.

Fuseli scholars agree that *The Nightmare* and the portrait may both allude to Lavater's niece, Anna Landholt, for whom Fuseli conceived a "hopeless passion" during his stay in Switzerland as he returned to England. Hopeless, because she was already betrothed, and in any event her prosperous family would never have countenanced a union with the impecunious, and then unknown artist.

Did he have, as has been suggested, "Werther-fever?"—in love with hopeless love? Apparently he never "declared" his passion to the young woman.[33] But it is also possible that she may have been aware of it, and flirtatiously encouraged Fuseli's infatuation, knowing she was protected by her family and position. He expressed his most unethereal desire—lust—in a number of letters, one of which, to Lavater is quoted by nearly every writer on Fuseli, and describes a dream of the artist's own:

> Last night I had her in bed with me—my bed was rumpled—my hot, grasping hands wound around her—fused her body and her soul into mine—my spirit, breath, and strength poured into her.

Anyone who touches her now commits adultery and incest. She is mine and I am hers. . . .[34]

Is the grinning goblin sitting on the girl's chest Fuseli himself, having ravished, in imagination, dream and painting, the woman with whom he was obsessed? Powell suggested that one visual source for the goblin might have been antique sculptures of Silenus, particularly common in Roman art, and sometimes portrayed with erect phallus.[35] If the goblin is a Silenus, the scene may be an allusion to a Bacchanalia, especially if the female figure derives from either a sleeping Ariadne or Maenad. Perhaps Fuseli saw himself as Silenus!

Fuseli's fascination with the Maenad, or Bacchante, is abundantly illustrated in his drawings. Not only do they abound with prostitutes and courtesans, and erotic, even pornographic scenes, but they also offer a wide variety of images of women modeled on the antique, clearly symbolic of the Bacchante. One of the most interesting of these is an illustration for an edition of Lavater's studies on physiognomy, showing Salome as Bacchante, entitled *The Daughter of Herodias with the Head of St. John* (fig. 13).

The artist included a footnote to the engraving with Lavater's text, saying that it was Salome's mother Herodias who persuaded her to dance, and since she (Herodias) was Greek, the dance she commanded was the orgiastic rite of the *Bacchae* of Euripides.[36] That is, since the Corybantes, priests of Cybele, and the Goddess herself, were associated with the rites of Dionysis—Greek—it was appropriate for Herodias—Greek—to suggest to her daughter the Bacchic form of dance to be performed for Herod. In the Biblical story, it is Herodias who is lethal, her daughter merely being her weapon of revenge upon St. John. A subtle transformation takes place in the engraving, which presents Salome herself as seductive and fatal.

Fuseli's illustration departed sharply from earlier depictions of Salome. Such Baroque painters as Guido Reni (see fig. 8) used a conventional classical prototype of wholly different meaning: Perseus with the head of Medusa, the Hellenistic sculpture in the Vatican collection, well-known to artists from the Renaissance forward. The sculpture served as a compositional model not

only for illustrations of the story of John the Baptist but also for depictions of the Biblical story of Judith with the head of Holofernes.

Perseus as hero offered an appropriate model for Judith, who saved her city by the murder of Holofernes, and is equally a hero. Given our understanding of Salome today, the choice of classic hero as prototype for her posture might seem odd at best. Clearly, artists like Reni were far less concerned with the content of the story than with the classicizing forms. The emphasis in such a work is on equilibrium, the perfect combination of unity and variety, the Classic ideal of form to which any content was subordinated. Fuseli's choice of a wholly different prototype, that of Bacchante, created a marriage of form and content that greatly altered the overall meaning of the subject.

Obviously his choice was deliberate. His knowledge of the classical world, both its art and its literature, was extensive. The footnote appended to his illustration for Lavater indicates not only that he knew he was departing from tradition, but that he knew others would be aware of his innovation, and would require some explanation. Fuseli's interpretation of Salome as Bacchante is ancestral to later versions of Salome, if not the direct source. His new Salome, seductive and lethal, is central to the emergence of the femme fatale.

At least as interesting are two other drawings: one entitled *Witch,* utilizing the energy and windblown drapery of a classical Bacchante; another, very similar, called *Lady Macbeth* (fig. 14). Here there is a coalescence of Salome's orgiastic eroticism with the "virago." It is as though Lady Macbeth, Adelheid, and Salome had been combined into a single threatening and erotic figure.

His drawings are crowded with monumental, depraved women whom he unquestionably found enticing. In one, a seated woman holds a switch; in another, a woman standing in front of a fireplace, suggestively naked from waist to toe, towers over tiny figures flanking her. This figure, like his eroticized Lady Macbeth, is a "virago" if only in size. The overtly sadistic-erotic nature of much of the artist's work is a visual statement of his own sexual attitudes, and the dark nature of the sexuality dis-

played borders on the demonic. The instant popularity of *The Nightmare* is an index to how widely those feelings were shared. One of Fuseli's earliest acquaintances in London, the physician/writer John Armstrong, wrote a didactic poem of some popularity, published in 1744, entitled *The Art of Preserving Health.* In it he warned men against the pleasures of sexual attraction:

> The body wastes away; th'infected mind,
> Dissolved in female tenderness, forgets
> Each manly virtue, and grows dead to fame. . . .
>
> Nor in the Wanton arms
> Of twining Lais melt your manhood down.
> For from the colliquation of soft joys
> How changed you rise! The ghost of what you was!
> Languid and melancholy, and gaunt and wan;
> Your veins exhausted, and your nerves unstrung. . . .
>
> Who pines with love, or in lascivious flames
> Consumes, is with his own consent undone. . . .[37]

When Fuseli met Armstrong in the 1760's in London, he was only about twenty-five; the doctor was middle-aged, and impressively connected. Fuseli found in him a mentor, since he, like Armstrong, was a man for whom the "soft joys" of sexual embraces with women had compelling attractions. At one and the same time he masked with disdain a deep and genuine fear of the sex act itself, and saw women who attracted him as full of power. The similarity of Armstrong's words to those of General Jack Ripper in the movie *Dr. Strangelove*—who warned all his troops to preserve their "vital fluids"—is quite plain. Any shrinking Fuseli might have felt in the face of his own urges may than have been not moral, but physical.

Fuseli also possessed a strong sense of the right of man to dominate woman, and command her service and attention. His need to extract subservience, admiration, attention, from all comers, has often been attributed to his small stature. However, he may merely have expressed a commonly held opinion of the place of women in his time. Three aphorisms included among his *Aphorisms On Art* state his opinions succinctly and precisely:

Aphorism 108:

> The female able to invigorate her taste without degenerating
> into a pedant, sloven or virago, may give her hand to the man of
> elegance, who scorns to sacrifice his sense to the presiding phan-
> toms of an effeminate age.

Aphorism 226:

> In an age of luxury women have taste, decide and dictate; for
> in an age of luxury woman aspires to the functions of man, and
> man slides into the offices of woman. The epoch of eunuchs was
> ever the epoch of viragoes.

Aphorism 227:

> Female affection is ever in proportion to the impression of
> superiority in the object. Woman fondles, despises and forgets
> what is below her; she values, bears and wrangles with her equal;
> she adores what is above her.[38]

Virago, for him, was both "manlike or heroic woman"
and termagant, shrew, unmanageable woman. The definition
was altering during his lifetime, and the double entendre would
have delighted his satirical soul. He appears to have applied the
word to Mary Wollstonecraft, whom he met in 1788 at the pub-
lishing house and dinner table of Joseph Johnson in London. At
this time, Fuseli was a man in his forties, established as an artist
with a growing reputation, about to become a full member of
the Royal Academy, and recently married. The woman he mar-
ried perhaps offers evidence of his need to dominate women—
she was very young, had been an artist's model, beautiful, com-
pliant, and utterly non-intellectual. She was not only model,
apparently, but, by the standards of her day, model wife, staying
uncomplainingly in her domestic setting, available and obedient,
while her husband gallivanted and socialized all over London.

Mary, eighteen years younger than Fuseli when they met,
was by all reports fascinated by the man. In spite of comments
to the contrary—largely those of Fuseli's biographer, John
Knowles—Fuseli appears to have been equally fascinated by
her, since he spent much time in her company. Until 1782 theirs

was a close companionship. During that year, their relationship
was ruptured, and Mary left for France to "observe" the Revolu-
tion. Although Knowles refers to her as a "philosophical
sloven,"[39] whe must have been an attractive woman. Among
the many men who succumbed to her charms were the painter
Opie, a pupil of Fuseli's; the poet Southey; the painter William
Roscoe; William Blake; and Gilbert Imlay, by whom she had a
child; as well as William Godwin, whom she later married.

Clearly she felt she was Fuseli's equal, since—in the words
of his aphorism—they "wrangled." "I hate to see," she wrote on
one occasion, "that reptile vanity sliming over the noble qualities
of your heart."[40] It is evident also, from both Fuseli's biogra-
phy and Mary's own writings, in particular *Vindication of the
Rights of Women* (1792), that she felt herself to be infinitely
superior to women like Sophia, the artist's wife, who were con-
ventionally subservient to men. Outspoken, assertive, self-
reliant and self-employed, credited with a "masculine" under-
standing, Mary is not difficult to see as one example of the
"virago" of Fuseli's aphorism.

In his drawings, paintings, and writings, he gives the impres-
sion of a man whose feelings towards women were ambiguous at
best. That very ambiguity is no doubt responsible for an extra-
ordinarily wide variety of interpretations of his sexual attitudes.
He has been described as sharing the erotic attitudes of "men
like Wilde"[41]—therefore possibly homosexual; "haunted by . . .
lascivious, haughty, almost bestial women;"[42] as exploring the
"whole range of female experience and identity,"[43] and as "per-
haps striving after a virility he did not possess."[44] And, finally,
"normal," very much a man of his time, with attitudes formed
by Rousseau's theories of the proper education and place of
women, sharing during his youth the "antipathy towards the
emancipated woman which most of the Stürmer and Dränger
had."[45]

Certainly he had no high regard for the artistic and literary
accomplishments of women; he is recorded as flying into a
temper when it was suggested that the painter Maria Cosway
was his follower. Yet at one time he had been enamored of her.
When Benjamin West was elected to the presidency of the Royal
Academy, Fuseli cast the celebrated single dissenting vote for

Mary Moser, a charter member of the Royal Academy, explaining that he thought "one old woman was as good as another" (though she had befriended him in his youth). He was also "enamored" of Angelica Kaufmann, but "did not at any time hold her professional talents in high esteem."[46]

Whatever the intimate psychological profile of such a man might be, "viragoes,"—aggressive, independent women—fascinated him, and possibly evoked in him the need to dominate lest h he be dominated—castrated—their era being always the "age of eunuchs."

The overall body of his work includes an opposition of types similar to that of Goethe. Beside the heroic seductive "virago"—towering women of Michelangelesque proportions, elaborate coiffeurs, and occasional switches, there exist also "seduced and abandoned" maidens, sweet and innocent victims of male passion and fury. Like Goethe—and probably most of their contemporaries—he saw the "Eternal Feminine" as limited to two stock types.

Fuseli's reputation as a painter diminished rapidly after his death in 1825, but some of his work, in particular his writings and his teaching, continued to exert substantial influence on younger artists. His *Lectures on Painting,* the published version of his performance as Lecturer on Painting at the Royal Academy, went through many editions, both before and after his death. His biography, complete with Aphorisms, first published by John Knowles in 1831, is still widely available. His one-time pupil, Benjamin Robert Haydon, friend of Keats, first worshipped at Fuseli's feet, then rejected his influence. But Haydon's drawings and paintings offer perennial tribute to his teacher. At work on a painting of Lady Macbeth in 1829, he wrote triumphantly that he had "hit completely" the proper expression for his subject, and made of her a "beauty and a devil."[47] His Lady Macbeth, like Fuseli's before him, was intended to be Bacchanalian, seductive and fatal.

None of the foregoing examples constitutes a full-fledged femme fatale, but all exhibit one or several components of the iconography of the mature form. The dual concept of the Eternal Feminine is well represented, becoming ever more

sharply accentuated. One of the more vivid images is that of the wronged or deserted woman returning from the grave, or haunting the earth forever: Gretchen, in *Faust;* Goethe's *Bride of Corinth*. Equally compelling is the image of Lilith's magic net of hair, imprisoning her lovers. The examples also hint at the relationship of the lover to the femme fatale—in Goethe's "wish" to be "in fetters," in Dr. Armstrong's admonition that the "pining" lover is "with his own consent undone." The victim of the femme fatale, it would seem, goes willingly and in full awareness to the sacrifice.

Of all these women, Lilith, in Goethe's *Faust,* and Fuseli's engraving of the *Daughter of Herodias* contain more of the major lethal characteristics of the later fully developed femme fatale than the others. Adelheid is beautiful and destructive, but is politically motivated, and the play forecasts her execution by the forces of law in its concluding scenes. She is not allowed to escape the consequences of her ambition, and is not demonic, in the sense that Lilith in *Faust* is, not really allied to Satan. Fuseli's women are exaggeratedly erotic, but are prostitutes, or else victims of their own eroticism, mindless and will-less, more used by men than destroying them. Even Salome, however seductive, is more a tool of her mother's rage than acting out of her own desire. Only Lilith is primordial, wholly evil, and totally bent on destruction.

But in Goethe's drama, Lilith is only a vignette, not a central character. One way of reading the story would lead to an interpretation of Lility as almost gratuitous, one of a number of transient symbols of the erotic experience on which Faust had set his will. Another possible interpretation would present Lilith as central to the plot, a pivot on which the action turns, a demonic version of Helen of Troy, who is essential to the apotheosis of Faust in the second part of the drama. No matter how she is interpreted, her appearance is fleeting. She fails to occupy center stage.

But each of the examples selected offers a contribution to the synthesis of elements created by later writers and artists. Since each of the characters listed above, in particular Salome and Lilith, provide some components of the femme fatale, they function as prototypes for later forms. They are by no means

the only ones. The later image of the femme fatale is a combination of all the elements suggested in these forms: danger, death, eros, beauty, demonism—and *intent* to destroy, as well as being a central figure in imagery or plot. She is Goethe's Lilith expanded to center stage.

NOTES

[1] J. A. C. Hildner, in the Introduction to J. W. von Goethe, *Götz von Berlichingen* (New York and London: Quinn & Company, 1938), p. lxvii.

[2] *Ibid.*, p. 141.

[3] Sir Walter Scott, *The Poetical Works, With a Memoir of the Author* (Boston: Little Brown, 1857), vol. 9, p. 312.

[4] Hildner, p. lxvii.

[5] Goethe, *Götz*, Hildner edition, p. 55f.

[6] Scott, vol. 9, p. 369.

[7] *Ibid.*, p. 353.

[8] Goethe, *Götz*, Hildner edition, p. 42.

[9] Hildner, p. xc.

[10] William Shakespeare, *Macbeth*, Act I, Scene V (Harvard Classics, vol. 46, New York: P. F. Collier & Sons, 1910).

[11] Hildner, p. xliii.

[12] *Ibid.*, p. xxv.

[13]Thomas Mann, *The Permanent Goethe* (Toronto: Dial Press, 1948), p. xxxviii.

[14]*Ibid.*, p. xxxvi.

[15]Theodore Reik, quoted by Henry Hatfield, in *Goethe: A Critical Introduction* (Cambridge: Harvard University Press, 1964), p. 28.

[16]J. W. von Goethe, *Poetry and Truth From My Own Life* (London: George Bell and Sons, 1894), translated by John Oxenford, vol. I, p. 497.

[17]J. W. von Goethe, *Early and Miscellaneous Letters of J. M. Goethe,* edited by Edward Bell (London: George Bell and Sons, 1889), p. 80.

[18]Goethe, *Poetry and Truth,* vol. 2, p. 80.

[19]J. W. von Goethe, *Faust, in Two Parts,* translated by Anna Swanwick (London: George Bell and Sons, 1879), p. 175.

[20]*Ibid.,* p. 176.

[21]Hatfield, p. 169.

[22]P. B. Shelley, *The Poetical Works of P. B. Shelley,* 3 vols. (London: Edward Moxon, 1857), vol. 2, p. 421-422.

[23]Swanwick, p. 178.

[24]The best source for the legends surrounding Lilith is Lewis Ginzberg, *The Legends of The Jews,* 7 vols. (New York: Simon and Schuster, 1956). References in all volumes.

[25]In the Introduction to Goethe's *Faust,* edited by R. M. S. Heffner, Helmut Rehder, and W. F. Twaddell (Boston: D. C. Heath & Company, 1954), p. 9.

[26]Author's translation. The original is "Das Ewig-Weibliche/Zieht uns Hinan." *Eine Tragödie von Goethe,* edited by G. von Loeper (Berlin: 1879), p. 321.

[27]Peter Tomory, *The Life and Art of Henry Fuseli* (New York: Praeger, 1972), p. 28.

[28]Goethe, *Early Letters*, p. 253.

[29]Frederick Antal, *Fuseli Studies* (London: Routledge & Kegan Paul, 1956), p. 68.

[30]Paul Ganz, *The Drawings of Henry Fuseli* (New York: Chanticleer Press, 1949), p. 18.

[31]Nicholas Powell, *Fuseli: The Nightmare.* Art in Context (New York: The Viking Press, 1972), p. 60.

[32]*Ibid.*, p. 70.

[33]Tomory, p. 31.

[34]Eudo C. Mason, *The Mind of Henry Fuseli* (London: Routledge & Kegan Paul, 1951), Letter of 16 June, 1779, p. 155.

[35]Powell, p. 75.

[36]Tomory, p. 124.

[37]John Armstrong, M.D., *The Art of Preserving Health* (Philadelphia: Benjamin Johnson, 1804), pp. 136-138.

[38]John Knowles, *The Life and Writings of Henry Fuseli, Esq.*, 3 vols. (London, 1831), vol. 3, p. 103; p. 144.

[39]*Ibid.*, vol. 1, p. 164.

[40]*Ibid.*, vol. 1, p. 363.

[41]Ganz, p. 57.

[42]Antal, p. 117.

[43]Tomory, p. 107.

[44]Powell, p. 66.

[45]Tomory, p. 168; p. 177.

[46] Knowles, vol. 1, p. 34.

[47] Benjamin Robert Haydon, *The Autobiography of Benjamin Robert Haydon* (Oxford: Oxford University Press, 1927; first publication, 1853), vol. 3, p. 403.

CHAPTER 3

GOTHIC PLOT AND ROMANTIC BALLAD

Matthew Gregory Lewis (1775-1825) was a third major contributor to the gestation of the femme fatale. He wrote a novel *The Monk,* his best-known and earliest work, in a burst of feverish energy during a period of no more than ten weeks, when he was nineteen years old. He described his frenetic bout of composition in a letter to his mother from The Hague, dated 1794.[1]

By the time he had written letter and novel, Lewis had completed his Oxford degree, visited Germany, met Goethe, and embarked on what was intended to become a career of diplomatic service to the nation. His novel, according to his letter, was nonetheless composed out of infinite boredom, the Hague being, in his view, the habitation of "the Devil Ennui."[2]

The story of *The Monk* has been dealt with extensively in various studies of the Romantic period on the one hand, and the Gothic novel on the other. It is prolix, confused, panoramic, and contains subplot interpenetrating subplot interwoven with the main theme, all expressed in what today is usually called purple prose. The main plot concerns a monk, Ambrosio, of impeccable virtue and great gifts, living in Madrid, who falls prey to the advances of a beautiful young woman named Matilda. In order to gain access to Ambrosio, she disguises herself as a (male) novice and enters the monastery, gains Ambrosio's affection and confidence, and then reveals herself (literally) not merely as a woman, but as one who is consumed with desire for his admirable person. Upon her self-revelation, Ambrosio dutifully tells her she must leave the monastery. But she threatens to kill herself, lifting a "poignard" to her bosom, which her agitation has exposed.

> The weapon's point rested upon her left breast: and Oh! that was
> such a breast! The Moon-beams darting full upon it, enabled the
> Monk to observe its dazzling whiteness. His eye dwelt with in-
> satiable avidity upon the beauteous orb. A sensation till then
> unknown filled his heart with a mixture of anxiety and delight: A
> raging fire shot through every limb; The blood boiled in his veins,
> and a thousand wild wishes bewildered his imagination.[3]

He allows Matilda to remain, in disguise. And, inevitably, he
Falls. Visiting her in her cell:

> Drunk with desire . . . he forgot his vows, his sanctity, and his
> fame: He remembered nothing but the pleasure and the oppor-
> tunity.[4]

Matilda, it hardly needs saying, is learned in the "cabbalis-
tic arts;" a witch. By the time Ambrosio's desire for her is satis-
fied, she has taken further steps into perdition; she has conjured
the devil, struck a bargain with him, and become a demon-
woman. She uses her infernal arts to control Ambrosio's newly
awakened lust—first evoking it for an innocent and virtuous
maiden, Antonia, and then, through many vicissitudes, providing
him with a means to satisfy it. In the closing episodes, Ambrosio
rapes and murders Antonia; he and Matilda are imprisoned;
Matilda frees herself, and with the help of the Devil, pleads with
Ambrosio also to sell his soul. He succumbs, and is finally and
utterly destroyed.

For so young an author, Lewis had achieved real mastery
of the literary cliche. Not only did Matilda possess "beauteous
orbs," but also "golden hair" which "poured over" the manly
chest of Ambrosio; she was a "fair wanton" who used "every
invention of lust" and "every refinement of pleasure" to bind
her lover close. He, being in the "full vigor of manhood" was
unable to resist the temptation to "riot in delights" the night
through. And, on at least one occasion, at dawn—"intoxicated
with pleasure," the Monk rose from the "Syren's luxurious
couch."[5]

These adolescent effusions would be of little moment if
it were not for the fact of their enormous popularity. The novel
was received with wild enthusiasm, and endowed its creator with

the nickname of "Monk." His effort made him famous, earned him entry to aristocratic circles, and augmented his income sufficiently for him to escape the diplomatic career for which he had been trained.

Highly praised by some reviewers, the book was also rewarded with criticism as immoral by the time it went into its fourth edition, shortly after 1800. Montague Summers pointed out in *The Gothic Quest* that as late as the end of the nineteenth century, *The Monk* and its imitations—of which there were many—were read with "sniggers" and considered "semi-pornographic." He quoted the comments of a lady of Dublin, who kept a circulating library around the time the book was still fairly new, who was reproved by a concerned citizen for allowing it into the hands of her customers, especially young women. Her response: "A shocking bad book . . . but I have looked through every copy, and *underscored* all the naughty passages, and cautioned my young ladies what they are to skip without reading it."[6] No doubt the book automatically fell open at the appropriate pages from much handling—as does many another volume.

In addition to his best-seller, Lewis completed and produced a number of plays, including the highly successful *A Castle Spectre*. He also wrote short stories of "wonder" and "terror," published as a series of *Tales*. He included in them the work of other authors, and legends of the past—the gleanings of European folklore. The fame of his early work created a welcome for him in the society of literati as well as in upper-class social circles. As is well-known, he was part of the circle involved in the famous literary contest in Switzerland, including Byron, Shelley, John Polidori (Byron's personal physician), and Mary Godwin Shelley. Out of this contest came her *Frankenstein*, and later, Polidori's *Vampire*. Both Shelley's letters and Mary Shelley's journal describe Lewis' delight in entertaining them with ghost stories.

Unlike either Goethe or Fuseli, Lewis had no history of long erotic association with women. Montague Summers considered him a homosexual, and listed several affairs of the heart with young men.[7] Eino Railo, author of *The Haunted Castle*, believed the opposite, and described a single youthful love affair, a summer "idyll," with a duke's daughter who later became a life-long friend. Lewis was only twenty-two at the time, and

the lady was so far above his social class, Railo wrote, that any engagement would have been out of the question.[8] He never married. Byron considered him to be kindly, but boring; the picture that emerges from contemporary descriptions and his own letters is of a man who was talkative, pedantic, well-meaning and extremely conventional in his social attitudes and values.

Like most of his contemporaries, Lewis disapproved highly of women in "masculine" professions. When his mother, who was separated from her husband, proposed to take up her pen and become an author, he stated his objections in a letter to her with more clarity, given the nature of his fiction, than one might expect:

> I cannot express to you in language sufficiently strong, how disagreeable and painful my sensations would be, were you to publish any work of any kind, and thus hold your self out as an object of newspaper animadversion and impertinence. I am sure every such paragraph would be like the stab of a dagger to my father's heart. It would do material injury to Sophia; and although Maria [his sisters] has found an asylum from the world's malevolence, her mother's turning novel-writer, would (I am convinced) not only severely hurt her feelings, but raise the greatest prejudice against her in her husband's family. As for myself, I really think I should go to the continent immediately upon your taking such a step.[9]

Several days later, he continued to admonish his mother: "I hold that a woman has no business to be a public character," he wrote, "and that in proportion as she acquires notoriety, she loses delicacy. I always consider a female author to be a half-man."[10]

These letters were written in 1804, and are truly prophetic of Victorian sensibilities. Marriage, clearly, was "an asylum from the world's malevolence"—for a woman. And indelicacy—notariety—in a woman—might drive her outraged male relatives right out of the country, so shaming would it be. The moral is: ladies! be delicate; modest; retiring! Be Antonia. Do not be assertive, ambitious, noticeable—you might turn into Matilda! It should be noted that Mrs. Lewis protested, and acceded only reluctantly to her son's wishes—and may have done so in the end only because he was her major source of financial support.

This dichotomy of types—in both Lewis's novel and his conventional habits of mind—is notable for its resemblance to the stock type: Mary/Eve, Snow-White/Rose-Red. The contrast was a favored fictional device in his day. Railo traced a line from the early Gothic novels to Sir Walter Scott to the poetry of Byron and Shelley, in which the "Young Hero and Heroine" are defined as coming in pairs. On the light side (literally, wince they are usually fair in complexion):

> The young hero and heroine have an important part assigned to them. . . . He is the romanticist's symbol of young, pure and idealistic heroism; she, a rosy embodiment of womanly beauty and virtue. The dark side of the former finds its expression in the Byronic hero, of the latter in the demon-woman. . . .[11]

The fair and the dark, the good and the bad, the virtuous and the sinful, stand endlessly in relief one against the other. The point of this author's analysis is that unfortunately, the fair and the virtuous fail to be as interesting as the dark and the sinful.

This simplified description of types breaks down in detail; not all sinners are brunette, nor all saints blonde, not even in Gothic novels, let alone in the visual imagery that emerged in their wake. But the dichotomy of personality does exist. Matilda, though she is blonde, is the "demon-woman," and is offset by the young and virtuous Antonia, the second object of Ambrosio's lust, and who is ravished and dies at the hands of the obsessed cleric.

Walpole's *Castle of Otranto,* Mrs. Radcliffe's *Mysteries of Udolpho* were both, with medieval folklore and the works of Goethe, important to Lewis, as well as the slightly more digni-fied adventures of Sir Walter Scott.[12] In all of these there are repeated examples of the contrast, which is ramified by the multiplication of characters. Heroes and heroines come in dupli-cate forms, themselves frequently contrasts of types—as though they were mirror image twins. As described by Railo, virtuous youths are contrasted with sinful youths, and virtuous and sin-prone damsels stand side by side.[13]

Though he did not use the phrase, this writer might have been defining the dual nature of the Eternal Feminine in his

"subdivision into types" of light versus dark. The division is occasionally more subtle than saint opposed to demon:

> The first named type [light] breathes a fine feminity, a tender and maternal spirit, fighting the battles of life with the weapons of resignation and tears, and bringing to love everything that is divine, passion excluded. The second type [dark], more spiritedly poetical, is represented in the independent and oppositional beauty, who feels deeply, demands freedom and choice, and is not impervious to passion.[14]

Buried in this elegant prose is the polar opposition of soul and body, spirit and flesh, attached to the female. She who is feminine—maternal—cannot possibly be erotic, and she who is erotic cannot possibly attain the Higher Virtue. Also lurking here is the notion that, in women, passion and independence go hand in hand, possibly together with sin.

The opposition of types listed here, a derivation of the medieval and Renaissance Mary/Eve dichotomy, exhibits an additional facet of the Romantic attitude that is new. The virtuous chaste wife and mother becomes more and more the chaste *virgin*. The heroines on the "light" side become younger and younger; Antonia was fifteen years old, Faust's Gretchen barely sixteen. The Dark Lady moved even further from the frail sinner, becoming ever more the author and less the victim of dark deeds. Like Matilda, the femme fatale appears to have been born of a pact with the devil. She is, in at least some cases, a female Faust.

Like Lewis, like in fact his entire generation, Percy Bysshe Shelley too was fascinated by the works of Goethe, in particular *Faust*. He translated extensively from the Walpurgisnacht scene, including the description of Lilith:

> Beware of her fair hair, for she excels
> All women in the magic of her locks;
> And when she winds them round a young man's neck
> She will not ever set him free again.[15]

Shelley, like Rossetti after him, is given credit for the creation of a "new type of Beauty": that of Medusa, in his poem

inspired by the painting of her severed head in the Uffizi Gallery, at that time attributed (erroneously) to Leonardo da Vinci.[16] The beauty is the beauty of Death, the beauty of Gretchen on Walpurgisnacht with bleeding throat, and the beauty of Lilith. Shelley's ode to Medusa and his translations from *Faust* were complete by 1819, and reflect clearly the shifting attitudes of artists and poets towards erotic images of women. They illustrate the beginning of the Romantic love affair with Death.

To these altering images, John Keats added the atmosphere of thralldom, enchantment, remote from any expeirience that might be labelled "real." In the ballad *La Belle Dame sans Merci* he created a "faery child" extricated from medieval legend, who belongs in a different category altogether from figures derived from classical or Biblical legend. The Belle Dame casts a spell on the wandering knight so that he wanders forever outside time, warmth, light; he is condemned, by a single act of love with a changeling, to lose his knightly power. She is a magical ghostly inhabitant of folklore rather than any established artistic tradition, and represents something of a milestone in the medieval revivalism of the Romantic Movement.

Keat's knight is apparently cousin to Lancelot in Malory's *Morte D'Arthur.* Lancelot fell from grace, and wandered, mad, for years. When he found the chapel of the Holy Grail, he could not enter, since he had sacrificed his chastity to his desire for Guinevere. He lived much of his life deprived of honor and of the companionship of the Round Table—deprived of hope, of love, and of conquest. The knight in thrall to the Belle Dame in Keats' ballad is some steps further removed from the light—forced by the evil charm laid upon him to wander in limbo, with life on one side, and the Belle Dame on the other, both forever out of reach.

Leigh Hunt, first publisher of the poem, believed that Keats found the inspiration for the figure of the Belle Dame in a poem by Chaucer, the title of which was based on a French ballad. He may have been referring to a late work called *Merciles Beauté.*[17] Others have equated the shadowy Belle Dame with Fanny Brawne, with Death, with Woman, and in one case with Keats' adored and tragic mother.[18] Praz considered Keats' Belle Dame to be a variant on the Tannhäuser theme, and commented that it

was obviously inspired by Coleridge's *Dark Ladie*.[19] A more recent critic regards the "false Florimel" in Spenser's *Faerie Queene* to be the source for the Belle Dame. On the day Keats wrote his poem, he apparently also wrote a review for *The Examiner* in which he referred to this figure from Spenser's work. The false Florimel, like the Belle Dame, it is said, is not real, but a disappearing spirit.[20]

The difficulty with extricating a single specific source from earlier literature for Keats' remarkable image rests in the fact that he shared interests with his predecessors. Surely he knew Chaucer, Spenser, Coleridge—but, like them, he also knew legend and folklore, and was moreover steeped in the generalized fascination with things medieval that characterized the poets and artists of his time. His poems, *The Eve of St. Agnes* and *The Eve of St. Mark* testify to his love of legend.

Spenser's false Florimel, unlike Keats' Belle Dame, appears to be a Doppelganger, phantom twin to a living, breathing virtuous maiden: the true Florimel. Title alone connects *La Belle Dame sans Merci* to Chaucer's *Merciles Beauté,* who is a hardhearted woman of flesh, addressed by the poet in the language of Courtly Love. The Belle Dame is at least as similar to the ubiquitous "phantom bride" of European folklore as to any other figure. The maid who dies on the eve of her marriage or reunion with a lover, and then haunts him until she succeeds in luring him into her world of death, ranges from Scotland to Russia to Goethe's *Bride of Corinth.*

More often than not the phantom bride is not a ghost but a revenant, a material manifestation of the deceased rather than a disembodied spirit. Since she is present in the flesh in his ballad, Keats' Belle Dame seems to be such a form. Though she is a "fairy's child" who lives in an "elfin grot," the love she shares with the knight is tactile as well as erotic.

The narrative content of the ballad provides only the statement that the knight and lady meet, make love, and fall asleep in her "elfin grot," whereupon the knight dreams, a dreadful dream, finally wakening *alone* on the "cold hill side." He *remains* "alone and palely loitering," in thrall, apparently, to the Belle Dame who has herself disappeared.[21] The vision of kings,

princes, warriors, "death-pale," who cry a terrible warning to the knight in his dream, seem to be those who have been enchanted before him by the same Belle Dame.

The sense of a ghost story is very strong. The Belle Dame may not be the phantom bride of *this* knight, since no promise of love and fidelity exchanged by them is mentioned, but he—like those who preceded him—may be a substitute for a faithless knight in the forgotten past. Like many another haunting figure, the Belle Dame seems to be tied to the earth by an ancient wrong.

That is, while the knight is enchanted, trapped, by the Belle Dame, she too is trapped. Insofar as she is beautiful, destructive, enthralling, Keats' Belle Dame does embody some of the central characteristics of the femme fatale. But she is fey—made and doomed; "her hair was long, her foot was light, and her eyes were wild." Her love is lethal for the knight, but there is no hint of wilful malevolence on her part, only of some strange enchanting force, unnamed, that has bewitched all the inhabitants of the poem. The knight goes to his fate not knowingly, but in ignorance of it. The Belle Dame is dangerous, but is not yet a full-blown femme fatale.

Keats may have been inspired by multiple sources instead of just one, and drawn not only from literature but from the circumstances of his life as well. Given the dramatic nature of those circumstances, and the compelling imagery of his poetry, it is tempting to make biographical hay with his work. When he wrote this poem, his brother Tom had recently died of tuberculosis, and the poet himself had met and possibly become engaged to Fanny Brawne.[22] It is moot whether he knew then that he was already afflicted with the disease that had killed his brother—certainly he must have feared it. The familial patterns of tuberculosis, however misunderstood they may have been at the time, were well-known. Keats, trained as a doctor, was medically better informed than most contemporaneous laymen. Any fears or ideas concerning tuberculosis that he had must have been compounded by the then current beliefs regarding the effect of the disease on sexuality. Afflicted children were believed to be sexually precocious; afflicted adults were held to be sexually driven. Medically naive people believed this as recently as the

1930's, and they may still so believe in various parts of the world. In this situation, it is easy to see Keats describing himself as the Knight, caught forever between death and desire. Whatever he drew upon for the Belle Dame, however, literary or personal, has been synthesized and transmuted into new and compelling imagery. The poem's major significance for later artists and writers who did produce full-fledged femmes fatales is demonstrated by Praz's use of its title for his chapter on the Fatal Woman.

Keats contributed substantially to other elements of the iconography of the femme fatale. His *Lamia,* published with a group of other poems in 1820, popularized a hybrid legendary form from classic legend, the snake-woman. He found the story in Burton's seventeenth century *Anatomy of Melancholy,* an ancient tale of a youth seduced by the Lamia, and taken to her house in Corinth, where eventually they plan a wedding.[23] The youth's teacher, the philosopher Appolonius, among the guests, alone recognizes and proclaims the woman's monstrous nature, whereupon she vanishes, and the youth dies. Since the stories are so similar, one wonders if Keats had read Goethe's epic, or if (since he was an Anglophile) Goethe also knew Burton's anecdote.

The image of the Lamia became one source for the vampirism of the full-fledged femme fatale. In Keats' poem she contained life and death in her breath and lips. When she first seduces Lycius, the youth, she binds him closer by threatening to leave him, and he swoons, near death. But then she—

> Put her new lips to his, and gave afresh
> The life she had so tangled in her mesh:
> And as he from one trance was wakening
> Into another, she began to sing. . . .[24]

At the end of the poem, unmasked as a snake, she "breath'd death breath"—and then, "with a frightful scream she vanished."[25] The death breath was perhaps her own, but it was Lycius', too, since at the moment she vanished, he died.

There is only a hint of vampirism here, but it was enough to catch the attention of later writers. Years later, Swinburne

used the Lamia as a comparison for one of Michelangelo's drawings, describing the woman as having "eyes full of proud and passionless lust after gold and blood; her hair, close and curled, seems ready to shudder in sunder and divide into snakes . . . her mouth crueller than a tiger's, colder than a snake's, and beautiful beyond a woman's. She is the deadlier Venus incarnate . . . readier to drain life out of her lover than to fade for his sake at his side. . . .[26]

Now, this interpretation belongs to Swinburne, and might easily have startled both Michelangelo and Keats rather severely. Keats' Lamia, far from being cruel, cold, or passionless, is gentle as well as beautiful, sinking into silent melancholy when Lycius determines to parade his passion in a public wedding ceremony. Here, surely, is the willing consent of the victim, but he is his own rather than the Lamia's sacrifice to love. It is Lycius, in other words, who brings about his own final distruction, and not the Lamia, who struggles to dissuade him from his disastrous course. She consents to the wedding, finally, in "misery" . . . "knowing surely she could never win/His foolish heart from its mad pompousness."[27]

More argument has focused on the meaning of this particular poem than on any other element of Keats' work. The conventional interpretation has consisted until recently of identifying the Lamia as Beauty, Lycius as Poet, and Appolonius as the unattractive "cold voice of reason" who destroys the lovers' idyll.[28] The Lamia has also been defined as Muse, from an enchanted land, chased away by Philosophy and Science.

More recently the Lamia has been called "Circean." The "recurrent theme of destructive love and the Fatal Woman" formed the substance of a discussion of the poetry of Keats in 1957.[29] It would seem that the writer, discussing Romanticism in Keats, utilized the concept of the Fatal Woman from Praz's then recently revised and reissued *Romantic Agony* for an understanding of the women in Keats' poetry. The label offers an excellent example of the retroactive application of a relatively new concept to earlier work. The women invented by Keats, however, might just as easily be interpreted as Imagination, Love, or even Muse, as earlier critics have remarked.[30] The personification of Imagination, or Muse, as female, would then follow the

traditional classic pattern, which is a far cry from the femme fatale.

A variation on the theme of the Lamia, equally a source for vampire legends, and for the "vamp" as a less emphatic femme fatale, is the Poison Damsel. Stories of Poison Damsels derive their motive force from ancient Asian Indian folklore. A poison damsel is one raised on snake venom, so that she herself becomes venomous—to touch her, or, above all, to kiss or make love to her, is fatal. One well-known story of the Poison Damsel entered Europe in the Middle Ages in the guise of a letter (probably apocryphal) purporting to be written by Aristotle to Alexander the Great during the latter's campaigns in India. Aristotle warned the young general that a native rajah would attempt to destroy him by sending him the "gift" of a daughter. It need hardly be said that treachery was intended; the daughter was in reality poisonous. Alexander, however, being warned in good time, was able to avoid her lethal embraces.[31]

Nathaniel Hawthorne used the device for his short story, *Rappaccini's Daughter,* first published in *The Democratic Review* in 1844. Rappaccini, in the story, is a physician who has developed a rare poisonous plant in his efforts to find powerful medicines for the treatment of disease. His beautiful daughter, Beatrice, has been rendered dependent upon the plant, its scent and its flowers, for her own breath, for life itself. She too is poisonous. Giovanni, a young medical student, sees her in her garden through his bedroom window and falls in love with her. He arranges to call on her, and during one visit, he reaches out to touch the plant, but Beatrice, screaming, puts her hand on his wrist to stop him. The next day he wakes in pain. "On the back of that hand there was now a purple print like that of four small fingers, and the likeness of a slender thumb upon his wrist."[32] Eventually, Dr. Rappaccini, to provide his daughter with a companion, renders Giovanni poisonous too, and the young couple is doomed.

Hawthorne said his plot came from an "old classic author," but did not mention Aristotle. He did relate Alexander's alleged hazardous experience. Though Beatrice has been called a "toxic variant" on Praz's Fatal Woman,[33] she is neither cruel nor malevolent, but is instead gentle, beautiful, and only involun-

tarily lethal. She is therefore hardly even a vamp, let alone a femme fatale, though she marks and injures her lover. Obviously, however, if in some future manifestation she developed the requisite intentional evil, she could qualify as a femme fatale. In Hawthorne's tale she does not so qualify.

Gothic tales, ranging from "Monk" Lewis's tortuous plot before 1800, to this story by Hawthorne, illustrate a generalized growing fascination with the macabre, with witchcraft, with death. The Romantic love affair with death among writers in the early decades of the nineteenth century clearly extended to a wide audience. Under the circumstances, it is singular that before mid-century, only a few artists focused on the more macabre aspects of Goethe's *Faust, Part I*. At least one writer has remarked that *Faust* was among the most popular and most illustrated of Goethe's works, while others have pointed out that though illustrations to *Faust* are many, very few center on Walpurgisnach.[34] Among those that exist is the English artist Theodore von Holst's painting (fig. 15), variously titled *A Scene From Goethe's Faust* (1833), or, alternatively, *Faust and Lilith*.[35]

In this work, the golden hair of the woman in the central dancing pair streams down beside Faust's face in an echo of Lilith's magic net. In the text of the play, however, Faust dances with a young witch, not Lilith. Gert Schiff identified the actors in the painting as Marguerite, on the right with her face hidden in her hands, surrounded by figures representing good and evil contesting for her soul; the group at the left as Euphorion, playing his harp, from *Faust, Part II*. In the center Faust dances with a young witch, while behind them, Mephistopheles makes advances to an "enchantress" sumptuously garbed in medieval fashion.[36]

This figure, like Goethe's Lilith, and von Holst's central dancing female figure, has long golden hair. Perhaps she, rather than the dancer, is Lilith. The dancer might be the young witch who was so delighted still to possess the kind of apples that tempted Faust.

Von Holst's most important mentor and teacher was Fuseli. However the figures are identified, von Holst's painting, together

with a few similar scenes, provides an important channel of ideas from Fuseli to later artists, in particular the young Pre-Raphaelites. The relationship of white gown, drapery, and musculature between Fuseli's and von Holst's work is immediately apparent. Perhaps this is one of a group of von Holst's works that were hung in a restaurant, recorded in Ford Madox Brown's diary, which the Pre-Raphaelites frequented in 1855.[37] Von Holst died relatively young, in 1844, at the age of 34, just four years before the Brotherhood was formed.

The artist may have combined elements from both Part I and Part II of *Faust* in this composition, as Schiff has stated, but, if so, has placed them in the setting of medieval gloom that pervades Walpurgisnacht. A few illustrators and an occasional painter gave this scene their devoted attention; most avoided it scrupulously.[38] Perhaps the neglect arose from the fact that some elements of the narrative bordered on the obscene, attracting a few artists, but offending the Victorian sensibilities of others. In Goethe's original text, certain events follow in rapid sequence. First, Faust sees the apparition of Lilith; next he dances with the young witch, describing his vision of apples. After the young witch replies that she is delighted that her garden contains them too, two short comments follow:

Mephistopheles, to Old Witch:

> Once a weird vision came to me;
> Therein I saw a rifted tree.
> It had a ;
> But as it was it pleased me, too.

Old Witch, to Mephistopheles:

> I beg most humbly to salute
> The gallant with the cloven foot!
> Let him a have ready, here,
> If he a does not fear.[39]

With little thought, it becomes apparent that the omitted words are slang or obscene references to sex organs. Nineteenth century editions of Faust, both German and English, follow one of two patterns in publication: either, as above, omitting the

offending words, or, in some cases, omitting the two quatrains altogether. No doubt the omissions, like the strictures of the book seller in regard to *The Monk,* served to focus the attention of any reader on the meaning of the passage.

Goethe offered great impetus to the imagination of later artists and writers like Lewis by resurrecting the late medieval obsession with the pact with the Devil. He gave shape to the concept of the dualistic Eternal Feminine in the first half of the nineteenth century, and invented a series of women possessing important traits for the development of the femme fatale. The virago, in Adelheid; Eve, become a witch, still possessing the apples of temptation; Lilith, the snake herself, the bride of Lucifer; and Marguerite, the fallen woman, who, in her state of sin becomes Medusa, destroyer of all who look upon her face. Fuseli contributed the visual iconography of the erotic swoon, and also the subtle alteration of Salome from victim to actor in the drama of John the Baptist. Keats added bewitchment, and the notion that a woman damned will vengefully haunt her lover until he enters perdition with her. All of these creative men perpetuated and intensified the dual iconography of Woman. Their followers completed the picture of the full-grown femme fatale by adding the oriental exoticism, the sterility and the androgyny celebrated by the Symbolists.

NOTES

[1] Mrs. C. Baron-Wilson, *The Life and Correspondence of M. G. Lewis,* 2 vols. (London: Henry Colburn, 1839), vol. 1, p. 133.

[2] M. G. Lewis, Esq., M. P., *The Monk, A Romance,* in 3 vols. (Waterford: Printed for J. Saunders, 1796), vol. 1, p. 128.

[3] *Ibid.,* vol. 1, p. 126-127.

[4] *Ibid.,* vol. 1, p. 175.

[5] *Ibid.,* vol. 2, p. 177.

[6] Montague Summers, *The Gothic Quest: A History of the Gothic Novel* [1938] (New York: Russell and Russell, 1964), p. 219.

[7] *Ibid.,* p. 263.

[8] Eino Railo, *The Haunted Castle* (New York: The Humanities Press, 1973; first published by Routledge and Kegan Paul, 1927), p. 99.

[9] Mrs. Baron-Wilson, vol. 1, p. 276-277.

[10] *Ibid.,* p. 278.

[11] Railo, p. 283.

[12] *Ibid.,* p. 88ff.

[13] *Ibid.,* p. 283.

[14] *Ibid.,* p. 291.

[15] P. B. Shelley, *The Poetical Works of P. B. Shelley,* edited by Mrs. Shelley (London: Edward Moxon, 1840), p. 362.

[16] Praz, p. 40.

[17] Hunt's opinion is noted in H. Scudder's *Complete Poetical Works of John Keats* (Houghton Mifflin, 1899); Chaucer's poem may be found in his *Works,* edited by Robinson, p. 982.

[18] Peter Quennell, *Romantic England* (New York: Macmillan Company, 1970), p. 100.

[19] Praz, p. 202 and p. 274, n. 17.

[20] Robert Gittings, *John Keats: The Living Year* (New York: Barnes and Noble, 1954), p. 117f.

[21] H. Buxton Forman, editor, *The Complete Poetical Works of John Keats* (New York: Thomas Crowell & Company, 1901), vol. 3, pp. 22-25.

[22]Keats, *Complete Works,* Scudder edition, notes.

[23]Keats, *Complete Works,* Forman edition, vol. 2, pp. 9-32.

[24]*Ibid.,* p. 22.

[25]*Ibid.,* p. 32.

[26]Algernon C. Swinburne, "Notes on Old Masters in Florence," *Essays and Studies* (London, 1888), p. 319. Reprinted from *Fortnightly Review,* 1868.

[27]Keats, *Complete Works,* Forman edition, vol. 2, p. 27.

[28]Walter Jackson Bate, *The Stylistic Development of Keats* [1945] (New York: Humanities Press, 1962), pp. 142-143.

[29]Judith O'Neill, editor, *Critics on Keats* (Miami: University of Miami Press, 1968); the opinion is that of Pettet, p. 32.

[30]Bate, p. 143.

[31]N. M. Penzer, *Poison Damsels* (London: Charles Swayer, Ltd., Grafton House, 1951), pp. 3-70.

[32]Nathanial Hawthorne, "Rappaccini's Daughter," *Mosses From an Old Manse* (New York: George P. Putnam, 1850), p. 108.

[33]D. Bruce, "Vamp's Progress: A Late Eighteenth Century Affectation," *Cornhill Magazine,* Fall 1960, vol. 171, pp. 354-355.

[34]William Vaughan, *German Romanticism and English Art* (New Haven and London: Yale University Press, 1979), p. 113.

[35]Vaughan, p. 112.

[36]Gert Schiff, "Theodore Matthias von Holst's 'A Scene from Goethe's Faust' " *Arts,* January 1980, pp. 6-14. Professor Schiff gave the painting the title he used for his article, and identifies the central figure as a young witch.

[37]William M. Rossetti, *Pre-Raphaelite Diaries and Letters* (London:

Hurst and Blackett, Ltd., 1900), p. 176. William Rossetti gives the information in a footnote to Ford Madox Brown's diary, April 12, 1855.

[38] Vaughan, p. 113. The Catalogues of the Annual Exhibitions of the Royal Academy, available in their library at Burlington House, list very few scenes from *Faust* as titles of exhibited works.

[39] Goethe, *Faust,* Swanwick translation, p. 176.

CHAPTER 4

SAINT AND PROSTITUTE:
THE FRENCH CONTRIBUTION

Theophilé Gautier's reputation stood exceedingly high in the Paris of his own day. Though born in the provinces in 1811, he was raised and educated in Paris, and lived there all his life, providing the twentieth century with a picture of the ultimate in urbane Parisian. His path to achievement was relatively smooth, unlike Baudelaire's, and his relations with his family warm, seemingly unmarked by the kind of strife that so distressed the younger poet. He began as an art student, moved rapidly into a literary career, came early to the notice of Saint-Beuve, published his first poetry while still in his teens and his first novel at twenty-three. He then entered—evidently without a single backward glance of regret—the lucrative field of journalism that he had once castigated. All seems to have been accomplished without undue difficulty.[1]

Baudelaire paid him perhaps the most eloquent expression of homage in an article written for *L'Artiste* in 1859. He lauded the entire body of Gautier's works: poetry, novels, short stories, travel accounts, criticism. "Gautier," he said "is a writer whose talent is both *new* and unique. It may be said of him that as yet he has no *understudy*."[2] He was particularly impressed by the historical and geographical range of Gautier's Muse. She lived, he said, in a more "ethereal world" than that of Balzac, who was fascinated only by the daily doings of ordinary Parisians; she—

> loves landscapes that are terrible or forbidding or those that breathe a monotonous charm—the blue shores of Ionia or the blinding sands of the desert. . . . Her characters are the gods, the angels, the priest, the king, the lover, the rich, the poor. She loves to bring to life cities that have vanished and to have the dead whom she restored to youth recount their interrupted passions.[3]

Baudelaire reserved special praise for *Mademoiselle de Maupin,* Gautier's first novel. "With its marvelous style," he wrote, "its correct and studied beauty, pure and ornate, the book was a veritable sensation." He continued:

> With *Mademoiselle de Maupin* there appeared in literature what may be called Dilletantism, which by its exquisite and superlative character, is always the best proof of the faculties indispensable to art. This novel, this tale, this picture, this reverie, developed with the persistence of a painter, this hymn to Beauty, so to speak, had above all the important result of establishing once and for all the exclusive love of the Beautiful, the *Fixed Idea,* as the generating condition of works of art.[4]

Obviously Baudelaire there used the word "dilletante" to mean one who is delighted rather than one who dabbles in the arts, according to the original meaning of the French verb: dilletare, to delight, from the Latin: delectare. He championed, in this passage, precisely those elements in Gautier's works which have received critical disapproval, then and now, by those who prefer a more orderly, a more consistent and restrained theory and expression in any art form. Those elements are: Gautier's rejection of moral commitment, his extravagant and mellifluous prose, and his wide-ranging excavation of antiquity and geography, not to mention literature, for the setting, plot, and character that mark his work.

Baudelaire pointed out that Gautier's adherence to the single principle of Beauty and no other was already apparent in his first volume of poetry, published several years before the novel. So far from being a single-minded adherent of Romanticism, he

> applied himself very early to the study of the Greeks and the beauty of antiquity. . . . On this score one can consult *Mademoiselle de Maupin,* where Greek beauty was vigorously defended in the very midst of Romantic exuberance.[5]

The range of Gautier's interests—the omnivorous quality of his muse, perhaps—is indeed already apparent in this early work. *Mademoiselle de Maupin* derives its central character from a seventeenth century history of a real woman, transvestism from

Shakespeare's *As You Like It*,[6] a love of the antique possibly from Johann Joachim Winckelmann, the eighteenth century historian of ancient Greek art.

The story concerns D'Albert, a well-born and leisured young gallant in search of the perfect mistress (though his current one was compliant), and Madeleine, a beautiful young woman, a virgin, who assumes the dress of a man in order to explore and gain knowledge of the world. They meet in a country-house setting, in circumstances clearly ancestral to those of drawing-room comedy. A remarkable tangle of chase and pursuit of love ensures, conducted in a summer holiday atmosphere. As the story approaches its inevitable denouément—this is comedy rather than tragedy, and the lovers do discover and bed one another—we find D'Albert as yet unaware of the true sex of Theodore (Madeleine) but beginning to love him. He meditates on the peculiar and compelling charms of the Androgyne: ancient sculptors, he muses, understood adolescent beauty, in both male and female, unlike those of times since the birth of Christ. In classic times, the two genders were much alike:

> There is scarcely any difference between Paris and Helen. And so the hermaphrodite was one of the most cherished chimeras of idolatrous antiquity.

> This son of Hermes and Aphrodite is, in fact, one of the sweetest creations of Pagan genius. Nothing in the world can be imagined more ravishing than these two bodies, harmoniously blended together and so perfect, these two beauties so equal and so different, forming but one superior to both. . . .

D'Albert does not suspect that Theodore is woman—and yet, much to his confusion, is greatly attracted to the youth. For D'Albert, Theodore "would be an excellent model for this kind of beauty; nevertheless, I think, that the feminine portion in him prevails. . . .

> To an exclusive worshipper of form, can there be a more delightful uncertainty than that into which you are thrown by the sight of the back, the ambiguous loins, and the strong delicate legs. . . .[7]

There can be little question that the young author, in the fashion of youth since the beginning of time, intended deliberate shock and titillation of his large (he hoped) reading audience. His preface to the novel was a long and satirical condemnation of the persecution and censorship then being imposed in Paris on the "new" art of the Romantics. In the novel itself, he explored, as above, a vast range of sensual delights, and all the longing of the young searching for the experience as well as the emotion of love.

In the end of the novel, Madeleine/Theodore succumbs to both desire and curiosity. In a single night she makes love to D'Alabert in her actual form as Madeleine, and also, separately and unknown to him, to his mistress, who has fallen in love with her in her guise as Theodore. She is, then, genuine Hermaphrodite, alluring to both sexes. But before she reaches that point, she agonizes over whom to choose as lover, expressing terror at the possibility that she might choose someone unworthy, whose "slime would remain always" with her:

> Ah! Cleopatra. I can now understand why in the morning you had killed the lover with whom you had spent the night. Sublime cruelty, for which informerly I could not find sufficient imprecations! Great voluptuary, how well you knew human nature, and what penetration was shown in this barbarity! You would not suffer any living being to divulge the mysteries of your bed, the words of love which had escaped your lips should not be repeated.[8]

To Shakespeare and the antique the author has added Egypt. His fascination with this ancient land and people later expanded this short passage into his novella, *Une Nuit de Cleopâtre* (1845). His full and detailed description of the Hermaphrodite in the novel no doubt came, as did Swinburne's three decades later, from standing in front of the Hellenistic sculpture of the *Sleeping Hermaphrodite* in the Louvre, then still a relatively new public museum. Numbers of these sculptures exist, primarily in Italy. Ovid, among others, relates the myth of the Hermaphrodite illustrated by the work of his *Metamorphoses.*

The popularity of the sculpture in the ancient world assumes the character of an historical oddity in the twentieth cen-

tury. It is perhaps an example of fashionable taste of the day: Hellenistic chic. The version in the Louvre may have had the virtue of novelty in the nineteenth century by being only newly visible to the general public during Gautier's youth. The Louvre was turned into a museum by the revolutionaries in 1792, but much of its present collection remained for some years in private hands, and much of its space was occupied by the Royal Academy schools until they were expelled by Napoleon in 1806, to further the conversion of the buildings to museum space. The flood of new work that came to the building in the wake of his military campaigns only began to be housed and visible during the next several decades.[9] The actual completion of the buildings did not begin until 1848, when the museum became the property of the state.[10]

Undoubtedly a major factor in Gautier's admiration of the "Greek" was the influential body of eighteenth century historical publications by J. J. Winckelmann. Inserted into Winckelmann's scholarly exegesis of the beauties of ancient art was a paean of praise for the nubile youths of ancient sculpture. Not only did Greek sculptors succeed in producing ideal adult forms, both male and female, in his view, but, even more beautiful, their combination:

> Art went still farther; it united the beauties and attributes in the
> figures of hermaphrodites. The great number of hermaphrodites,
> differing in size and position, show that artists sought to express
> in the mixed nature of the two sexes an image of higher beauty;
> this image was ideal.[11]

Ideal or fanciful, the Hermaphrodite in the Louvre displays all the sensuous qualities that mark Hellenistic sculpture. The languid figure is marble translated into flesh, its undulating surface reflecting a play of light and shadow so subtle that it seems to breathe (fig. 16). The sculpture may indeed exhibit the "higher beauty," but much more evident to the senses of the casual viewer is its intense eroticism. Winckelmann's approach to the classic was incipiently "romantic," and no doubt his homage to the Hermaphrodite was a major source of the nineteenth century love of androgynous images.

Gautier must have been familiar with Winckelmann's books,

which were widely popular and available in several languages. His interest in Egypt had an even more direct source: the wide range of antiquities being installed in the Louvre, and the continuing publication of Francois Jomard's *Description de l'Egypte.* This multi-volume work began to come out in 1809, and continued to emerge over the next two decades, during Gautier's youth.

To his love of Greece and Egypt, Gautier added fascination with the dual nature of the Eternal Feminine. As early as his first book of poetry the attractions held for him by the contrast of fair and dark, ethereal and voluptuous—echoing the contrast of types in the Gothic Novel—are made abundantly clear. In his *Elegie I* he begins:

> Nuit et jour, malgré moi, lorsque sius loin d'elle,
> A ma pensée ardente un souvenir fidele
> La ramene; . . .

and she of whom he dreams is pale, fair, seen and heard distantly as though through a haze. Finally

> Et je l'aime d'amour profond:

Towards her he yearns. But she is unattainable—not so another,

> Mais une jeune fille inconstante et frivole,
> Qui ne rêve jamais; une brune créole
> Aux grande sourcils arqués, a l'oeil brilliant et noir
> Ou son âme se paint aisi qu'en miroir;
> A la taille élancee, à la gorge divine
> Que sous les plis du lin volupté devine.[12]

However he might yearn for the "femme frêle," the pale and fair-haired northern beauty, he was more often physically drawn to the Latin brunette. These, it is said, were becoming "literary cliches" and "essential" to the growing cult of exoticism.[13]

The step from "Latin beauty," who is fickle and frivolous, under whose "divine throat" one may discern the lines of "volupté," to Gautier's Cleopatra, is a fairly short one. The

"archetypal" femme fatale, according to Praz, is an amalgam of vampire with this Cleopatra, who suffers from "ennui." "The knowledge of her body is an end in itself," and she indulges in "sexual cannabalism." "Like the praying mantis," he declared, the femme fatale "kills the male whom she loves."[14] And eats him.

But the lady in *Une Nuit de Cleopâtre* merely passively submits to an obsessive and irrational passion on the part of a young man who has seen her only from a distance. She neither wills his passion, nor seduces him. Rather, he pursues her, knowing that to spend a night with her will bring his death, and is therefore a "willing" victim. He finally achieves his goal—a form of self-destruction. But the part played by Cleopatra is minimal; of her we learn very little. The only detail we are given, other than that she is beautiful, is that, like the Creole in the author's poem, her hair is black: "Dark as the starless night."[15] This is in contrast to the pyramiding of endless descriptive detail of dress, jewels, and sumptuous Oriental settings, which may have contributed later to the gem-encrusted surfaces of Gustave Moreau's paintings.

Somewhat less subtle, though to some tastes more terrifying, is the actual vampire that Gautier created in the figure of Clarimonde, in his short story *La Morte Amoureuse* (1936). For this, Gautier's sources were multiple. The most direct was Goethe's *Bride of Corinth,* but between that epic poem and Gautier's story there stood a whole series of ever more popular forms of the dead—and deadly—lover. In an echo of Lewis's Matilda, Clarimonde is the dead beloved of a priest, who brings her back to life with a kiss. When she becomes weak, his blood restores her. But Clarimonde is not thoroughly evil; when she needs the restorative of human blood, she takes only enough to stay alive, not to injure her lover.[16]

The figure of Clarimonde—and the author's attitude to his creation—are, in other words, ambiguous. Clarimonde, as a beautiful dead courtesan, brought back to life by her lover, may have seemed to Gautier to be "real," with some of the ambivalent mix of good and evil that characterizes actual persons.. He was apparently a deeply superstitious man, utterly convinced of, for instance, the actuality of the Evil Eye.[17] Whether or not

another source for his story was, as has been suggested, *Rappaccini's Daughter,* he did translate this into French, and in turn his own story did indeed "unloose" the vampire—the "toxic variant" —of the Fatal Woman—on the continent. Baudelaire, in his turn, is said to have decided the story "symbolized" Jeanne Duval.[18]

Gautier's fascination with beautiful dead women was one that was widely shared. It finds an echo in Heinrich Heine's *Florentine Nights* (1837), published originally in his *Salons,* beginning in 1833. In this tale, Maximilian, called upon to entertain Maria, who is ill, tells her the story of his own and others' love affairs with paintings and statues of women. She asks him, "And you always loved only chiselled or painted women?" "No! I have loved dead women too," he says to her, proceeding to relate the details of an affair with a woman seven years dead, whom he adored for six months. So strong was his love that living women had no enchantment for him until long afterwards.[19]

Gautier's story was published before Heine's third *Salon,* which is therefore not a source for him, but the correspondence of idea illustrates how widespread the interest in macabre forms of infatuation may have been. To some extent it also illustrates some of the nostalgia inherent in the Romantic movement. To fall in love with a woman long dead is one of several dimensions of a rejection of one's own time and place, and is also a rejection of living women. Gautier's fascination with other times and places is well-documented, and reflected endlessly in all his writings. He was something of a magpie, picking up ideas and plot lines from the entire range of literature and art available to him, and, in turn, through his own work of all kinds, serving as a storehouse of strange and exotic themes for his contemporaries.

He is of course best known for his espousal of the principle of *L'Art pour L'Art,* the critical attitude underlying the later Aesthetic movement, which espouses the idea that any didactic or moral motive on the part of poet or painter will destroy the art. Generally, it is said that the first demonstration of the principle emerged in his publication of his poetry, *Emaux et Camées* (1856), and in his history of art (1855). But two decades earlier, in his preface to *Mademoiselle de Maupin,* he attacked the idea that art should be either moral or useful. Part of

his condemnation of the restrictions on the art and literature of the time included condemnation of jouranlism (he had not yet become a journalist) and, more significantly, it included a condemnation of "utilitarian" political philosophy. "Republicans and Saint-Simonian utilitarian gentlemen," he said, offered "nonsense" to the effect that a novel has two uses—one material and the other spiritual—a point of view he then took pains to refute. Nothing, he stated, is of any particular usefulness. "To begin with," he wrote, "it is not very useful that we are on the earth and alive. I defy the most learned of the land to tell us of what use we are. . . ." He continued:

> Nothing that is beautiful is indispensable to life. . . . What is the use of a woman's beauty . . . of music . . . of painting. . . . There is nothing truly beautiful but that which can never be of any use whatsoever; everything useful is ugly, for it is the expression of some need, and man's needs are ignoble and disgusting like his own poor and infirm nature. . . .

> For my own part, may it please these gentlemen, I am one of those to whom superfluity is a necessity—and I like things and persons in an inverse ratio to the services they render me. . . Instead of offering a Monthyon prize as the reward of virtue, I would rather, like that great but misunderstood philosopher Sardanapolus, give a large premium to any one inventing a new pleasure; for enjoyment appears to me to be the only useful thing in the world.[20]

His time was one in which the new Romantic literature was tainted, in the eyes of the old guard, with the Revolutionary principles that threatened the stability of government. The ideas of Ingres ruled the Academy, not those of Delacroix; Victor Hugo, Balzac, were vilified and persecuted. In one way this passage is Gautier's veiled defense of his won idols—Hugo, Delacroix—and in another it is part and parcel of rebellion against the status quo. The statement is an emphatic early form of the aesthetic credo that became so significant for later artists and writers. It is intriguing to consider that major theoretical principles underlying the arts in the second half of the nineteenth century may owe almost as much to political attempts at suppression of creative freedom as to the unfettered exercise of that freedom.

Gautier early earned a scandalous reputation among conservatives, flaunting his red (Romantic and therefore revolutionary) waistcoat and his defiant opinions in the unsettled Paris of the 1830's. His choice of subject indicates he courted that reputation deliberately. His prose works, centered on bizarre forms of love and sex, pushed against the boundaries of what was then, and in some quarters still is, considered indecent. His themes were quite evidently based on the desire to startle and—insidiously—arouse the reader. He moved from the radical and "revolutionary" Romanticism of his youth to an eclecticism in middle life that permitted him to praise Ingres with Delacroix, Baudelaire with Saint-Beuve. From the *Flamboyants* confronting the *Grisâtres* at the entrance to the Theatre Francais in 1830, during the debut of Hugo's controversial play, he altered to the stately gentleman who remarked to the Goncourt brothers "that it was not a red waist coat he had worn at the opening of *Hernani,* but a pink doublet."[21]

His adherence to the Beautiful included his personal assessment of what the Beautiful *was*—namely, what attracted *him.* Unlike his political and artistic opinions, his attitude toward women, and his opinion of what traits made them examples of The Beautiful, did not change over time. He had no particular reverence for the adult female of the species, and gives the impression of a man who was both fascinated and repelled by the physical facts of womanhood. In one of the more hilarious and bawdy of the famous dinners at Magny's restaurant, recorded in infinite detail in *The Goncourt Journal,* the conversation turned to the fact that there were few ways for women to support themselves other than prostitution. Gautier found this natural. "I have always said," he remarked on one occasion, "that prostitution was woman's normal state."[22]

Predictably, the women he found most attractive were virginal. At another dinner, the Goncourt brothers describe him thus: "Gautier extolling the asexual woman, that is to say, the woman so young that she repels all notion of childbearing, of obstetrics." He disdained the sex act, maintaining that to make love once a year was "quite enough."[23] An odd comment from a man who once declared he had fathered seventeen children!

His work has been described as expressing a conflict be-

tween real and ideal, an example of Romantic dualism that rejuvenated interest in Manichaean dualism.[24] Whether he suffered from so esoteric a philosophical conflict is moot. Certainly he exhibited personal conflict in his work, and perhaps also in his failure to marry any of the women he loved. He seems to have been convinced that no living woman could match his ideal, and yet constantly to have sought one who could. His recorded children appear to have been three in number: a son and two daughters, each by a different mistress. Though he never married, he supported and educated his children.

Despite his claimed disdain for sexual activity, his fiction concentrated on it, and he railed against continuing political and critical restrictions on subject matter in the arts for most of his life. In 1862 he was still deploring to the Goncourt brothers the repressive atmosphere of the rule of Napoleon III—"who veers to right and left and back again, so that one can never guess what he is after."

> Meanwhile, one is not allowed to write anything at all. They won't have sex in novels. There is a sculptural and plastic side to me which I am obliged to repress, in writing. Now I am reduced to describing conscientiously a wall; and even so, I am not allowed to say what is sometimes written on it.[25]

His preferred subject, however censored, was Woman, though he professed to disdain most women. The "asexual woman"—the barely pubescent, possibly hermaphroditic figure (Madeleine) was the most beautiful, in his view, the one most calculated to arouse the ardor of the "exclusive worshipper of form." This worshipper, the practitioner, one must assume, of L'Art pour L'Art, found that the normal state of the *grown* woman, one with a full component of female sexual parts, is that of prostitution. Theodore/Madeleine on the one hand, and Cleopatra on the other, seem to be new disguises for Mary/Eve.

Theodore/Madeleine loses her virginity in the closing episodes of Gautier's early novel, which removes her from the virtuous throne of Mary. But Diana-like, she preserves a different form of virginity than the physical. She leaves her lover of one night forever, and maintains her independence.[26] Rather than never knowing men, she will never be subservient to them.

Madeleine, in other words, may be a transition form between virgin and femme fatale—headed for a career of lovers for a night, in emulation of Cleopatra; leaving in her wake a trail of seduced and abandoned men.

Gautier's ambivalence toward women was obviously extreme. He insisted that only the maiden without sexual experience was attractive, then created a series of heroines whose sole purpose in life was to destroy men by the exercise of their sexuality. In doing so he greatly increased the distance between the two poles of the Eternal Feminine. He also, in fiction if not in fact, rejected living women, as well as his own time and place, as fit subjects for contemplation.

Mademoiselle de Maupin shocked the prosaic public nearly as much when it was published as did Baudelaire's *Les Fleurs du Mal* over twenty years later. But Gautier's subjects dealt as often with the lighter aspects of love as with the somber or the tragic, and herein lies a major difference between the two men. Baudelaire was for the most part as devoid of humor as a Pre-Raphaelite portrait. Even Gautier's most somber works, such as *Une Nuit de Cleopâtre,* retain a tinge of irony that relieves the gloom, and allows the reader a sense of lofty detachment from the doings of these peculiar mortals.

He achieved the sense of detachment, as in *Mademoiselle de Maupin,* by the epistolary form, or as in the story of Cleopatra, by what Praz has labelled a "laconic descriptive style."[27] Gautier's narrative style is unaccented, unjudging, and this absence of dramatic emphasis earned for him the most criticism in his own time, disconcerting even some of his admirers. The clue to his approach is in his word "plastic"—he was, in his own words, an "exclusive worshipper of form," concentrated largely on the formal aspects of writing, the architecture of prose and poetry, in which the story or emotions of his protagonists were only vehicles for the structure, and the lilting stream of words. The dispassionate, disengaged tone of his writing allows the reader to be observer rather than participant, to stand apart from the passing scene. This above all is the quality which removes any of his heroines from the stance of confronting or directly threatening the reader—viewer.

Gautier was, to put it another way, that rare creature among artists, one whose theory and practice were in considerable harmony. His "plastic" interests allowed him to create, in words, women whose breasts were perfect "marble," "Parnassian," rather than flesh—and, as such, less blatantly erotic than much of the work of, say, Baudelaire. His detachment from his subject has been termed a "distancing device" much emulated by later artists.[28] It provides a key to the character of the femme fatale as understood by those who created her many versions in the *fine de siecle.*

By contrast, in Baudelaire's work the reader is ever conscious of the relentless voice of the poet, the anguished cry to Heaven for release from pain, for unattainable obliteration of feeling. The reader identifies more with the speaker than with the image he creates. His poetry especially demands that we focus at least as strongly, if not more so, on his personality and the demons that haunted him as on his purported subject. Precisely for this reason Gautier is a more appropriate progenitor for the femme fatale than Baudelaire. Gautier offered his public a series, if you will, of contour drawings of the forms a seductive woman can take; Baudelaire inundated his public with a torrent of passion evoked by those images.

Neither of these men *intended* a femme fatale. Their subject, by and large, like Goethe's or Lewis's, was the dual nature of the Eternal Feminine. But the very focus of their work more on the dark than the virtuous pole of that concept allowed for later writers and painters to extricate from it, and emphasize, the salient elements that became stereotypical by the end of the century.

Baudelaire, unlike Gautier, was an urbanite from birth. He was born in 1821 in Paris, to a family of means, and early chose a literary career. The circumstances of his childhood: his father's death, his mother's remarriage, his adoration of his mother and antagonism to his step-father, are well-known, and provide the departure point for much critical and biographical writing about the poet.

He was interested in the Gothic novel, and discovered Edgar Allan Poe in 1846, whereupon he immediately began his transla-

tions of that author's works. Baudelaire was particularly in-
fluenced by Poe's essay on the "Poetic Principle" in which ideas
are expressed not unlike those of Gautier on the function of
morality in art.

Baudelaire published a number of translations, individual
poems, and many critical essays in various periodicals. His major
effort culminated in the publication of *Les Fleurs du Mal* in
1857. Only a handful of the poet's contemporaries praised his
work, but the general public accorded him their scandalized at-
tention. He, his publisher, and the printer of his book, were
prosecuted and convicted of offenses against public morality,
and a second edition of his poetry (1862) omitted a number of
poems—which were published later in a separate edition in Brus-
sels.

Like Gautier, Baudelaire was committed, in his art if not his
life, to the concept of the dual nature of the eternal feminine.
The clearest demonstration of this commitment comes from his
close friend and admirer—Gautier, who was one of his more com-
passionate biographers. Writing an essay on Baudelaire's life and
work in 1868, just a year after the younger man's death, Gautier
said:

> Many women pass through the poems of Baudelaire, some
> veiled, some half discernible, but to whom it is impossible to at-
> tribute names. They are types rather than individuals. They repre-
> sent *l'eternel feminin,* and the love the poet expresses for them is
> *the* love rather than a love. . . .
>
> Among these women some symbolize unconscious and almost
> bestial prostitution, with plastered and painted masks . . . ; others,
> of a colder corruption . . . transpose the vice of the body to the
> soul. They are haughty, icy, bitter, finding pleasure only in
> wickedness; insatiable as sterility, mournful as ennui, having only
> hysterical and foolish fancies, and deprived, like the devil, of the
> power of love. Gifted with a dreadful beauty, almost spectral, that
> does not animate life, they march to their deaths, pale, insensible,
> superbly contemptuous, on the hearts they have crushed under
> their heels. . . . But it is to none of these creatures of plaster,
> marble or ebony that he gives his soul. Above this black heap of
> leprous houses, this infectious labyrinth where the spectres of

pleasure circle . . . far, far distant in the unalterable azure floats the adorable spirit of Beatrice, the ever-desired ideal, never attained; the supreme and divine beauty incarnated in the form of an ethereal woman spiritualized, fashioned of light, fire, and perfume. . . .

From the depths of his fall, his errors, and his despairs, it is toward this celestial image, as toward the Madonna of Bon-Secours, that he extends his arms with cries, tears. . . .[29]

Gautier appears to have had enough admiration for Baudelaire's work to endow it with his most elaborate prose. He has conveyed in vivid detail the younger man's profound and unleavened tone of seriousness, combined with a black vision, that creates a sense of damnation both inexorable and total.

Baudelaire's treatment of "l'eternel feminin" is completely different from Gautier's, as well as that of many other artists preceding him, but the theme is similar. His ideas received their most emphatic statement in his *Fleurs du Mal.* Here lives not only the famous "Black Venus," but white and glowing purity as well. To the "Vampire" is opposed "The Spiritual Dawn," beginning "O pure beloved Goddess. . . ." To all of the corrupt, the rotting, the sinful women who haunt his poems is opposed the Madonna; to the "femmes damnees" who so shocked his contemporaries, to the condemned woman of his "Allegory," to the personified female figure of Death in the "Dance of Death," is opposed the Angel in his hymn to "Flawless Love."

To Baudelaire the artist, Woman personified all there is: life, death, virtue, sustenance, torture, damnation, and redemption. There is hardly a poem in this extraordinary volume in which there is *not* a woman or female personification. Yet in his critical writings, and his letters, he exhibited little, if any, regard for woman as *person.* Woman is significant only as an adjunct to man, and as Mother. "I think *absolutely finally* that only the woman who has suffered and conceived can be man's equal," he wrote to his own mother. "To conceive is the only thing which gives a female moral intelligence."[30] Shades of the curse of Eve! Redeemed only in travail, in the labor of childbirth. And also, echoes of almost exactly contemporary Evangelical opinion in England. Charlotte Tonna, writing in *The Wrongs of Woman* in 1844, "confessed" her "entire dissent"

from those women who claimed equality with men. She declared, "we repudiate all pretensions to equality with man save on the ground . . . in Christ is no male or female. Woman, being 'first in transgression,' is only saved in childbearing."[31]

The notion that sterility in women is in and of itself among the most evil of their sins recurs over and over in the growing emphasis on the dark pole of the Eternal Feminine during midcentury. The full iconography of the concept that became stereotypical by the century's end is included in many of Baudelaire's Black Flower. One example suffices:

> Here is a woman richly clad and fair
> Who in her wine dips her long heavy hair;
> Love's claws, and that sharp poison which is sin
> Are dulled against the granite of her skin.
> Death she defies, debauch she smiles upon,
> For their sharp scythe-like talons every one
> Pass by her in their all-destructive play;
> Leaving her beauty till a later day.
> Goddess she walks; sultana in her leisure;
> She has Mohammed's faith that heaven is pleasure,
> And bids all men forget the world's alarms
> Upon her breast, between her open arms.
> She knows, and she believes, this sterile maid,
> Without whom the world's onward dream would fade,
> That bodily beauty is the supreme gift
> Which may from every sin the terror lift.
> Hell she ignores, and Purgatory defies;
> And when black Night shall role before her eyes,
> Whe will look in Death's grim face forlorn
> Without remorse or hate—as one newborn.[32]

Not only sterility, but exoticism, beauty, eroticism, fatality—all are here. The "onward dream," propelled by Goethe's Eternal Feminine, here is sterile, identified with sin.

Like Gautier, Baudelaire sought and found the dualism of Woman not only in the work of poets like Goethe, but in the work of painters, including Delacroix, about whom he wrote more extensively than almost any other artist. Delacroix, he said, was the "Master" of the art of painting women. The painter,

in Baudelaire's opinion, divided them into "two classes." On one hand, there are those who are mythological, and "present no difficulties to the understanding," "opulent," "abundant," with a "wonderful transparency of flesh and superb heads of hair." Others were "sometimes historical" but "more often women of fancy . . . Marguerites, Ophelias, even Blessed Virgins or Magdalens—women in intimacy."

> Whether they owe their distinction to the fascination of crime or to the odour of sanctity . . . they . . . have in their eyes the leaden hues of fever, or the strange abnormal sparkle of their malady,—and, in their glance, the intensity of a supernatural vision. . . . I would say M. Delacroix seems to me to be above all artists the best equipped to express modern woman, and above all, modern woman in the divine or infernal interpretation of the word.[33]

Painted women, heroic mythological women, both "divine" and "infernal," evidently commanded Baudelaire's attention. But for living women, especially those who stepped out of the conventional social mold, he had only scorn, and sometimes condemnation. His vilification of George Sand is characteristic. In his *Intimate Journal,* he called her stupid, dull, indelicate, and implied that she was bound for perdition.[34] Without referring to her by name, he included condemnation of her subjects, style and person in a short essay on the work of Madame Desbordes-Valmore, of whose work he apparently approved.

> If ever a man desired the gifts and honors of the muse for his wife or daughter, he couldn't wish for others than those bestowed on Madame Valmore. Among the rather large number of women who have plunged into literary work today, there are very few whose works haven't been, if not an affliction for their family or even for their lovers (since the least modest men like modesty in the object of their affections) at least a blemish resulting from some form of those masculine absurdities which in women assume the proportions of a monstrosity. We have known the philanthropist woman author, the systematic priestess of love, the republican poetess, the poetess of the future, Fourierist or Saint-Simonian; and our eyes, enamored of the beautiful, have never succeeded in becoming accustomed to all this studied ugliness, to all this impious villainy (there are even poetesses of impiety), to all these

sacrilegious imitations of the masculine mind.

Madame Valmore, however, was a credit to her sex. She:

> was a woman, always a woman, nothing but a woman; . . . the
> poetic expression of all the natural loveliness of a woman . . . her
> song always keeps the delightful accent of a woman; no borrowing,
> no meretricious embellishment, nothing but the *eternal feminine,*
> as the German poet says . . . only in the poems of the ardent
> Marceline will you find that warmth lavished by a mother on her
> brood which a few sons, less ungrateful than others, long remember
> with pleasure.[35]

Now, the translators of this remarkable piece of prose refer to Marceline Desbordes-Valmore as an "unsophisticated" and "sentimental" writer of "verse."[36] Modest efforts as well as modest demeanor constituted for Baudelaire, obviously, the essence of womanhood. To attempt serious subjects—as in the case of the "priestess of love," the "republican poetess"—George Sand—was a sufficient invasion of the male domain as to amount to sacrilege.

Like Gautier, then, and many another a man of his time (not to mention a great many alive today) Baudelaire was a most unconventional man with highly conventional ideas about women. The German poet with whom he agreed so heartily was obviously Goethe, with whom he also shared an extreme form of desire for and dread of Woman—as described by Karen Horney. It would be easy, feminist fashion, either to attack or dismiss these fulminations as a typical expression of misogyny in the male animal. This particular element of this work makes uncomfortable reading for some people today. But attack or dismissal evades the issue of the passionate intensity of his writing, a passion so personal that it issues an equally personal challenge to the reader.

His work, that is, conforms to his aesthetic attitudes in that it is an expression of his *own* highly individual imagination— the "Queen of Faculties." He championed the *"Beauty [that] is always strange"* as the aim and end and content of his art, denying that "Beauty" should uphold a moral principle.[37] These two phrases, the first from his translation of Poe's "Poetic Principle,"

the second from a statement in his review of the Exposition Universelle in 1855, form the heart of his position as both artist and critic.

In spite of his apparent rejection of moral purpose in art, however, his poetry is riddled with moral conflict. By speaking with an anguished personal voice rather than from a lofty pinnacle of cosmic wisdom, detached from events, as a classicist might do, he confronts his reader with extreme statement of a set of moral and sexual dilemmas that are impossible to ignore.

So much has been written about Baudelaire's relationships with the actual women he knew: his mother, Jeanne Duval, Madame Sabatier, that to speculate whether he was virgin, impotent, sadist, or possessed any of the other "abnormalities" attributed to him would be redundant. What is very clear from his writings is not only the longing but the revulsion which women inspired in him. "Woman," he wrote in his Intimate Journal,

> is the opposite of the Dandy. Therefore she should inspire horror.
>
> Woman is hungry, and she wants to eat; thirsty, and she wants to drink.
>
> She is in rut and she wants to be possessed.
>
> What admirable qualities!
>
> Woman is *natural*, that is to say abominable.
>
> Thus she is always vulgar; the Opposite, in fact of the dandy.[38]

Possibly Baudelaire's recoil from the "natural" as distinct from—or the opposite of—art, his embrace of the Dandy as the essence of the artist, the non-natural, had its roots in his disgust with the female body and its functions. "The more a man cultivates the arts," he said, "the less he fornicates. A more and more apparent cleavage occurs between the spirit and the brute."

> Only the brute is really potent. Sexuality is the lyricism of the masses.[39]

In other words, for him the artist was spirit and the brute is flesh: nature. Since Woman (to him) was the essence of "natural," distinct from art, it Baudelaire only one short step to include her among the brutes. And brute flesh, that which was natural, was by definition sinful:

> I have always been astonished that women are allowed to enter churches. What conversation can they have with God.

> The Eternal Venus (capricious, hysterical, full of whims) is one of the seductive shapes of the Devil.[40]

The poet carried the traditional Christian separation of body and soul, with man as soul, and woman as body and occasion of sin, to an extreme, equivalent to that of an early Christian Cenobite. His opinions would have earned the approval of Tertullian. Woman is the devil—and though he does not use the phrase, it is obvious that Baudelaire (at any rate in his private thoughts) had complete faith in the ominous reality of the femme fatale.

His poetic imagery reflects intimate acquaintance with the icons and sacred images of the medieval church with which Europeans are so familiar. *Metamorphoses of a Vampire,* one of the half dozen poems for which he was prosecuted, and forced to exclude from the second edition of *Les Fleurs du Mal,* is a pertinent example. In this poem the woman "with strawberry lips," who is "like a snake on red hot coals," alters in a single moment after making love to the poet from warm, seductive voluptuous body, into a "slimy rotten wineskin, full of pus"—"the cold ruins of a skeleton."[41] Unbidden, a popular form of Late Gothic art rises before one's eyes: portrait sculpture in the form a *Vanitas,* donated to the church by pious supporters of the parish, serene and handsome front surfaces presented to the eyes of the viewer, while behind, the bodies are scabrous, rotting, full of worms, with decaying flesh falling away from the bones.

Two of the poems included under the heading of "Femmes Damnees," also condemned, may have owed something to Gautier's Madeleine. Madeleine, making love not only to D'Albert but also to his mistress, is Lesbian as well as wanton,

bisexual as well as Hermaphrodite. Such women, to Baudelaire, were

> . . . demons, monsters, virgins, martyrs, you
> Who trample base reality in scorn,
> Whether as nuns or satyrs you pursue
> The infinite. . . .
> You. . . .
> Poor sisterhood I pity and adore. . . .[42]

And in "Delphine and Hippolyte," he says:

> Far from your kind, outlawed and reprobate,
> Go, prowl like wolves through desert worlds apart!
> Disordered souls, fashion your own dark fate,
> And flee the god you carry in your heart.[43]

From Winckelmann to Gautier to Baudelaire, then, the Hermaphrodite emerged from scultpure into literature, and here began to melt into the femme fatale. The community of interest was acknowledged by Baudelaire, who inscribed his book of poetry to Gautier, calling him MAITRE ET AMIE, to whom he dedicated CES FLEURS MALADIVES.

Baudelaire was hardly *popular* in his lifetime, but his name, among respectable people—who, for the most part, never read his poetry—was a byword for corruption. Those who were actually familiar with his work were a small coterie who became "decadents" in Paris, "aesthetes" in England. It is an interesting question whether Baudelaire would have approved of either label. Possibly he would not. His life—at least his creative life—gives the effect of an inchoate search for faith and repentence. Everything he wrote shrieks out his religious struggle, and his conviction of two things: God had turned his face away from the poet, but somewhere, somehow, expiation for un-named sin was possible.

The English and French versions of sin personified as female and sexual contain interesting differences from each other. The variation may be rooted in the Calvinist and Evangelical tradition of the one country, as distinct from the Catholic tradition of the other. I speak here not of theological niceties and doctrinal

difference, but of the impact the forms of faith have on the lay public. In a Protestant country such as England—or New England, for that matter—whether or not one is of Calvinist persuasion, the doctrine of the Elect has achieved remarkable weight and staying power. The subliminal conviction of almost anyone exposed to that heritage is an odd mix of theology and social Darwinism. Such a person is caught in the tautological belief that those who are virtuous are successful, and those who are successful are virtuous. If you are of the Elect you do not sin, and if you sin you are therefore not of the Elect. The Biblical justification for assuming that the successful and happy are among the Elect is found in the popular sermon text: "By their fruits shall ye know them" [Mathew 7:20].

In other words, sin—especially the kind of sexual sin that produces an illegitimate child or gets names into the news, is utterly inexpiable. There is no redemption; there is only hell-fire. The end result of such convictions in the Victorian period seems to have been to drive the sexually obsessed individual even further underground than had been usual earlier in Christian countries. Hence, the euphemistic quality of much nineteenth century art in England—not to mention in the United States— and the absolute insistence that any sensual (to use Ruskin's term) or even mildly erotic art have the justification of allegory, High Art, or, more recently, socially redeeming value.

In Catholic communities, as we all know, confession for the penitent sinner is urgent as well as available. For a man with so vast a sense of sin as Baudelaire, confession would be of little value if the sin were venal. His exploration of the most terrifying mixtures of rage, dread, and longing that end in what must have been for him, raised a Catholic, a form of sacrilege, echo through his ode, "To a Madonna":

> Madonna, mistress, I shall build for you
> An altar of my misery, and hew
> Out of my heart's remote and midnight pitch,
> Far from all the worldly lusts and sneers, a niche
> Enamelled totally in gold and blue
> Where I shall set you up, and worship you.

Out of his verse, the poet continues, he will clothe, embellish,

and "encase" his idol—a "mortal girl"—and

> Victorious queen, I place beneath your heel
> The head of this black serpent that I feel
> Gnawing at my intestines all the time,
> Swollen with hate and venomous with time.

He has created here a picture of the late medieval Madonna of the Immaculate Conception: crowned, and with a "silver footstool of the moon," her foot on the serpent that symbolizes original sin, the New Eve who brings not death but redemption into the world. And this Queen of Heaven will conquer (beneath her heel) the "black serpent" of sin and temptation that is destroying the poet.

In this ode, Baudelaire constructed an extraordinary mixture of the cult of Mary and the cult of Courtly Love, a faithful echo of thirteenth and fourteenth century ballads that blend Mary Virgin with erotic Mistress. But this poet lashed out at the object of his desire: love and faith; and inflicts it with his own pain.

> And finally, to render you more real,
> I shall make seven blades of Spanish steel
> Out of the Seven Deadly Sins, and I
> Shall mix my love with murderous savagery,
> And like a circus knife-thrower, I'll aim
> At the pure center of your gentle frame,
> And plunge those blades in to your beating heart.[44]

The sadism of which Baudelaire is so often accused may be expressed here, but so also is the emotion felt by the cynic—defined in the popular cant phrase as disappointed idealist. Baudelaire, perhaps sunk in sin, was searching, frantically, for a path to faith and forgiveness—to make the Madonna "more real"—to find a road to penance and salvation. To turn the Seven Sorrows of Mary into seven blades of Spanish steel is to increase her pain to torture, to find a great sin, and possibly therefore an enhanced and magnificent penance and absolution.

The "Decadents" and "Aesthetes" who championed the cause of Baudelaire interpreted his artistic theory in a way that

was perhaps not wholly accurate. While he adopted some of the positions articulated by Poe—that the poem has its own purpose for existing, and should never endeavor to support conventional morality—he did, in the end, believe that the pursuit of Beauty provided its own moral. This was not aimed at "teaching a lesson," but at opening spiritual dimensions beyond "Truth"— ". . . a poem excites and uplifts the soul, and the real merit of the poem is due to this excitation, this *uplifting* of the soul."[45]

Here he departed somewhat from Gautier, who felt that insistence upon or even the appearance of any kind of moral in a work of art destroyed it. The minor variations and detailed content of the theory, however, are less important than the freedom of choice it created for the poet or artist. To espouse "art for art's sake," and to maintain that art has no obligation to morality, is to open greatly enlarged areas of expression to artists. The sexual implications of the femme fatale in her full blown forms in the second half of the nineteenth century were precisely dependent on the development of this theoretical basis for the arts.

The general spread of the idea of freedom from conventional morality in art is frequently credited to European popularity of Poe's *Poetic Principle.* (Poe's work generally was better known in Europe in the nineteenth century than in his native land.) It is also occasionally attributed to James McNeil Whistler, the expatriate American painter. The English often lay it at the door of the painter D. G. Rossetti, or Swinburne, or both, as predecessors to Wilde and Beardsley. The choice of progenitor for the dictim appears to some extent to be based on the nationality and affectional proclivities of the writer. Since Gautier, Baudelaire, Rossetti, Swinburne, and Whistler were all equally familiar with the works of Poe—as well as each other's—it seems more likely that their separate feelings and expressions were equally based on a revulsion from the then suffocating Academic insistence on didactic art. Baudelaire was already acquainted with and admiring of the work of Gautier when he first came across Poe's famous essay; and Gautier had early expressed a similar position. Whistler, arriving later in Paris, became acquainted with the ideas of both these men. He was perhaps more of a "carrier" of anti-academicism between the two cities of Paris and London than an innovator. When he met Rossetti and

Swinburne in London, they in turn were both already thoroughly acquainted with the works of the two French writers.

The principle is so much a part of the fabric of our thought today that it is perhaps difficult to conceive of a time when the idea was not merely new but revolutionary. When I say that almost no artist of the second half of the nineteenth century was untouched by its effect, I do not mean that the Impressionists, for instance, owe their style or content to, say, Gautier or Baudelaire. Rather, they subscribed to underlying notions that enabled them to see a far wider variety of subjects as legitimate concerns for the artist. This contributed substantially to the freedom from academic restriction, claimed by the Impressionists, and by a large variety of other artists, whose work helped to create the bewildering complexity of modern art. Almost none of the work of the last century would have been possible without the widespread conviction that art—and the artist—exist for their own sakes and not to fill a social, moral, or economic purpose. Baudelaire's enfranchisement to express such feelings as rebellious rage against the unattainable White Venus/Madonna, and obsessive fascination with the Black Venus, is a direct outcome of Gautier's and Poe's theory of the arts.

One critical appraisal of Baudelaire's work identifies his White Venus as "psychological health," and the Black Venus, accordingly, as the product of a sickly imagination. According to this scheme such manifestations of the White Venus as the Madonna possess an insulting and unbearable—to the poet—superiority. It is against this "health," on the one hand, and corruption on the other, presumably, that the poet rebelled in sado-masochistic passion. In the same scheme, the Black Venus is identified as emerging in Baudelaire's early poems, as Lady Macbeth, Night, the Giantess.[46] A "superior" White Venus, and "giant" Black Venus both belong, in other words, to the same family as Fuseli's "virago," Goethe's "Machtweib," who both threaten to overwhelm the poet. In either case, if in fact Baudelaire's much vaunted misogyny did exist, it applied most fiercely to the woman who perpetrated the sin of sterility or the failure of mother love. These are Baudelaire's most important contributions to the developing idea of the femme fatale.

Neither Gautier nor Baudelaire gave the label of "femme

fatale" to their women. Rather they capitalized on Goethe's phrase, and gave radical emphasis to particular feelings about the opposite poles of the Eternal Feminine. The work of both provided new images of oriental exoticism, androgyny, and sinful sterility for the oncoming generations.

NOTES

[1] Richard V. Grant, *Theophilé Gautier* (Boston: Twayne Publishers, 1975), pp. 13-17.

[2] Lois Boe Hyslop and E. Francis Hyslop, *Baudelaire as a Literary Critic: Selected Essays* (University Park, Pennsylvania: Pennsylvania State Univeristy Press, 1964), p. 167. Italics in original.

[3] *Ibid.*, p. 171.

[4] *Ibid.*, p. 161.

[5] *Ibid.*, p. 158.

[6] Theophilé Gautier, *Mademoiselle de Maupin* (London: Nonesuch Press, 1944), quoted in the introduction by Jaques Barzun, p. viif.

[7] *Ibid.*, p. 146f.

[8] *Ibid.*, p. 162.

[9] Pierre Quoniam, *Le Louvre* (Paris: editions Musees Nationaux, 1977), p. 5.

[10] *Ibid.*, p. 6.

[11] J. J. Winckelmann, *The History of Ancient Art,* translated by G. Henry Lodge, 4 vols. in 2 (Boston: James R. Osgood & Company, 1880), vol. 1, section 39, p. 318.

[12]Theophilé Gautier, *Poesies Complétes* (Paris: Charpentier, 1855), pp. 37-38.

[13]Harry Cockerham, edited by Theophilé Gautier, *Poesies* (London: The Athlone Press, University of London, 1973), fn. p. 104.

[14]Praz, pp. 204-205, p. 209.

[15]Theophilé Gautier, *Mademoiselle de Maupin and One of Cleopatra's Nights* (New York: Modern Library, n.d.), p. 302.

[16]Grant, p. 123.

[17]*Ibid.,* p. 119.

[18]D. Bruce, "Vamp's Progress," p. 355.

[19]Heinrich Heine, *Florentine Nights,* Complete Works, vol. 1 (London: William Heinman, 1891), p. 10.

[20]Gautier, in Introduction to *Mademoiselle de Maupin,* p. xxix ff.

[21]Lewis Galantiers, editor and translator. *The Goncourt Journals* (New York: The Greenwood Press, 1968), p. 157.

[22]*Ibid.,* p. 154.

[23]*Ibid.,* p. 159.

[24]Grant, p. 29.

[25]Galantiere, *Goncourt Journals,* p. 111.

[26]Bachofen, in his *Mutterrecht,* stated that "virgin" in antiquity did not ordinarily mean *virgo intacta* but more usually was applied to independent women: those who were free of guardianship or tutelage, unmarried. In the case of Diana, it did not refer to celibacy or chastity, but to her independence—she who ruled herself.

[27]Praz, p. 183.

[28]Timothy Hilton, "Pre-Raphaelite Problems," *Studio International*

183, no. 944 (May 1972), p. 220.

[29]Theophile Gautier, *Baudelaire,* translated by Guy Thorne (New York: Brentano's, 1915), pp. 43-44.

[30]Arthur Symons, translator, *Letters of Charles Baudelaire to his Mother* (John Rodker, Publication #92 of 675, n.d.).

[31]C. E. Tonna, *The Works of Charlotte Elizabeth,* vol. 2 (New York: M. W. Dodd, 1847), p. 397.

[32]Charles Baudelaire, *Flowers of Evil,* revised edition, edited by Marthiel and Jackson Mathews (New York: New Directions, 1963), p. 258. Translation of this poem: F. P. Sturm. This edition is useful since it has the original French and the translations on facing pages.

[33]Charles Baudelaire, *Art in Paris: 1845-1862* (Exposition Universelle). Translated and edited by Jonathon Mayne (London: Phaidon Press, 1965), p. 140.

[34]Charles Baudelaire, *Intimate Journals.* Translated by Christopher Isherwood, Introduction by W. H. Auden (Hollywood: Marcel Rodd, 1947), pp. 7-8.

[35]Hyslop and Hyslop, pp. 336-337.

[36]*Ibid.,* p. 334.

[37]Baudelaire, *Art in Paris,* p. 124.

[38]Baudelaire, *Intimate Journals,* p. 65.

[39]*Ibid.,* p. 97.

[40]*Ibid.,* p. 85.

[41]Baudelaire, *Flowers of Evil,* pp. 160-161.

[42]*Ibid.,* p. 156.

[43]*Ibid.,* p. 155.

[44] *Ibid.,* pp. 73-75.

[45] Hyslop and Hyslop, p. 130.

[46] D. J. Mossop, *Baudelaire's Tragic Hero* (Oxford: Clarendon Press, 1961), pp. 153-154.

CHAPTER 5

SAINT AND PROSTITUTE:
YOUNG ROSSETTI

Dante Gabriel Rossetti is perhaps best-known as a founder-member of the Pre-Raphaelite Brotherhood, a society of young rebels against the British Royal Academy, formed in London in 1848. Its membership was limited to seven, and besides Rossetti, included his younger brother William, and two other painters destined for fame: John Millais and William Holman Hunt. All were no more than twenty-three years old at the time.

At its inception, Rossetti was twenty, having been born in 1828 in London, the second child and first son of Gabriel Rossetti and Frances Polidori, sister of John, the unfortunate young physician who accompanied the poet Byron on some of his travels. The elder Rossetti was a political refugee, and a writer of some note whose literary interests concentrated on the medieval poet Dante. For this reason, no doubt, he named his infant son Gabriel Charles Dante Rossetti. At the age of twenty-one, young Rossetti altered his public name to Dante Gabriel, an event which has given rise to the widespread opinion that the medieval poet was his major, if not sole, source of inspiration.

Rossetti's practice of the two arts of painting and poetry began early in his life, and included a dual iconography of women almost from the start. His youthful reading undoubtedly spurred his interest in such an iconography. William Rossetti, the artist's younger brother and faithful biographer, listed Rossetti's literary interests in chronological order: Shakespeare, Sir Walter Scott, Mathew Lewis, Byron, the Bible, followed by Shelley, to whom Byron "gave place when my brother was about sixteen years of age."[1] These were followed by Old English and Scottish ballads, and "Mrs. Browning." It was not until about 1845, when Gabriel, as his family called him, was seventeen, that "he

first seriously applied himself to Dante." Then came *Faust,*
Victor Hugo, de Musset, and Homer, and finally "Tennyson
reigned along with Keats, and Edgar Poe and Coleridge along
with Tennyson."[2]

By his nineteenth year, Gabriel was "deep in Browning."
He had also already discovered William Blake. In addition, all
his life, William said:

> And writing about devils, spectres, or the supernatural generally,
> whether in poetry or prose, had always a fascination for him; at
> one time, say 1844, his supreme delight was the blood-curdling
> romance of Maturin, *Melmoth the Wanderer.*[3]

Given the catholic range of this reading list, Rossetti's
choices of subject in his early drawings offer interesting glimpses
of his inner life. Unlike other growing boys who so often choose
to draw battles, ships and warriors, he chose much more often,
from an early age, to illustrate confrontations between men and
women, good with evil, the spectre with the living being. Star-
crossed lovers, fallen maidens, sorceresses appear often in his
juvenilia.[4]

William Rossetti did not include *The Monk* in his list of
Gabriel's favorite reading, but he did include Mathew Lewis.
Likely as not, Gabriel devoured *The Monk* as he did *Melmoth.*
He had a strong predilection for Faustlike tales in which a pro-
tagonist sells his or her soul to the devil, even as did that female
Faust, Matilda. He used the device in an unfinished prose tale
written during his teens, which William said (with obvious re-
lief) that Gabriel destroyed "before he was of age."[5]

There is no question that young Gabriel was fascinated by
the other works of Mathew Lewis, and seems to have read them
all. Perhaps *The Monk* was not included in William's list because
it was considered immoral at the time. Their strong-minded
mother disapproved of such reading, and kept her children well
provided with cautionary tales.[6] Even these, so popular with
Victorian parents, offer the reader a contrast of good and evil,
virtuous children rewarded, naughty ones punished.

From early on, then, Rossetti was exposed to themes in-

volving sin, and—in reading not provided by his mother—passion and lust. He had a sufficient penchant for them to explore the themes consistently in his own early creative efforts. Possibly he met with a certain opposition in his household. His father, according to William, disapproved of the use of Sir Walter Scott's novels as a means of learning history. "When you have read a novel of Walter Scott, what do you know" he complained to his son, "the fancies of Walter Scott!"[7] Novels, it is clear, were not sufficiently didactic for Signor Rossetti.

Gabriel defied other strictures placed on his reading as well. In company with many of their time, his mother and her devout Polidori sisters disapproved mightily of Percy Bysshe Shelley. Their disapproval derived as much from Shelley's avowed atheism as from the irregularity of his marital affairs, though no doubt they considered these two facets of the poet's life to be causally connected. Gabriel's interest in Shelley therefore produced a family flap when he was in his teens. His mother, on a trip to France in 1843, evidently received a letter from one of her sisters telling her that her oldest son was reading "indecent" books. Rossetti wrote immediaely to deny the charge:

> On enquiry, I have succeeded at eliciting that the origin of all this [concern] was my having hinted at a vague intention of purchasing at some indefinite period the works of Shelley—which I should peruse solely on account of the splendid versification and not from any love of his atheistical sentiments.[8]

The defensive tone is marked. Perhaps the lure of the occult, the Faustian, the erotic, the shocking, existed for young Gabriel at least partly because his parents objected. At any rate the seeds of later artistic concerns were sown very early. His two basic iconographic forms appear in his visual and poetic imagery as early as 1847 and 1848: The Good, embodied in the Virgin Mary on the one hand; and Evil, embodied in series of erotic sinful women on the other.

One of the first personifications of female virtue appears in his long ballad, *The Blessed Damozel.* Simply described, the poem depicts a dead damsel in heaven, expressing longing for reunion with her lover on earth, the joy that reunion will bring, and fear that her prayers for it will not be granted. Her expres-

sion of longing is intercalated with commentary from her living lover on earth below.

Rossetti told his friend Hall Caine many years later that Poe's ballad *The Raven* had provided the model for his own poem. "I saw that Poe had done the utmost it was possible to do with the grief of the lover on earth" he said, "and I determined to reverse the conditions, and give utterance to the yearning of the loved one in heaven."[9]

He reversed the setting as well as the emotions. Poe's setting is dark and stormy, whereas Rossetti's glows with heavenly light. The description of evening is calm; the "curled moon was like a feather" and the stars were out. To the raven's croak is opposed the lingering echo of bird-song in the ether.[10] Rossetti deliberately created a total contrast, element by element, with the work that inspired him.

With the possible exception of his painting, *Beata Beatrix,* undertaken over a decade later, the *Blessed Damozel* is Rossetti's single most discussed and analyzed work. Critics have taken exception to the poet's theology, his cosmology, his failure to distinguish between spirit and flesh, his habit of continual revision— and even his departure from the precepts of Dante.[11]

This last criticism is obviously based on the assumption that the Damozel was intended to be Dante's Beatrice, and ignores the poet's express statement about how the work came into being. Rossetti, it is said, misunderstood the abstract nature of Beatrice as symbol of Divine Love, and created too solid, too human a concept. This misunderstanding resulted, apparently, from Rossetti's failure to grasp Dante's meaning and language.[12]

Now, apart from the fact that Rossetti grew up bilingual, the concept of Beatrice as abstract symbol was precisely that espoused and developed by his father. For the elder Gabriele she was a "symbolic personage."[13] It is unlikely that young Gabriel failed to understand what his father was talking and writing about through all the years they shared the same household. Certainly William, a much more prosaic person, was quite clear about the distinction. Furthermore, according to William, over-exposure to Dante in his youth "rather alienated my brother

than otherwise."[14]

Rossetti's alteration of his given name to Dante Gabriel bears the major responsibility for the popular belief that he "identified" with Dante Alighieri in the fullest psychological sense. His name change may have had no other purpose than practical. He apprently adopted the "D. G. R." signature and monogram in 1849, while he was planning the publication of the first issue of the short-lived Pre-Raphaelite journal, *The Germ.*[15] Simultaneously, he was looking for "chambers" of his own, a luxury he did not achieve until 1851. His father was a published writer and teacher of wide, if eccentric repute, and a familiar in London literary circles. Young Gabriel, embarking on his own career, may simply have wanted to be sure people knew his work was his, and not his father's.

In view of the extraordinary emphasis so often given to the importance of the medieval Dante in the total body of Rossetti's work, it is important to note that out of some 314 paintings and drawings listed in the Catalogue Raisonne by Virginia Surtees, only about twenty-two can be described as related to the subject of Dante or his work.[16] Neither the poetry nor the life of Dante formed anywhere near such an exclusive influence on Rossetti's work as is often supposed.

On the other hand there is no question that the poetry of Dante and his contemporaries did contribute to the formation of Rossetti's style. His interest in and frequent use of the "Petrarchan" sonnet form came from his study and translation of the early Italian poets that comprised his first published book in 1861.[17] His interest, however, appears to have been more in the broad area of structure and "versification" than in the embrace of a philosophy. Rossetti's rhyme schemes and concepts also owe much to Browning and Keats (as well as Poe).[18] While the work of Dante was one element that contributed to Rossetti's development, he was only one of several.

There is indeed considerable disparity between Dante's Beatrice and Rossetti's Damozel. Beatrice is Muse, disembodied symbol of Divine Light and Love, guide to Paradise. In the medieval poet's work she is wholly spiritual. The Damozel is human—

> She laid her face between her hands
> And wept. (I heard her tears.)[19]

Not only human but flesh: bodily imprisoned in Heaven. She "leaned out/From the golden bar of heaven," in the first stanza, and in the last she "cast her golden arms along/The golden barriers. . . ." However she may yearn for reunion, her lover is full of doubt, misgiving, and perhaps, reluctance. Says the lover on earth:

> (Alas! we two, we two, thou say'st!
> Yea, once thou was one with me
> That once of old. But shall God lift
> To endless unity
> The soul whose likeness with thy soul
> Was but its love for the?)[20]

The diametric reversal of the haunted longing lover in Poe's poem shows clearly. Poe's Lenore has slipped forever from her lover's grasp; he will see her "Nevermore," and is condemned to endless grief. In Rossetti's poem, the Damozel is physically confined behind golden bars, in a "lonely heaven," forever weeping for her earthly, and reluctant, lover. Dante's apotheosized Beatrice does not appear to have been intended.

Far from being Beatrice, the Blessed Damozel has more the character of a continental European than a Mediterranean medieval lady. The word "damozel" is Anglo-French and entered Middle English by way of the Normans, and its use is characteristic of the ballads that were a focus of interest for young Gabriel. The Damozel is like an imprisoned maiden in a tower in a fairy tale, forever separated from her knight. There is little if any religious feeling in the poem. The Paradise she inhabits is far removed from Dante's, though, like Beatrice, she is virtue personified.

Rossetti produced an additional form of personified female virtue in his prose tale, *Hand and Soul*, written in 1849 for *The Germ*. The story concerns a painter who receives a visitation from his "Soul," in the shape of a beautiful girl. She is a corporal manifestation of an aspect of his own nature, resembling a Jungian anima, for which he had been searching all his life.

Inevitably one is led to the conclusion that the young writer was seeking, as his protagonist was, his soul—or perhaps soul-mate. Certainly he was on the trail of his Muse. The figure he invented for his story had "hair [which] was a golden veil through which he beheld his dreams," and she was delicate, chaste, compellingly beautiful, infinitely compassionate, even as Beatrice in Paradise.[21] While William likened Gabriel's prose style to that of a popular Victorian story-teller, Charles Wells,[22] the content is kin to Dante's *Vita Nuovo.*

That kinship no doubt aided in producing the standard interpretation of Elizabeth Siddall as Gabriel's Beatrice. He met the young milliner's assistant probably in 1850, and soon they were in love. They did not marry, however, until 1860, and the following year their only child, a daughter, was de-livered stillborn. Some months later Lizzie was found dead of an overdose of laudanum. The sensational story of the burial of his manuscripts of his poetry with his wife, their exhumation in 1869 when he was preparing them for publication, and his own breakdown and illness during the last decade of his life, have all contributed to seeing Rossetti as a man haunted by Lizzie/Beatrice.

Given his background, it was perhaps inevitable that Ros-setti would become involved with the ideas of the medieval poet for whom he had been in part named. Given his flamboyant and self-assertive temperament (attested to by all who knew him), it was equally inevitable that he would struggle to impose a personal and original form upon those ideas. Quite likely Gabriel saw Beatrice in actual living women precisely because his father did not.

Standing in sharp contrast to the ineffable virtue of the Damozel and Beatrice is the Fallen Woman, in particular the prostitute immortalized in Rossetti's poem *Jenny.* According to William, Gabriel wrote this early in his career, soon after *The Blessed Damozel.* In the poem the narrator is seated with Jenny's head on his knees while she dozes, near dawn, and he meditates on the fate of fallen women. As he contemplates what has brought her to this state, he sees in her no longer a woman, but:

> A cipher of man's changeless sum
> Of lust, past, present, and to come.

He wishes virtuous women might see into Jenny's heart with charity, but "that can never be." Jenny's heart is

> Like a rose shut in a book
> In which pure women may not look.

He realizes with horror that men are the authors of both virtue and sin in women—

> Enough to throw one's thought in heaps
> Of doubt and horror,—what to say
> Or think,—this awful secret sway,
> The potter's power over the clay!
> Of the same lump (it has been said)
> For honour and dishonour made,
> Two sister vessels. Here is one.[23]

Man is potter and woman is clay. Men make prostitutes by their lust. Whether a woman is good or bad, she is a charge on male responsibility. The paternalistic tone is perhaps more generous than that of early Christian prelates who charged women with lust and saw men as their victims, but it is still the dominant patriarch speaking. Rossetti showed more compassion for women than some of his contemporaries, but they were still passive objects of his manipulation; under his "potter's power."

The general tone of Rossetti's letters conveys interest, liking, and genuine pleasure in the company of women. But as a young man he exhibited a revulsion from the actual flesh of women that was both prudish and prurient. Writing to his brother from Paris in October, 1849, he included a sonnet on the Can-Can he had seen the night before. Listing the dancers one by one, the poem reads:

> The first, a mare; the second, 'twixt bow-wow
> And pussy-cat, a cross; the third, a beast
> To baffle Buffon; the fourth, not the least
> In hideousness, nor last; the fifth, a cow;
> The sixth, Chimera; the seventh sphinx; Come now,

> *One* woman, France, ere this frog-hop have ceased,
> And it shall be enough. A toothsome feast
> Of blackguardism and whore flesh and bald row,
> No doubt for such as love those same. For me,
> I confess, William, and avow to thee,
> (Soft in thine ear) that such sweet female whims
> As nasty backsides out and wriggled limbs
> Nor bitch squeaks, nor the smell of heated Q---s
> Are not a passion of mine naturally.[24]

He added: "Now another word in your ear, in prose:—do not let anyone see this letter but yourself, I mean the family, of course; or else scratch out this sonnet first. It is rather emphatic, I know; but I assure you excusable under the circumstances."

William did not destroy the sonnet, but he never printed it in its entirety. Another poem written for a painting, called *Fête Champêtre,* was published first in *The Germ* and later revised for the 1870 edition of Rossetti's poems. The painting in the Louvre, then attributed to Giorgione (currently to Titian), is the famous group of nude women and clothed men ancestral to Manet's *Dejeuner sur L'Herbe* (1863). Gabriel loved the work—he called it "intensely fine," and in his poem dwelt tenderly on the "naked flesh," the lips, the hands, the trailing water, the "silence of the heat," and "solemn poetry" of the moment.[25] He found the sensual presence of a female body far more acceptable in high art than in physical reality; and in his own work expressed a grand mixture of paternalism, misogyny, and Romantic Love.

The juxtaposition of these two sonnets makes Rossetti's direction away from the "childlike submission to nature" mandated by his PRB colleagues such as Hunt more readily understandable.[26] The lure of the flesh, combined with repudiation of it, created his need to make images of women that were both remote and ideal. Whether he idealized living women as distinct from their images, at this early point, is not entirely clear. But he certainly was not long interested in the kind of "nature" Hunt wanted to paint.

Hunt, John Millais, and Rossetti's first mentor, Ford Madox Brown (who was not even a member of the PRB) found it neces-

sary to create with models and stage trappings the total physical presence of their compositions in order to produce the sense of immediate "reality" they desired in their painting. For example, Millais required Elizabeth Siddall to spend many a long hour in a full bathtub posing as the dead Ophelia.

Rossetti worked quite differently from his companions. He worked, as they did, from the model and from studies from the model. He insisted, as they did, especially in his early work, on factual accuracy in minor details of a composition as well as major elements. But the synthesis of elements in any one composition tended to create a setting that is neither "natural" nor "real," but imaginary. Most of his painting is permeated with a sense of the other—worldly.

Expressed another way, many of Hunt's and Millais' paintings seem to be stopped in time, whereas Rossetti's frequently appear to be outside of time. Only in a very few works is even a slight sense of the "genre" scene visible in Rossetti's work: his first exhibited oil, *The Girlhood of Mary Virgin*, in *Found*, begun in 1854 and never finished, and in his poem *Jenny*.

Jenny, as prostitute, is the ultimate fallen woman. It has often been remarked that the subject of the fallen woman had a special fascination for the Pre-Raphaelite Brotherhood. If so, they were part of an extensive company, since the problem evoked interest nearly everywhere in the mid-nineteenth century. Rossetti wrote the first version of *Jenny* at least a year before the Brotherhood was formed, so clearly the subject intrigued him.

Perhaps the subject was suggested by current events. One of the major social themes of the period was the state and fate of the prostitute. Extreme concern for the virtue of women of the "lower orders"—those most in danger of falling—was reiterated frequently in the news. Involuntary emigration offered one solution to the problem. "Forty young females, from the ages of fourteen to eighteen, were removed from the Sligo Union Workhouse last week," announced the *Illustrated London News* in 1847, "to proceed immediately on their voyage to Australia, where they are sent out as emigrants, at government expenses. . . ."[27]

The same summer saw several publications and reviews of scholarly studies of what was then perceived to be one of London's most pressing social problems. In a lengthy analysis of two earlier volumes: *A Short Account of London's Magdalene Hospital* (London, 1846) and *De La Prostitution dans la Ville de Paris* (Paris, 1837) the reviewer, after deploring the lack of facilities for the difficult task of redeeming fallen women, concluded that "Woman falls, like Wolsey, never to rise again."[28] Sinful women, in other words, are irredeemable. No doubt prostitution was in fact a serious social problem in Victorian London, given the displacement and extreme poverty of so many people in the wake of the Industrial Revolution. Women driven to prostitution for simple survival, however, were rarely understood to be victims of poverty rather than their own immoral lusts. The emphasis in the news, as above, on sexuality rather than sociology created a climate of opinion that turned the attention of many poets and painters, Rossetti among them, to the theme.

Not only did the twin themes of female virtue/sin appear in Rossetti's poetry and painting very early, but also two distinct physical types of women emerged in his visual art. The first of these types is the slender maiden commonly assumed to inhabit nearly all of his early art. She appears as Mary in first oil painting, completed in 1849: *The Girlhood of Mary Virgin* (fig. 17), and in *Ecce Ancilla Domini* (fig. 18), finished a year later, after Rossetti left Brown to work with Hunt. Rossetti's sister Christine, herself a gifted poet, acted as model for the Virgin in both of these paintings. Both offer straightforward visual evidence of his artistic interests at the date. The stable composition, carefully controlled lighting, and passages of bright primary color in the "Girlhood" are reminiscent of the late medieval woodcuts of which he was so fond, and the domestic interior with a window at the rear reminds one of fifteenth century Flemish painting. A few months later, on a trip to the continent with W. H. Hunt, Rossetti was drawn to Van Eyck and Memling as though by a magnet. He was already familiar with the work of Van Eyck before his trip, since the National Gallery had purchased *The Arnolfini Wedding* in 1842.[29]

Hunt regarded the painting of the Virgin's Girlhood as completed "under" him, and more successful than if Rossetti had

remained under Ford Madox Brown's "medieval supervision."[30]
But the origin of figure composition in this work is found less in
Hunt's work than in that of William Blake. The handling of
drapery in particular exhibits Rossetti's love of Blake's art. He
had purchased the famous "Blake Notebook" as a student in
1847, and it was still among his effects at his death.[31] This note-
book, now in the British Musuem, contains drawings, comments,
sketches, portraits, poems, and was the fruit of some of Blake's
musings from 1787 to 1818. Among the commentaries were at-
tacks on *Discourses on Art,* by Sir Joshua Reynolds, first Presi-
dent of the Royal Academy. These Rossetti greatly cherished;
he and the other Pre-Raphaelites used the word "slosh" for all
they scorned in contemporary British art, and to them, Sir
Joshua was Sir Sloshua.

 The repetitive long, slow, flattened curve that Rossetti
learned from Blake became a central element in his handling of
drapery and figure in a number of drawings and paintings. Es-
sentially Gothic in nature, this element in both Blake's and
Rossetti's figure design is reminiscent of the Soft Style of four-
teenth and fifteenth century European sculpture, characterized
by the "Gothic Sway"—the Classic "contrapposta" lifted from
the earth, uprooted, so to speak, a form in which the figure is
rendered as though boneless and floating. The "Gothic" quality
inhabits *Ecce Ancilla Domini* as well. In both of these paintings,
Christina's body is epicene, childlike nearly featureless beneath
the drapery, precluding any sense of the erotic in the works.

 These characteristics in Rossetti's early work have led to
the general assumption that Elizabeth Siddall always appeared
equally as slender, basically sexless, a spiritualized Beatrice.
But in Rossetti's first dated painting of Lizzie, a second physical
type appeared. In *Rossovestita,* a watercolor of 1850, the
painter rendered her tall, buxom, even monumental, with loose
hair and sensual mouth, clad in red, bosom and throat exposed
(fig. 19). Her face exhibits the soft roundness of youth, since
she was only about sixteen at the time, and her expression is
diffident, but she is clearly represented as of the earth, earthy—
an erotic object.

 Rossetti's choice of his mother and sister as models for St.
Anne and the Virgin is understandable. Apart from the fact that

they were conveniently at hand, and charged no fees, their religious devotion and orthodoxy would have commended them to him as fitting for his subject. It is unlikely that he would have considered Christina, an intensely devout Anglo-Catholic, an appropriate model for, say, a painting like *Rossovestita.* Lizzie, on the other hand, he evidently saw as more versatile. In some compositions, as in scenes from the life of Dante, she modelled for Beatrice, and is depicted as fully covered, slender, almost bodiless, in sharp contrast to the eroticism of the earlier work.

In other works she appeared as the fallen woman. One such work, *The Return of Tibullus to Delia,* a watercolor begun in 1851, illustrates a passage from the *Latin Elegies* of Tibullus, written on the reverse of the painting by Rossetti. Delia, the subject of a number of studies as well as the completed work, is not chaste. She is Tibullus' mistress. In the poem he instructs her, on his return from afar: ". . . all long and loose thy hair/Run to me, Delia, with thy feet bare."[3][2]

Rossetti depicted Delia in studies and painting as seated, head tilted back, eyes half-closed, throat arched, hair streaming down, with one strand of hair pulled around her shoulder and held to her slightly parted lips (fig. 20). Sitting in brooding melancholy, waiting for the return of her lover, she is not fatal. But the visual iconography in which she is cast is nearly identical to that of later works in which the woman *is* fatal. The thrown-back head, the langourous parted lips and drooping eyelids suggest a version of Fuseli's erotic swoon.

In other words, at least at the start of their relationship, Gabriel's Lizzie could stand in for either of the two types of women who appeared in his work. From early on women who exhibited the full-bodied, full-throated long-haired characteristics of his later versions of lethal womanhood shared the honors with a slender and etherealized Virgin or Beatrice. Since Lizzie initially could be either, the idea must have preceded the choice of model, and was superimposed on whatever woman happened to be sitting for him. That Rossetti looked for models who resembled some internal vision, ideal or erotic, was frequently reiterated by those who knew him. Clearly he also altered his model in the direction of his interior vision rather than toward "nature." And more than one model could represent his Muse.

Given Rossetti's fascinated interest in less than virtuous women, his devout mother was perhaps correct to be concerned about his moral instruction. How much his interest in the work of Shelley may have contributed to his ideas is moot. Rossetti was never confirmed, went very rarely to his mother's Anglican church, and then only "as the inclination ruled him." But he preferred piety in the fair sex, professing distaste for freethinking in women.[33]

Apart from religion, he was, like Gautier, a profoundly superstitious man all his life. He objected to thirteen at table, went frequently to seances, and informed his brother William that he thought his (Gabriel's) house was haunted.[34] He didn't *fear* the ghosts—he simply knew they were *there.* He could be described as a man who had no very coherent notions of deity, alien to theological abstractions, yet inconsistently convinced of physical survival after death.

This cast of mind was no doubt responsible for his predilection for Keats in preference to, say, Wordsworth, for whom he had no time at all. He expressed particular fondness for Keats' ballad *La Belle Dame sans Merci,* which he called "wondrous." Rossetti was familiar with the first published version of Keats' poem in *The Indicator,* which in later life he recalled reading at about the age of eighteen.[35]

Once discovered, the works of Keats secured a life-long place among Rossetti's most profound literary loves. "My brother," said William, "considered himself to have been one of the earliest strenuous admirers of Keats."[36] In correspondence with Henry Buxton Forman towards the end of his life, Rossetti exhibited not only admiration but considerable scholarly expertise concerning the earlier poet's work. He knew all the earlier editions, in particular those published by Richard Monckton Milnes in 1848 and 1849, together with other publications, and was able to spot variant forms of individual poems. He also knew and shared Keats' love of folklore, and illustrated several of Keats' poems.

By his twentieth year he had already produced the first of several illustration for *La Belle Dame sans Merci.* In 1855, Rossetti synthesized elements presaging the mature femme fatale in

another drawing of the same subject. The character of the femme fatale and her visual iconography are overtly combined here for perhaps the first time (fig. 21). The drawing shows a man on horseback with a woman seated in front of him on the saddle-bow, her body curved and arched back toward the man, her throat full and exposed, her lips parted and her expression languishing. One long tress of her hair, which forms a flowing cape behind them both, is wound around the man's neck to his mouth, held to his lips as he kisses her hand. Inscribed on the drawing above the horse's head is the following:

> I set her on my pacing steed
> And nothing else saw all day long,
> For sideways she would lean, and sing
> A faery's song.

This is the fifth stanza of Keats' ballad, which does not mention the encircling hair that binds the knight to his love. It appears nowhere in Keats' poem. To reiterate, Keats says only of the phantom lady that "Her hair was long, her foot was light,/And her eyes were wild." Long hair, but not curled around the knight's neck. Keats may have seen phantom, faery, or flesh in the Belle Dame, but Rossetti certainly saw the flesh. The girl in the drawing has the same solidity as the youth beside her. When the artist intended apparitions, he drew them differently, faint and transparent, as in Gretchen's visions in church, from *Faust.*[37]

One source of inspiration for imprisoning hair no doubt came from Goethe's *Faust,* which Rossetti had read in his adolescence in English, and possibly also in German, which he studied briefly, and from which he made at least some translations.[38] Goethe's Lilith, on Walpurgisnacht, offered a verbal picture for him to follow; Theodore von Holst's painting (fig. 15) of Walpurgisnacht may have suggested a compositional system. Something of a similar relationship between the two central figures appears in both Von Holst's painting and Rossetti's drawing. Lilith's "schönen Haaren" baits the trap, however, and this might be the element that Rossetti has added to Keats' poem to emphasize the fatal nature of the Belle Dame in his drawing. The "faery's child has become Lilith, who specializes in seducing men and injuring little children."[39]

No proof exists that Rossetti ever saw von Holst's painting, and it is quite possible that the two men were inspired independently by Goethe's macabre scene. But Rossetti, with his Pre-Raphaelite Brothers, probably saw much of von Holst's work in the restaurant they patronized in 1855 that was decorated with it, and he also owned engravings depicting some of the older artist's paintings.[40]

Also closely related to this drawing is Titian's *Lady at Her Toilette* (1515), then as now at the Louvre (fig. 22). In October of 1855 Rossetti made his second visit to Paris, ostensibly to see the great Exposition then on view, but to visit the Brownings as well. Rossetti had been entertained by them at their London home a month earlier, on the famous occasion of Tennyson's reading of his newly completed *Maud*.[41] In November, back in London, he wrote his friend Allingham:

> I spent some delightful time with the Brownings, at Paris, both in the evenings and at the Louvre, where (and throughout conversation) (found his knowledge of early Italian Art beyond that of anyone I ever met—*encyclopedically* beyond that of Ruskin himself.[42]

Whether Browning called Rossetti's attention to Titian is problematical at best. A comparison of Rossetti's drawing and Titian's painting, however, reveals a number of suggestive correspondences: the spatial relationship between the two figures, their postures, the angle of the women's heads.

Browning's poetic contribution to Rossetti's fascination with strangling hair is not in question. It came from Browning's poem *Porphyria's Lover*, first published in 1836. Browning's work would have been in the forefront of Rossetti's mind on this trip to Paris; Browning had just published *Men and Women*, and sent a complimentary copy to Rossetti, which arrived only a few days before Rossetti went to Paris. He took his new book with him for the author's autograph.[43]

Porphyria's lover is a speaker in a "Madhouse Cell," recounting his last moments with her:

That moment she was mine, mine, fair,
Perfectly pure and good; I found
A thing to do, and all her hair
In one long yellow string I wound
Three times her little throat around,
And strangled her. No pain felt she;
I am quite sure she felt no pain.[44]

The image in Rossetti's drawing is of course reversed—it is not the woman who is strangled by the man, with her own hair, but she whose hair is wrapped around him in an imprisoning embrace. The drawing could be described as initially inspired by Goethe's Lilith, amalgamated with ideas from Titian and von Holst, synthesized into the role of Keats' Belle Dame. The synthesis significantly intensifies Goethe's original meaning. Goethe implied that the young man, after time, may get loose from the temptress, as Tannhauser did from Venusberg. In the drawing, the meaning shifts: Rossetti portrayed the imprisoning hair as a strangle-hold. It is precisely out of this increased emphasis on the dark pole—demon-woman—of the Eternal Feminine that the femme fatale was born.

Similar and equally lethal figures emerged at almost the same time in Rossetti's poetry. After the Blessed Damozel and Jenny came *Sister Helen.* According to William, the poem was first published in the *Düsseldorf Artists' Annual* in 1856.[45] In this long ballad, which clearly reflects Rossetti's medieval interests in both style and content, Sister Helen has employed witchcraft to wreak vengeance on her lover, who has betrayed her for another. She resists all pleas to forgive him, and as she burns the wax model she has made of her lover, his body is consumed, and his soul enters the torment that she herself is willing to encounter rather than release him to his bride.

The preceding works are only a few samples of those Rossetti produced by 1855, but they constitute the more typical portion of his early work. The clean division of good and evil in his iconography: the soulful, chaste, "light" pole on the one hand, the dark, erotic pole on the other, reflect the traditional dualistic view of the Eternal Feminine. But even more, in these two works, the iconography is accentuated, driving the poles further apart.

Rossetti's drawing of the Belle Dame was very little known until recently, since it remained in the artist's possession until after his death, when it was sold to a private collector. It did not go into a public collection, that of the British Museum, until after 1900.[46] Thus it functions more as a source of enlightenment as to the nature of Rossetti's inward and personal feelings about women in his life and art than as a source of inspiration and influence on others around him. The works that helped to create his reputation as an artist began shortly after 1855, and came in two guises: illustrations for book publications of poetry, and the series of half-length portraits of women considered the hallmark of his work.

Hints of pervasive eroticism had of course appeared earlier, but much that Rossetti painted from this point forward looks like a series of variations on the theme of the swooning posture so noticeable in Fuseli's work. Some of the earliest of these appear in a group of illustrations Moxon commissioned for an 1857 edition of Tennyson's poems. Rossetti accepted his share of the commission reluctantly, and did so only after he was assured freedom of choice: subjects "where one can allegorize on one's own hook." "Allegorizing," for Rossetti, was a process of invention in which he created a variation on the poet's theme, attempting to do so "without killing, for oneself and everyone, a distinct idea of the poet's."[47] Apart from being given a free hand, his own fondness for much of Tennyson's work may have induced him to contribute illustrations to the edition. He clearly shared with Tennyson a fascination with the duality of the Eternal Feminine.

So marked is Tennyson's interest in the concept that he has been credited with a "conscious contrasting of the suffering maiden and the femme fatale" in an article written some years ago. On the side of virtue, according to the author, are ranged such heroines as "Mariana," and on the side of cruelty and sin are "Lilian," "Madelaine," and above all, "Eleanore," who is "*the* fatal woman."[48] Even Maud is included in the list of femmes fatales.

Lilian, however, is a coquette, and hardly fatal to the poet, who concludes that if her frivolous behavior does not stop, "Like a rose-leaf I will crush thee,/Fairy Lilian." Here the poet

threatens the woman, not the woman the poet. In *Eleanore* love, not the woman, is fatal to the poet, and *Maud* is "Faultily fault-less, icily regular, splendidly null."⁴⁹ She is equally difficult to cast in the role of full-fledged femme fatale, if only on the strength of her "nullity." Tennyson's heroines do not qualify as lethal.

Tennyson may have been one of several poets who helped to turn Rossetti's attention to the traditional dual representation of women, but it seems unlikely that the older poet was a source for the accentuated form it took in Rossetti's work. In particular Tennyson contributed little if anything to the intensely erotic mold that Rossetti chose for the heroines of the poems he illus-trated. The most notable of the group is "Saint Cecilia" (fig. 23), from the *Palace of Art*. In *The Palace of Art* the poet has built a "pleasure House" for his Soul, where "she" may remain "alone unto herself" and "abide" in "bliss." There follows a series of stanzas, each describing a room of the Palace with its vistas, decorations, and entertainments. Tennyson envisoned St. Cecilia dreaming:

> Or in a clear-wall'd city on the sea
> Near gilded organ-pipes, her hair
> Wound with white roses, slept St. Cecily;
> An angel looked at her.⁵⁰

For the other choices he made, Rossetti stayed moderately close to Tennyson's text. His drawing for this stanza is far re-moved from the text he was illustrating, and Tennyson himself professed to be puzzled as to Rossetti's meaning. In Rossetti's drawing St. Cecilia is kneeling in a swoon, hands stretched to the keyboard of the oragn in front of her, learning back against a male figure who leans down as though to kiss her. The figure is obviously intended to be the angel, but here the connection to Tennyson's verse ends. Tennyson included no figure like the helmeted man at the lower left, evidently the sentry guarding the imprisoned saint, who is eating a piece of fruit. He might be a metaphor for Adam eating the apple, in which case St. Cecilia takes on the semblance of Eve.

In another drawing, a study for the same composition, the

angel is actually kissing the saint.[51] William Rossetti provided an explanation:

> Tennyson here speaks of St. Cecilia as sleeping, "while an angel looked at her." Rossetti however has chosen to represent the subject from a more special point of view. He supposes Cecilia, while kept a prisoner for her Christian faith, to be taking the air on the ramparts of the fortress; as she plays on the hand-organ, an angel gives her a kiss, which is the kiss of death.[52]

William went on to comment that Elizabeth Siddall might have suggested the inclusion of the "kiss of death" to Gabriel. She had herself been working shortly before on a drawing of *La Belle Dame sans Merci.* Ruskin, friend and patron of both Rossetti and his Lizzie, gave the latter the nickname of "Ida," the emancipated princess in Tennyson's poem, *The Princess.* Tennyson constructed "Ida" as a metaphor for the new woman rather than the fatal woman; she reflects his concern with important social events of the time—the building wave of feminism, current demands for improved education for women.[53] One wonders how emancipated or strong-minded Lizzie may have been to earn the soubriquet, and how much she might have contributed to her lover's ideas.

Whatever the source for the "kiss of death," the saint's streaming hair, arched body, tilted back head, exposed throat and nearly closed eyes produce an atmosphere of sharply marked eroticism. Like others before him, Rossetti identified spiritual ecstasy with the petite morte of orgasm. One source that has been suggested for this drawing is Ingres' *Roger Rescuing Angelica,* which so impressed Rossetti when he first saw it that he wrote a sonnet for it.[54] Rossetti's illustration, however, more closely resembles Fuseli's *Nightmare.* Ingres and Rossetti shared a source in Fuseli, since it is hardly possible that either artist could have been ignorant of the earlier work.

In addition a striking resemblance exists between this illustration by Rossetti and a drawing by Fuseli now in the Kunsthaus in Zurich (fig. 24). While the drawing is now in Switzerland, it was originally in an English collection, and could possibly have been seen by Rossetti.[55]

Rossetti's illustrations, especially *St. Cecilia,* evoked considerable interest, and appear to have been a major factor in the creation of his public reputation. Not only by Ruskin, but also by writers as far afield as Prosper Merimée singled this illustration out for praise. The two were agreed that the design was superior, but that the woodcuts, done commercially, failed to do it justice.[56] After 1855, then, Rossetti's career entered upon a new stage, one in which he experienced growing reknown even without much public exhibition of his easel paintings. The work he produced during this period, together with the championship of Ruskin, led directly to his acquaintance with the group of young men at Oxford who formed what is usually dubbed the second generation of Pre-Raphaelites. Chief among these were William Morris, Algernon Swinburne, and Edward Burne-Jones. Burne-Jones and Morris were already among Rossetti's disciples and devotees by 1856, and Swinburne became one in 1857 when Rossetti and his new followers went to Oxford to decorate the Debating-room of the Oxford Union.

Woodward, the architect, according to William, had approached Rossetti a year earlier, and left the subject to the painters. They chose to illustrate Malory's *Morte Darthur* in fresco. The subject had long been one of interest to them all. For Madox Brown recorded lengthy discussions of Malory's book with Rossetti in his diary in 1855, well before Rossetti met Morris.[57] Their mutual interests surely drew them together, and dictated the choice of subject for the murals.

The content and unhappy fate of the Oxford frescoes have been the subject of much analysis. The inexperience of the group in the technique of fresco created great technical problems for them; they never finished the project, and their work began to deteriorate very rapidly. Some restoration has been attempted, but the scenes are best known through their drawings. Rossetti's major contribution to the cycle was *Sir Lancelot's Vision of the Holy Grail* (fig. 25). Sir Lancelot lies sleeping before the Chapel, which he may not enter, since he failed to keep his vow of chastity; Guinevere stands in the center of the composition, her outstretched arms entangled in the boughs of an apple tree. Behind her floats the damsel of the Holy Grail, holding the sacred object forever forbidden to the Knight.

The study conjures up Goethe's beautiful witch offering her apples to Faust. Guinevere in this composition seems to be Eve, or evil temptress, symbol of the sin of lust—the original sin. The Fallen Maiden—or Fallen Woman—has here acquired some of the same dark emphasis as the Belle Dame. The birth of the femme fatale out of Eve, who ushered the wages of sin: death—into the world, could hardly be more clear. As was his wont, the painter had strayed from Malory, whose text included no such description of Guinevere entwined in a tree.[58] Rossetti's identification of Guinevere (Woman) with Eve and with Sexual Sin is his own.

Jane Burden, not yet Jane Morris, modeled for this composition. While her body is posed in a graceful and seductive curve, her feminine charms are not so emphatic as those of women in paintings that succeeded rapidly upon this one. By 1858 and 1859, the languorous, full-bodied beauty who is preeminently a Victorian sex-object had begun to invade nearly all of Rossetti's canvases. One of the most typical, dated 1859, bears the title *La Bocca Baciata*: the "kissed mouth" (fig. 26). Fanny Cornforth, whom Rossetti apparently met in 1856 or 1857, and who may have been a prostitute, acted as model for the painting, which portrays the head and bodice of a young woman facing the viewer, surrounded by flowers, with an apple on a ledge in the foreground. She wears a rose in her hair, which flows down in abundant red-gold waves. Surtees describes the work in this way:

> Condemned at the time as "coarse" and "sensual," this painting . . . represents a turning point in the career of the artist. Arthurian and Dantesque subjects had begun to vanish from the easel; with the declining health of Elizabeth Siddall the small angular figures from the earlier water-colors gradually disappear, and in her place there appears a new type of woman . . . in which the sweep of the neck, the curved lips, the indolent pose of the head and the emphasis given to the fall of hair foreshadow his prolific output of studies of women . . . sensual and voluptuous, mystical and inscrutable, but always humorless. . . .[59]

The physical characteristics here had, in fact (as has been noted), already started to appear in Rossetti's earliest works, such as *Rossovestita*. But in this work the figure has become

monumental, expanding to fill nearly the entire canvas surface. In addition Rossetti combined sensual paint surface with sensual subject, so that the form reinforces and emphasizes the content —and may in fact have preceded it. The artist himself considered it to have "rather a Venetian aspect," and expressed pleasure at avoiding what he felt to be earlier faults in flesh-painting.[60] It was perhaps this quality in the work that so distressed William Holman Hunt in 1860, when he saw the work. He wrote Thomas Coombe that year that "I will not scruple to say it impressses me as very remarkable in power of execution—but still more remarkable for gross sensuality of a revolting kind, peculiar to foreign prints."[61] Others of Rossetti's acquaintance were more enthusiastic. His disciple Arthur Hughes wrote their mutual friend Allingham that "Rossetti has lately finished a beautiful head. Boyce has bought it and will I expect kiss the dear thing's lips away before you come over to see it."[62]

For Rossetti's contemporaries, evidently, the odd combination of real and unreal, the mystical and the sensual, of flesh and imagination, was precisely the element in all his work that created its power, and made him a focus of adulation and imitation. He synthesized sinful Eve with seductive demon, and in so doing had imbued a traditional sex object with supernatural power. The femme fatale had not yet grown to full lethal maturity in these works, but the path of her development was well laid out.

By the end of the decade of the 1850's, Rossetti was approaching a zenith of popularity and influence with his coterie of friends, and the tracks of his style in the work of Burne-Jones and Morris, as well as lesser known artists, are palpable. Part of the secret of his extraordinary charisma for others may have been a largeness of spirit not often mentioned in his biographies. Far from insisting on a slavish imitation of himself, he encouraged his most devoted admirers to look to themselves and others. "Towards other men's ideas he was decidedly the most generous man I ever knew," said Edward Burne-Jones. "No one so threw himself into what other men did—it was part of his enormous imagination."[63]

This encouragement to look far and wide for ideas and models led Burne-Jones to Blake and to the Italians, in the wake

of Rossetti; it led Swinburne to the French, in particular to Baudelaire. The work of Swinburne and Rossetti during the decade of the 1860's introduced the iconography of the full-blown femme fatale in complete detail.

NOTES

[1]Dante Gabriel Rossetti, *The Collected Works of Dante Gabriel Rossetti*, preface and notes by William M. Rossetti (Boston: Roberts Brothers, 1887), p. xxv.

[2]*Ibid.*, p. xxvi.

[3]*Ibid.*, p. xxviii.

[4]Virginia Surtees, *The Painting and Drawings of Dante Gabriel Rossetti: A Catalogue Raisonne*, 2 vols. (Oxford: Clarendon Press, 1971), vol. 1, see plates.

[5]W. M. Rossetti, *Family Letters with a Memoir*, vol. 1, p. 103.

[6]*Ibid.*, p. 61.

[7]*Ibid.*, p. 104.

[8]Oswald Doughty and John R. Wahl, eds., *The Letters of Dante Gabriel Rossetti*, 4 vols. (Oxford: Clarendon Press, 1965), vol. 1, p. 19.

[9]W. M. R., *Memoir*, vol. 1, p. 107.

[10]D. G. R., *Collected Works*, vol. 1, pp. 232-236.

[11]Ronnalie Roper Howard, *The Dark Glass* (Athens, Ohio: Ohio University Press, 1972), pp. 40ff.

[12]Carl A. Peterson, "The Poetry and Painting of Dante Gabriel

Rossetti" (Unpublished doctoral dissertation, University of Wisconsin, 1961), p. 349.

[13]W. M. R., *Memoir*, p. 16.

[14]*Ibid.*, p. 16.

[15]D. G. R., *Letters*, vol. 1, p. 253.

[16]Surtees, vol. 1, p. 243-247, and William M. Rossetti, *Dante Gabriel Rossetti as Designer and Writer* (London and New York: Cassell and Company, Ltd., 1889), pp. 268-269, for works listed by subject.

[17]Paull Franklin Baum, *The House of Life by Dante Gabriel Rossetti* (Cambridge: Harvard University Press, 1928), p. 233.

[18]Peterson, pp. 269, 293.

[19]D. G. R., *Collected Works*, vol. 1, p. 236.

[20]*Ibid.*, p. 235.

[21]*Ibid.*, p. 391.

[22]*Ibid.*, p. xxvi.

[23]*Ibid.*, pp. 88-90.

[24]D. G. R., *Letters*, vol. 1, p. 72f. Omission in original.

[25]W. M. R., *Memoir*, vol. 2, p. 69. The current label of the painting in the Louvre, and the current catalogue of the museum, both give the work to Titian.

[26]William Holman Hunt, *Pre-Raphaelitism*, 2 vols. (London: 1905), vol. 1, p. 269.

[27]Unsigned Article, "Epitome of the News," *Illustrated London News*, September 2, 1848, vol. 13, no. 333, p. 135.

[28]Unsigned Article, "London's Magdalene Hospital," *Quarterly Review* 83, no. clxvi (June-September, 1848), p. 360).

[29] D. G. R., *Letters,* vol. 1, p. 84.

[30] Hunt, vol. 1, p. 174.

[31] William Michael Rossetti, *Rossetti Papers: 1862-1870* (London: Sands & Company, 1903), pp. 10-20.

[32] Surtees, vol. 1, p. 64.

[33] W. M. R., *Memoir,* vol. 1, p. 114.

[34] *Ibid.,* pp. 252, 255.

[35] D. G. R., *Letters,* vol. 4, pp. 1879-1880.

[36] W. M. R., *Memoir,* vol. 1, p. 100.

[37] For example, Surtees, vol. 12, plate 35a.

[38] See William's introduction to D. G. R.'s *Collected Works,* or refer to the privately printed translation of Burger's *Lenore.*

[39] Heffner, et al, *Faust,* notes, p. 409.

[40] Max Browne, "A Source for Rossetti: A Painting by von Holst," *Burlington Magazine,* CXX (February, 1978), p. 899.

[41] D. G. R., *Letters,* vol. 1, p. 272.

[42] *Ibid.,* p. 280.

[43] *Ibid.,* p. 279.

[44] Robert Browning, *Complete Poetical Works* (Boston: Macmillan & Company, 1894), vol. 5, p. 292.

[45] W. M. R., *Memoir,* vol. 1, p. 166-167.

[46] Surtees, vol. 1, p. 40.

[47] D. G. R., *Letters,* vol. 1, p. 239.

[48] Clyde de L. Ryals, "The Fatal Woman Symbol in Tennyson," *PMLA* 74 (1959), p. 439.

[49] Alfred Tennyson, *Poems* (London: Macmillan & Company, 1894), p. 65f.

[50] *Ibid.,* p. 46.

[51] Reproduced in Surtees, vol. 2, plate 109.

[52] W. M. R., *Designer and Writer,* pp. 28-30.

[53] See John Kilham, *Tennyson and the Princess* (London: University of London—Athlone Press, 1958).

[54] Linda Nochlin, "Lost and *Found*: Once More the Fallen Woman," *Art Bulletin* 60, no. 1 (March, 1978), pp. 139-153.

[55] The drawing is no. 1584 in the complete catalogue of Fuseli's work prepared by Gert Schiff. The entry states that it had been in the collection of the Countess of Guiford, and was purchased by the Kunsthaus, Zurich, in 1914.

[56] William Sharp, *Dante Gabriel Rossetti* [1882] (New York: AMS Press, 1970), p. 111.

[57] William Michael Rossetti, *Ruskin: Rossetti: Pre-Raphaelitism: Papers 1854-1862* (London: George Allen, 1899), p. 35.

[58] Thomas Malory, *Morte Darthur* (New York: E. T. Dutton and Company, 1927), p. 437.

[59] Surtees, vol. 1, p. 68.

[60] D. G. R., *Letters,* vol. 1, p. 358.

[61] Quoted in Surtees, vol. 1, p. 69.

[62] *Letters to William Allingham,* ed. by H. Allingham and E. Baumer Williams (London: Loughans Green & Company, 1911), p. 67.

[63] Georgiana Burne-Jones, *Memorials of Edward Burne-Jones* (New York and London: The Macmillan Company, 1904), vol. 1, p. 137.

CHAPTER 6

COMING OF AGE

Gautier, Baudelaire, and Rossetti owe an equal debt to Goethe's "Ewig-Weibliche" for a range of ideas embodied in their own dual iconography of Woman. Woman as Eve, and an Occasion of Sin, was an article of faith for this group. She was far more so for Algernon Swinburne, who, as a "second generation" follower of the Pre-Raphaelite ideal, bears a large measure of responsibility for the transformation of Eve into Satan's handmaid. This stems in part from his startling personality and behavior, in part from the nature of his poetry, and in part from his critical theories.

Possibly those aspects of his activity viewed as most dubious by his contemporaries had their roots, as psychoanalysts would have it, in his childhood experiences. Students of his life and work, however, often blame the influence of other artists and poets whom he came to know during his education and early maturity. From his Oxford tutor, Benjamin Jowett, forward, there is a strong tendency to blame Rossetti for Swinburne's oddness, his failure to finish his degree, his dissolute life, and the "unhealthy" tone of much of his early poetry.[1] With slightly more accuracy one might lay the responsibility for the corruption (if corruption it was) at the feet of Richard Monckton Milnes, who introduced Swinburne to the writings of the Marquis de Sade. Swinburne's letters make clear, however, that his interest preceded his knowledge, since he importuned Milnes for access to the latter's justly reknowned collection of erotica beginning early in 1860. He was not allowed to see it until 1863.[2]

Well before Swinburne had the chance to read the "Divine Marquis" and even before he met the Pre-Raphaelites, he exhibited symptoms of one already at odds with social convention. Contemporary descriptions offer a picture of a young man who

was small, shrill, and agitated, even bizarre. His general circumstances give few direct clues to the reasons. Tutored at home, petted and indulged by his mother and sisters, educated at Eton and Oxford, outwardly his life was conventional in its adherence to upper class norms. But he failed to finish his schooling either at Eton or Oxford, and disappointed his family's ambitions for a career in the church.

He left both public school and university surrounded by an odor of sexual scandal. The exact nature of the proclivities that provoked the events is speculative, but that they were outside the pale of acceptable behavior, as it was then defined, seems certain. A number of surviving letters to select correspondents center on the erotic delights of flagellation. These include Milnes, later Lord Houghton; the painter Simeon Solomon, one of Rossetti's imitators; and Charles Howell, sometime studio assistant and agent for Rossetti, whom Rossetti suspected of forging his drawings.[3] In later life Swinburne may have been blackmailed—by Howell, by one of his publishers, and by Soloman, who was selling some of Swinburne's letters on the street in 1870.[4]

Like Baudelaire, Swinburne offers posterity a case-study guaranteed to arouse all the detective instincts of a Freudian analyst. His life included all that is now popularly construed as the standard appurtenances of sado-masochistic, possibly homosexual personality development: indulgent mother, autocratic father, the famous whipping block at Eton. In addition, Swinburne was, like Fuseli, a small man, and also like the painter, dwelt on the monumental female, the virago, in his work.

Rather than being corrupted by the older men whom he admired, however, Swinburne may have found in them examples of freedom of idea and behavior most attractive to one who found himself at odds with ordinary values and norms. The Oxford "Pre-Raphaelite" group were indulgently tolerant of his whims and follies; Milnes may have participated in them. Swinburne brought to his association with Rossetti and others an already distinct set of attitudes toward the expression of love and desire in life or art. Their association was one of a convergence of ideas, of shared enthusiasms for certain literature and particular kinds of art. Like Rossetti, Swinburne had found Blake and

Keats for himself in his youth. Apart from these, his studies followed a standard pattern: a bowdlerized Shakespeare, the Bible, the acceptable poets and novelists of the day. His Eton years were spent with the standard classics, unencumbered by science or "modern" literature.[5] The latter he found for himself.

If the group at Oxford exposed him to any as yet unknown literary joys, those may have been their own medieval interests, especially Malory. Lafourcade, his most careful biographer, has stated that the most important influence on young Swinburne was that of William Morris, not in the direction of content, but in the area of practice. Morris, evidently, encouraged Swinburne to develop a *discipline* of writing, to polish his form and technique.[6] Rossetti, on the other hand, was probably essential to much of what Swinburne came to know and feel about the visual arts. To what Swinburne knew of Blake's poetry, Rossetti would have added what he knew of Blake's art. In addition, Rossetti owned a copy of an *Hypnoteromachia Polyphili* that he believed (mistakenly) to be illustrated by Botticelli, and was probably instrumental in directing the eyes of all around him to that long neglected artist.[7]

Little, if any, influence was brought to bear on the *content* of Swinburne's poetry by either his acquaintances or his reading. Well before Rossetti's production of lethal ladies in painting during the 1860's, and also well before Swinburne read either Baudelaire or de Sade, he was already fascinated with the figure who became "Our Lady of Pain." "Rosamund," published in 1860, presages the fierceness of vampirish love that radiates through much of his 1866 volume of *Poems and Ballads.* Her "bitter kiss," mingled with teeth and blood, is found also in "Queen Yseult," written in 1858, but not published until after the poet's death.[8]

The figure moving into focus in his work during his time of closest association with Rossetti in London was a monumental, coldly sensual, sterile goodess, intent upon enslaving and torturing men. Or Man. The composition of *Poems and Ballads* was well under way in 1861 and 1862 as Swinburne prepared also to write *Atalanta in Calydon.* For the latter, Swinburne received wide acclaim when it was published in 1865. Not so in

the case of *Poems and Ballads,* published a few months later. According to William Rossetti, it evoked "an amount of rage and noise such as the literary world seldom rings with."[9]

Described as prurient, blasphemous, fleshly, insulting to pure womanhood, this body of work was read far more for its sensational value than its poetry. John Morley, writing in the *Saturday Review,* August 4, 1866, singled out "Laus Veneris," "Dolores," and "Hermaphroditus" for special opprobrium.

> This stinging and biting, all these "lithe lascivious regrets," all this talk of snakes and fire, of blood and wine and brine, of perfumes and poisons of ashes, grows sickly and oppressive on the senses. . . .[10]

Mr. Morley, in time-honored fashion, selected the juiciest passages for quotation and condemnation. As for the poet:

> . . . no language is too strong to condemn the mixed vileness and childishness of depicting the spurious passion of a putrescent imagination, the unnamed lusts of sated wantons, as if they were the crown of character and their enjoyment the great glory of human life.[11]

Swinburne had in fact described "Dolores" as though he were gazing on an enamelled altarpiece that, Pygmalion-like, he had called into life:

> Cold eyelids that hide like a jewel,
> Hard eyes that grow soft for an hour;
> The heavy white limbs and the cruel
> Red mouth like a venomous flower;
> When these are gone by with their glories,
> What shall rest of thee then, what remain,
> O mystic and somber Dolores,
> Our Lady of Pain?[12]

Love dies, but Dolores is immortal, "fed with perpetual breath." The kisses she gives are "bloody," she herself is forever "fresh from the kisses of death."

> Could you hurt me, sweet lips, though I hurt you?
> Men touch them, and change in a trice
> The lilies and languors of virtue
> For the roses and raptures of vice.[13]

Dolores has "never ached with a heart," and in the end is more kind than love that dies; her kisses "hurt not the heart or the brain." Swinburne allied his "Lady of Pain" to the ancient Goddess whose worshippers gave her their blood and lives:

> Where are they, Cotytto or Venus,
> Astarte or Ashteroth, where?
> Do their hands as we touch come between us?
> Is the breath of them hot in thy hair?
> From their lips have thy lips taken fever,
> With the blood of their bodies grown red?
> Hast thou left upon earth a believer
> If these men are dead?[14]

Dolores is the "daughter of Death and Priapus," the "one thing as certain as death." In the end, only when we die, will we know "whether hell be not heaven."[15]

The burden of the poem seems to be that Dolores is Dark Eros personified, inflicting pain and death on the body, but leaving the heart, and perhaps the soul, of the lover intact. In antiquity Eros was light-hearted, worshipped by all, but has now been rejected for other forms of belief:

> What ails us, O Gods, to desert you
> For creeds that refuse and restrain?
> Come down and redeem us from virtue,
> Our Lady of Pain.[16]

Her worshippers are all dead, and a present worshipper will join them: "shall fade as they faded before," not knowing until "darkness discovers" what death will bring. The poem is as much a lament for classic and pagan antiquity, a celebration of ancient belief, as it is an expression of perverse eroticism. It is also a defiant rebellion against the code of social virtue in which Swinburne was raised.

Morse Peckham has offered the opinion that much of Swin-
burne's early poetry was part of the poet's attempt to become
reconciled with his own inescapable nature. This nature was one
of enslavement to a warped erotic drive, uncontrollable and
humiliating.[17] Victorian morality, of course, with its insistence
that only domestic, and theoretically non-erotic, marriage of-
fered acceptable outlets for sexual expression, forced humiliation
on the poet.

Other biographers such as Lafourcade also express compas-
sion for a man they describe as at odds with conventional virtue
through no fault of his own, and admire his literary courage at
least as much as his extraordinary language. Certainly some of
Swinburne's friends shared this attitude. Most of his respectable
contemporaries emphatically did not. It was not his theology,
his anguish, or his language that stuck most firmly in their minds
—it was Dolores. And her sisters: Faustine, Anactoria, Phaedra,
Cleopatra, Venus in *Laus Veneris,* et al. Is there "really nothing
worth singing about," asked Mr. Morley,

> except "quivering flanks" and "splendid supple thighs," "hot sweet
> throats" and "hotter hands than fire," and their blood as "hot wan
> wine of love?" Is purity to be expunged from the catalogue of de-
> sirable qualities?[18]

It would be unfair to be too hard on Morley, since he performed
an excellent service for Victorian readers by singling out the most
rousing phrases of Swinburne's poems for quotation. Those who
wished to preserve their respectability, yet be informed, need go
no further than his—and a number of other equally lubricious—
reviews.

Swinburne owed much to French literature, and can be
credited with acquainting the English with the work of, among
others, Gautier, Hugo, and Baudelaire. The teeth, the eyes of
fire, the perfume, "glut" and "sate" of an inescapable and hated
physical passion create a close kinship between the work of Swin-
burne and Baudelaire; Swinburne was familiar with *Les Fleurs du
Mal,* if not in the first edition of 1857, at least with the later edi-
tion that he reviewed for *The Spectator* in 1862.[19] In his review
he exhibited a thorough knowledge of all Baudelaire's work:
poetry, translations, criticism and art reviews. He could hardly

have avoided recognizing the family resemblance between Dolores and Baudelaire's Black Venus.

He must also have recognized the family resemblance between these two and Gautier's Clarimonde, and, standing behind them, Hawthorne's Beatrice: Rappaccini's Daughter. The correspondence between Rosamund's "bitter kiss," Dolores' "Red mouth like a venomous flower," and the beautiful Beatrice, sister to a deadly plant and herself poisonous, is striking. Swinburne read and admired Hawthorne's *Tales* as early as 1857,[20] and for him, all these writers appear to have been—to use the nineteenth century phrase—elective affinities. Like them, he was predisposed to see Woman as lethal.

Not only lethal but sterile. The fruitless, barren, empty nature of the objects of desire inhabiting his poetry is reiterated endlessly, as in the work of Baudelaire. Faustine was hid in a "barren bed," Dolores is "splendid and sterile," and above all Heramphroditus is the "double blossom of two fruitless flowers," a "thing of barren hours."[21]

"Hermaphroditus" and "Anactoria" were especially vilified, as unclean abominations, "loathsome" and "foul," which adjectives Swinburne appropriated and applied to the minds of those who so described his poems. His intent in the first poem, he wrote, in an essay rebutting his critics, was to paraphrase Sappho, "the greatest poet who ever lived." He meant to "express and represent not the poem but the poet." As for Hermaphroditus:

> The sad and subtle moral of this myth, which I have desired to indicate in verse, is that perfection once attained on all sides is a thing thenceforward barren of use or fruit; whereas the divided beauty of separate man or woman—a thing inferior and imperfect —can serve all the turns of life.[22]

Swinburne stands here in a line of tradition celebrating the beauty of the Hermaphrodite that includes artists of antiquity, Winckelmann, Gautier, and Shelley, whose *Witch of Atlas* he quoted in this essay. Shelley's Hermaphrodite, however, unlike Swinburne's, is a "sexless being," winged and possessed of supernatural beauty, who lies dreaming through the ages, and presumably arouses only aesthetic pleasure. Swinburne's by con-

trast evokes the most exigent physical longing:

> And whosoever hath seen thee, being so fair;
> Two things turn all his life and blood to fire;
> A strong desire begot on great despair,
> A great despair cast out by strong desire.[23]

Like Baudelaire's *Femmes Damnées,* Swinburne's "Hermaphroditus" was understood by the public to celebrate the mysteries of the "love that dares not speak its name." Moreover, he drew a clear picture of the sexually desirable woman, whoever she might be, as evil. In "Hermaphroditus" he said:

> Love made himself of flesh that perisheth
> A pleasure-house for all the loves his kin;
> But on the one side sat a man like death
> And on the other a woman sat like sin.[24]

Of his Venus in "Laus Veneris" he remarked:

> If anyone desires to see . . . the conception of the medieval Venus
> which it was my aim to put into verse, let him turn to the magnifi-
> cant passage in which M. Baudelaire describes the fallen goddess,
> grown diabolic among ages that would not accept her as divine. . . .
> The queen of evil, the lady of lust, will endure no rival but
> god. . . .[25]

Swinburne was accused, then and now, of concentrating his entire interest in this volume on morbid or abnormal eroticism. That may or may not have been his intention, but his rebuttal to his detractors aided and abetted the interpretation. In other words, his defense of his poetry against accusations of indecency and lasciviousness may have confirmed his critics in their opinions.

Possibly part of the clamor against Swinburne was evoked by his subtle appropriation of a theme earlier used by, among others, Tennyson. "The Masque of Queen Bersabe," included in the first edition of *Poems and Ballads,* bears something of a resemblance to the older poet's "Dream of Fair Woman." In Tennyson's poem, the dreamer sees a series of famous women, including Helen, Cleopatra, Rosamund, each of whom narrates

the story of her life. Tennyson acknowledged his formal debt, which Swinburne did not, to Chaucer's "Legend of Good Women." Swinburne, though he uses a similar structure, may not have mentioned Chaucer because the women he listed were far from "good." He characterized his poem as a "miracle play," in which the prophet Nathan shows King David "fair and foul" women, all queens "made as this Bersabe" (Bathsheba). Bersabe resembles Botticelli's famous Venus:

> The long hair of this Bersabe
> Fall round her lap and round her knee
> Even to her small feet. . . .

The queens include Pasiphaë, Semiramis, Aholibah, whose "mouth's heat was the heat of flame;" Cleopatra, whose "lips held fast the mouth o' the world;" Myrrha, who fed upon sin, and in concluding crescendo, Messalina:

> I am the queen of Italy,
> These were the signs God set on me,
> A barren beauty subtle and sleek,
> Curled carven hair and cheeks worn wan
> With fierce false lips of many a man,
> Large temples where the blood ran weak
> A mouth athirst and amorous
> And hungering as the grave's mouth does
> That being anhungered, does not speak.[26]

And among those Nathan calls forth in Sappho, "queen of the Lesbians," who is afflicted with "intolerable infinite desire," she whose "blood was the hot wan wine of love" that so offended Morley.

Swinburne eroticized and "corrupted" a traditional form used by Tennyson with elements he was encouraged, possibly, to utilize through his reading of the French. Particularly in Messalina, he produced a figure who seems to be to a description of one of Rossetti's paintings, who hints at being a vampire, who is barren, pale, beautiful, and as corrupt as the grave. She offers a quite complete iconography of the full-fledged femme fatale.

The idea of the female of the species as uniformly fatal

permeates Swinburne's critical essays as well as his poetry. From the entire range of artists whom he discussed in his *Notes on Old Masters,* written in 1864, and published in *Fortnightly* in 1868, he chose to discuss primarily:

> Fair strange faces of women full of dim doubt and faint scorn; troubled by the shadow of an obscure fate; eager and weary as it seems at once, pale and fervent with patience or passion; [that] allure and perplex the eyes and thoughts of men.[27]

In those studies of a woman's head by Michelangelo where he saw a Lamia, with hair "shuddering into snakes," he saw also a peculiar mystery: (see p. 66)

> In some inexplicable way all her ornaments seem to partake of her fatal nature, to bear upon them her brand of beauty fresh from hell; . . . many names might be found for her . . . Lamia . . . Cleopatra . . . Amestris . . . Jezebel. . . .

Finally, he likens her to Salammbô, whose "mystic marriage transforms her death into a meeting of serpents."[28]

In Andrea del Sarto's paintings he found two kinds of Salome. The first, a maiden:

> grave or graceful, light and glad, the song of a bird made flesh, with perfect poise of her sweet slight body from the maiden face to the melodious feet; no tyrannous or treacherous goddess of deadly beauty, but a simple virgin . . . indifferent and innocent. . . .[29]

But, he continued, the "time came when another Salome was to dance before the eyes of the painter"—after his "life was corroded" by the "poisonous solvent of love"—

> In those later works, the inevitable and fatal figure of the woman recurs with little diversity or change. She has grown into his art. . . .[30]

The deadly desirable woman depicted by Gautier, Baudelaire, Rossetti, was finally *labeled*—"fatal"—by Swinburne. To the frequent comment that Swinburne's writing was deliberate

description of Rossetti's paintings, one might rejoin that it as often appears that Rossetti's paintings were illustrations to Swinburne.

Rossetti, blamed and credited with being a major influence on Swinburne, was certainly an object of the younger man's devoted and unquestioning admiration for many years. Their letters record repeated instances of the close coordination and mutuality of their interests. For his own part, Rossetti acted for years as Swinburne's unflagging supporter, recommending his work to friends, publishers, editors and critics, praising and encouraging him. He unbent sufficiently in correspondence with Swinburne to allow himself a faintly ribald, even scatalogical tone that does not often appear in his letters. Writing to Swinburne in Paris in 1864, he said:

> It is good news to hear of *Atalanta's* approaching publication. I really believe on the whole that this is the best thing to bring out first. It is calculated to put people in a better humour for the others, which, when they do come, will still make a few not even over particular hairs to stand on end, to say nothing of other erections equally obvious. I tremble for the result of your reading Baudelaire's suppressed poems, the crop of which read I expect you to be in fine flower, not to say fruit, by the time I reach London. If so, and these new revelations are to be printed too, I warn you that the public will not be able to digest them, and that the paternal purse will have to stand the additional expenses of an emetic presented gratis with each copy to relieve the outraged British nature.[31]

So, though Rossetti had from youth disdained, with few exceptions, things French, he was certainly familiar with them, as well as the tenor of Swinburne's as yet unpublished poetry. Clearly, also, Swinburne's debt to Baudelaire was no secret.

Beginning in 1863, Swinburne's interests converged in the writing of his *Essay on Blake,* finally published in 1868. The essay furnished the reading public with a lucid and fervent espousal of the principle of Art for Art's Sake, and gave major impetus to the English Aesthetic Movement.[32] From it came his oft-quoted "Save the shape and art will take care of the soul for you," and his dictum that moral intentions spoil the art.

Though Rossetti clung to the conviction that the beautiful contained its own moral purpose, his close associates' espousal of the principle that art existed for its own sake may have encouraged him to follow new creative directions. The long line of half-length female figures he produced after *La Bocca Baciata* (fig. 26) exhibits a growing interest in, first, the erotic, and then the lethally erotic elements that had earlier appeared in his drawing, *La Belle Dame sans Merci* (fig. 21). He moved from this form, which can be termed "private" art, into more major commissioned products. The paintings of the early 1860's, with such titles as *Regina Cordium, My Lady Greensleeves* and *Monna Rosa* typify his beginning incursions into depictions of seductive women, and are for the most part sentimental tributes to Desirable Womanhood.

While his brother William said that these paintings were all based on Gabriel's Lizzie, who died in 1862 after less than two years of marriage, the works themselves imply otherwise. Rossetti's models included Ruth Herbert, the actress; Jane Morris; "Red Lion Mary," a servant girl; the wives of several friends, and some unidentified. The features and lovely golden hair of Fanny Cornforth (who became his "housekeeper" after Lizzie's death) appear most often. But the variety of models is less striking than their similarity. Rossetti imposed what can only be called a schema on the features of each of his models. The lips, eyelids, expression, posture of the head are all very much alike. In most of his half-figure paintings, the woman fills the canvas, alone and languidly dreaming, in a still, even breathless atmosphere, as though gazing into the dream world he created in his poem, *Love's Nocturne*:

> Poet's fancies all are there:
> There the elf-girl floods with wings
> Valleys full of plaintive air;
> There breathe perfumes; there in rings
> Whirl the foam-bewildered springs;
> Siren there
> Winds her dizzy hair and sings.[33]

The atmosphere is unquestionably "hothouse," and effect is intensely, though euphemistically, seductive. *Fazio's Mistress*, completed in 1863, provides a notable example (fig. 27). De-

picting a young woman braiding her hair, the work seems initially to have been undertaken for purely formal considerations. Rossetti wrote a friend on October 25, 1863:

> I am now painting a woman plaiting her golden hair. This is in oil, and chiefly a piece of color.[34]

His statement about the purpose of the work echoes the desire to do "rapid flesh painting," the comment he made in reference to *Bocca Baciata.* After the work was completed, however, he gave it its title, derived from a "canzone" written by Fazio degli Uberti. Rossetti had translated it several years earlier and included it in his book *Early Italian Poets* (1861). The lady in the poem is a "gentle girl," full of beauty and virtue—not fatal. But the poet's opening lines are:

> I look at the golden-threaded hair
> Whereof, to thrall my heart, Love twists a net.[35]

The recurring theme of the enthralling net of hair marks a growing emphasis in Rossetti's work that came to full fruition in a group of paintings produced between 1864 and 1868. The fatality of the Belle Dame was heightened, brought to the fore, and synthesized with the sensual imagery of such earlier works as *St. Cecilia* (fig. 24) and *La Bocca Baciata.*

Chief among these works is *Lady Lilith* (fig. 28). She has a long ancestry: from Goethe's Lilith to Keats' Belle Dame to this languid self-absorbed creature, combing her veil of hair, of whom her creator wrote:

> Of Adam's first wife, Lilith, it is told
> (The witch he loved before the gift of Eve,)
> That, are the snake's, her sweet tongue could deceive,
> And her enchanted hair was the first gold.
> And still she sits, young while the earth is old,
> And, subtly of herself contemplative,
> Draws men to watch the bright web she can weave,
> Till heart and body and life are in its hold.
>
> The rose and poppy are her flowers; for where
> Is he not found, O Lilith, who shed scent

And soft-shed kisses and soft sleep shall snare?
Lo! as that youth's eyes burned at thine, so went
Thy spell through him, and left his straight neck bent
And round his heart one strangling golden hair.[36]

The amalgamation of enthralling phantom with witch in the shape of an apparently "real" woman in her boudoir possesses most of the attributes of a full-blown femme fatale. Unlike earlier embryonic forms, this example received substantial public notice. In the fall of 1868, Rossetti learned that his brother William and Swinburne were planning a joint pamphlet review, to be entitled *Notes on the Royal Academy Exhibition*. William was to cover the annual summer showing, while Swinburne intended to write on the "unexhibited" paintings of the year. To Swinburne Rossetti wrote:

> I have just heard from William that you are describing in your pamphlet my Lilith and Palmifera. It is jolly beyond measure to be included in what you write if it is still possible at this date to give the reference to any [new?] work [of] importance in respect of other unexhibited things described.

The only other unexhibited artist included in Swinburne's completed essay was Whistler. Rossetti continued:

> I know your affectionate enthusiasm and the beauty which will be in every word you write; but I should like greatly to have had the opportunity of looking at my work with you at this particular moment, since much that is necessary to the scheme of the *Palmifera* (for instance) is not yet included. There is also the *Beata Beatrix* (which you have seen), the *La Pia* (which I have not yet shown you. . .) and the design of the *Aspecta Medusa* which I will shortly begin painting.[37]

Rossetti considered Lilith and the *Sibylla Palmifera* to be companion works, each one of a pair of dualistic opposites. They were so treated by Swinburne in his completed review:

> Among the many great works of Mr. D. G. Rossetti, I know of none greater than his two latest. These are the types of sensual beauty and spiritual, the siren and the sibyl.[38]

Here is a lucid statement of the dual concept of the Eternal
Feminine. Swinburne went on to provide a detailed physical
description of these two works, as well as several others, and
included with them full quotation of the sonnets Rossetti had
written as companions to his own painting. The Sibyl stood for
spirit, and Lilith for sin.

Rossetti's letter seems to carry a degree of anxiety that
his work could not be fully understood unless it was seen in its
own company; that it was important for the "schema"—the
plot, if you will, of related works to be comprehended as a unit.
Possibly he had in mind the internal scheme of the *Palmifera,* but
equally possibly that which he saw as "necessary" to the
"scheme" of this painting resided also in the other works, and
that the entire group of five paintings is inter-related.

The sonnet accompanying the painting *Sibylla Palmifera*
(fig. 29) was renamed "Soul's Beauty" for Rossetti's publication
of his poetry, as *Lady Lilith* was renamed "Body's Beauty."
"Soul's Beauty" begins:

> Under the arch of life, where love and death,
> Terror and mystery, guard her shrine,
> I saw Beauty enthroned. . . .[39]

In the painting, Love is Blind Cupid at the viewer's left, carved
on the arch, topped with luxuriantly blooming roses. Death is
the skull at the right, above which are equally abundant red
poppies. Incense burns below Cupid, and also below the skull.
Butterflies hover behind the woman's shoulder, and carved in the
niche behind her head is the sphinx. Traditionally butterflies
symbolize human souls; the sphinx is mystery as well as the
guardian of tombs. These are at the right, adjacent to the pop-
pies and death's head. The palm in the woman's hand is at the
left, next to Cupid and the roses—flowers of Venus. As in six-
teenth century emblem paintings, right and left symbolism pre-
vail; At the Sibyl's right hand is the Triumph of Love, at her
left the Triumph of Death.

Rossetti himself referred to the work as an embodiment of
the concept "of beauty the Palm-giver, I. E. the Principle of
Beauty."[40] The combination of palm, death's head, rose and

poppy create a curious mixture of disparate symbolic elements. The rose belongs to Venus, for love; the palm, in antiquity, to Victory and Fame, and in the Renaissance, to scenes of Christian redemption and occasionally to the Virgin Mary as Immaculate Conception. The death's head came into wide-spread use during the Middle Ages, with obvious meaning, and the use of the poppy, associated with Hypnos, God of Sleep, and Morpheus, God of Dreams, to symbolize night, sleep, and death, has been traditional from antiquity forward. Rossetti used a variety of herbals, numerologies, and works on physiognomy as sources for symbolism,[41] and no doubt became familiar with the range of symbolic meanings of these elements through such books. If not, he certainly would have been exposed to them through his study in the Royal Academy Antique School.

Swinburne mentioned all five of these paintings in his essay, and gave them the imprimatura of his highest praise. In his discussion of the *Palmifera* he referred to the palm as the symbol of peace and *power,* making his interpretation even more emphatic than Rossetti's own description of the work. For the painter, the Principle of Beauty "draws all high-toned men to itself," and the Sibyl's lover in the sonnet written for the painting is "The allotted bondman of her palm and wreath."

Rossetti implied, in other words, that bondage to spiritual love and beauty are identical to bondage to erotic love: Beauty is flanked by Love and Death, as lethal when she is Venus/Mary as she is when she is Venus/Eve—or Lilith. Floral decoration illustrates the interconnection between the *Palmifera* and *Lady Lilith*: "The rose and poppy are her flowers," Rossetti wrote of Lilith, and they also accompany the Sibyl.

These two companion works share characteristics with the other three: *Beata Beatrix* (fig. 30), *La Pia* (fig. 31), and *Aspecta Medusa* (fig. 32), listed in Rossetti's letter. Beatrix, Lilith and the Sibyl all possess the poppy—narcotic, poison, source of fatal oblivion—though there is a widespread tendency to associate the poppy only with Beatrix—Elizabeth Siddal—since she is believed to have died of an overdose of laudanum, one of the opiates derived from the flower. Lilith, doubly lethal, is surrounded also by foxglove, a source of digitalin, which is medicine for coronary patients, but also, as any reader of detective mysteries knows, a

deadly poison. In all five works, the faces of the women share physical features: eyes, mouth, hair, gaze, expression. They posses the same flowing hair, full throat, languor, and posture.

Like the *Blessed Damozel,* Rossetti's much earlier ballad, *Beata Beatrix* has been subject to highly diverse interpretation. The painting, undertaken between 1864 and 1870, is a portrait of Elizabeth Siddall, from studies done during her lifetime. According to one point of view Beatrice represents Rossetti's identification with Dante, and illustrates transcendence, the alteration of erotic into divine love.[42] Another opinion holds that the work, together with several related poems, signifies the poet's need to achieve an "ecstatic mingling," a fusion of the physical and spiritual aspects of love.[43] Still a third implies that Rossetti's Lizzie, of whom his work is a portrait, in transition from life to death, is in the process of becoming a form of fatal woman.[44] Lizzie, dead, in other words, became a haunting spirit, a femme fatale tormenting Rossetti.

Of all the variants, this last interpretation is nearest the traditional understanding of the artist's psyche. Surely, for Rossetti, Lizzie was as much phantom bride as Muse. He may even have thought of her as resembling Hawthorne's Beatrice, the Poison Damsel. Though the artist himself said the work did not represent death as such, but rather a trance in which Beatrice is "suddenly rapt from Earth to Heaven," the odor of death (perfumed though it is) hovers over the painting.

So also does the boudoir odor of seduction and desire. The figure of Lizzie is posed in the same erotic swoon of such earlier works as *St. Cecilia,* in an echo of Fuseli. Her hair has been "let down"—in the phrase associated with sexual abandonment. To deny the intense erotic component of the work would be to indulge in a curious, almost Victorian opacity of vision.

Death and Love permeate all five of these works. *La Pia* exists in Purgatory, a living death decreed by the betrayal of love. Venus, as the Sibyl, is guarded by Love and Death. Andromeda, in *Aspecta Medusa,* lives only through the death of another. The painting, for which this is a study, was never completed, since C. P. Mathews, who commissioned it, found the intended inclusion of the severed head of Medusa too gory.[45] The work was

planned to depict Andromeda leaning against Perseus' knee, while he holds Medusa's head behind her, reflected in a bowl of water in front of her, so that "mirrored in the wave was safely seen/That death she lived by."[46]

While Gabriel was at work on this group of paintings, his brother William was engrossed in a critical study of the poetry of Shelley. The coincidence may have brought Shelley's poem on the *Medusa* in the Uffizzi, with her "new kind of beauty," to Gabriel's mind. Even more, it may have triggered his memory of Goethe's *Faust*. Gabriel wrote to his brother in 1866, asking for a transcript of Shelley's translation of the quatrain in which Lilith appears.

He worked on the painting of Lilith, apparently, for some time before it had either a buyer or a title. Surtees states that it was begun in 1864, and William described it as well under way in 1865. Given the similarity of the work to Titian's *Lady at her Toilette* (fig. 22), Rossetti's flying trip to Paris in 1864 takes on added significance. He went primarily to see the great Delacroix exhibition, but also, in passing, to visit the Louvre, where he may have renewed his acquaintance with Titian's work.

At the same time he was also busy with the *Palmifera* and it was this picture that Frederick Leyland, the eventual buyer of *Lady Lilith*, first wanted, but Rossetti had already offered it to another patron. Seizing the opportunity to add another customer to his list, Rossetti wrote to Leyland in April, 1866:

> As you continue to express a wish to have a good picture of mine, I write to you word of another I have now begun, which will be one of my best. . . .
>
> The picture represents a lady combing her hair. It is the same size as the Palmifera—36 x 31 inches, and will be full of material,— and a landscape seen in the background. Its colour will be chiefly white and silver, with a great mass of golden hair.[47]

The painter's emphasis on surface and color implies that initially his pictorial interest focusses on formal issues rather than subject matter, as with his concentration on "rapid flesh painting" and the achievement of a "Venetian manner" in such

works as *Bocca Baciata* and *Fazio's Mistress*. Several months later he wrote his mother:

> I have been working chiefly at the Toilette picture, and at the one with the gold sleeve, both of which I think you know. The former will, I think, be my best picture hitherto.[48]

The label, "Toilette picture" reinforces the connection to Titian's work, as do a number of pictorial elements. Rossetti emulated Titan's treatment of flesh, hair, and gown, as well as pose.

By October of that year, the work had acquired its permanent title as well as an altered and expanded meaning. That month, Rossetti's friend and patron, George Boyce, recorded in his diary that "Gabriel has been painting a beautiful picture he proposes calling Lady Lilith, and has written a fine sonnet under it."[49]

The initial inspiration for the title, though perhaps not for the painting itself, was no doubt the fleeting appearance of Lilith on Walpurgisnacht. During the time he worked on the large oil, Rossetti also produced a small watercolor replica with the same title and composition (fig. 33). On the reverse of the work, in his own hand, is written Shelley's translation of Goethe's quatrain. Years later, going through his brother's note-books, William found his own transcript, including Goethe's original German, Shelley's translation, and yet a further translation, this time by Gabriel himself:

> Hold thou thy heart against her shining hair,
> If, by thy fate she spread it once for thee;
> For when she nets a young man in that snare,
> So twines she him he never may be free.[50]

He moved from Goethe's "erlangen," to catch, to Shelley's "wind," to his own "twine"—and also from Goethe's "not soon" to Shelley's "not ever" to his own "never," and in so doing substantially increased the threat to the lover.

In 1872, Rossetti altered the face in the oil version, replacing Fanny Cornforth's soft features with those of Alexa

Wilding, also frequently his model. In doing so, he formed one far more coldly and explicitly erotic. While the standard opinion recently has been that the work was damaged by the change, it pleased both Leyland, and its eventual owner, Samuel Bancroft mightily, as less "sensual and commonplace," and more appropriate to the subject of Lilith.[51]

Both versions of Lilith were underway during a wave of high popular interest in Goethe's *Faust*. Gounod's score for the opera was published in London in 1859, and one production of the opera played to rave reviews in London and the provinces in 1864. Popular plays based on Goethe's plot and popular music inspired by the opera poured out during the middle of the decade, and during the same period a variety of paintings on Faust subjects appeared in the Royal Acdemy exhibitions.[52] Few of these however, centered on Walpurgisnacht in general, and none on Lilith. In choosing Lilith as the subject for his sonnet, and then applying the title to his painting, Rossetti indeed seized one more opportunity to "allegorize on his own hook."

The sonnet, far more than the painting it accompanies, conveys the fatal quality of Lilith. The single strand of strangling hair that binds the lover forever seems to have its source, not in the appearance of Lilith, but in the far more ghostly apparition of Marguerite, whose throat is ringed with a single thread of blood. In his painting, his translation, and his own sonnet, Rossetti enormously intensified the threat and evil inherent in Lilith—and created a femme fatale as full blown as the roses which surround her.

In this group of paintings, as in his poetry, Rossetti may indeed have wished to "mingle" or "fuse" body and soul, though his opposition of "soul's beauty" and "body's beauty" would seem to contradict such an interpretation. He may even have wished to "transcent" the flesh, as an expression of profound emotional need, and have felt he accomplished it in at least some of his works. But the association of Love and Death, with its object or its personification in a beautiful woman, can produce a different equation for the viewer: Woman = Love = Death.

Whether or not Rossetti had an over-riding theme for this group of five paintings, he certainly was concerned that Swinburne, above others, understand the work truly, and convey that understanding to his readers. Rossetti had started working on these paintings while Swinburne was passing his own completed poems around among his friends for comment and advice; Rossetti himself undertook to take them to several publishers. His anxious letter to Swinburne suggests that he was off in a new creative direction, and that his young friend's opinion mattered to him. Swinburne, in other words, may have influenced Rossetti at least as much as the other way around.

During the 1860's Rossetti's symbolic identification of Woman with Love and Death began to appear in virtuous as well as fatal personifications. One of the more remarkable examples is his *Venus Verticordia* (fig. 34). Venus is shown half-length, nude, surrounded by honeysuckle, roses, and foliage, holding an arrow and an apple. Her hair streams down her shoulder, and butterflies hover around her crowned head. On the face of it, the subject and its appurtenances seem the epitome of Victorian sexual euphemism, verging on the saccharine.

Ruskin's criticism of the work is one of its more entertaining features. He disliked "Flora," as he called it, because the flowers were "wonderful but coarse."[53] These comments, in 1865, marked the end of Rossetti's and Ruskin's closeness, because, in William's words, as Gabriel "advanced in years, in reputation and in art, [he] became less and less disposed to conform his works to the liking of any Mentor . . . [and] Ruskin, serenely conscious of being always in the right, laid down the law. . . ."[54] In this instance, the last time Ruskin gave instructions to Rossetti, the law consisted of altering coarse *flowers* in Rossetti's painting of a *nude*—one of the very few he ever produced.

It may be that Ruskin sensed some more ominous erotic meaning to the work than immediately leaps to the eye. Rossetti's sonnet for the work creates a more somber atmosphere. Beginning "She hath an apple in her hand for thee," the octet of the sonnet conveys a picture of gentle reverie, of a maiden withholding her arrow out of concern for the fate of her potential lover. With the sestet the mood shifts to one of threat:

A little space her glance is still and coy,
But if she give the fruit that works her spell,
Those eyes shall flame as for her Phrygian boy.
Then shall her bird's strained throat the woe foretell,
And her far seas moan as a single shell,
And through her dark grove strike the light of Troy.[55]

Venus, Goddess of Love, no matter how gentle and sweet, has been identified by the poet with Eve, carrying the apple of Original Sin, with Cybele, for whom men sacrificed themselves, and with Helen, the fated beauty of classic legend. By this date he had also painted Helen herself, and inscribed on the back of the work the lines from Aeschylus's play *Agememnon,* in both Greek and English: "Helen of Troy, destroyer of ships, destroyer of men, destroyer of cities."[56] By 1868 he may also have planned, if not completed, his ballad "Troy Town," included in his *Poems* (1870). The ballad describes Helen kneeling at the shrine of Venus, offering the Goddess a double votive cup in the shape of a woman's breasts, comparing them to her own: "See my breast, how like it is; . . ."—as though she herself might be Rossetti's painted Venus. She longs for the Goddess to accept the cup, and grant her prayer to belong to Paris. She presents herself as a species of Eve:

Each twin breast is an apple sweet. . . .

Mine are apples grown in the south,
Mine are apples meet for his mouth.[57]

Venus, laughing, grants Helen's plea; Paris is smitten with desire, and the fate of Troy is sealed.

By the summer of 1869, Rossetti was hard at work on another ballad, called "Eden Bower." Once again the subject was Lilith. Before she was woman, she was snake:

Not a drop of her blood was human,
But she was made like a soft sweet woman.

She was the first to be driven out of Eden:

With her was hell and with Eve was Heaven.

Out of raging jealousy, she persuades the snake, with the promise of her body, to tempt Even.

> To thee I come when the rest is over;
> As snake I was when thou wast my lover.[58]

Clearly, before she was Lilith she was Lamia, and ultimately responsible for the Fall.

Lilith was an obscure figure in the nineteenth century, with no long literary or visual tradition such as attaches to Salome. Rossetti's choice of name for his version of the fatal woman is curious to say the least. No doubt the initial idea came from Goethe, but there is no mention of Lilith's snake-form in his *Faust*. Rossetti might have been directed to sources of information by his friend F. G. Stephens, an editor of the *Athenaeum* and one of the original Pre-Raphaelite Brotherhood. Stephens, writing a memorial to Rossetti long after the artist's death, stated that Rossetti "got a hint of the subject from that delightful repository of whim, wit and learning, *The Anatomy of Melancholy.*" From this passage in Burton and others from Shelley, he continued, "the painter-poet was able to educe in solid form his notions of the fair and evil-hearted witch, who, as a sort of Lamia, had originally been formed like a serpent."[59]

But Burton, in his chapter on demons, included nothing about Lilith's snake-form. He remarked only that "The Talmudists say that Adam had a wife called Lilis before he married Eve, and of her he begat nothing but devils."[60] Nor does Shelley mention Lilith as serpent. More likely Rossetti, interested from childhood in the Old Testament, gleaned this image from a new encyclopedia of Biblical iconography published in 1864, and revised the following year in one of Rossetti's favorite periodicals. This reference gives full information about the snake-Lilith of Jewish folklore.[61]

In Lilith's promise of sexual love to the snake in the garden there is a faint echo of Swinburne's "Felise," whose name captivated the speaker in the poem before he saw her:

> I said "she must be swift and white,
> And subtly warm, and half perverse,

> And sweet like sharp soft fruit to bite,
> And like a snake's love lithe and fierce."[62]

By the time Rossetti completed this series of paintings and poems, he like Swinburne seems to have forsaken "the lilies and languors of virtue/For the roses and raptures of vice."

The apple, reiterated over and over by Rossetti in both his art forms, makes manifest the origin of the femme fatale in Eve, author of Original Sin, even though, before the fall, "with her is Heaven." But the deadly nature of the women in Rossetti's paintings is hardly blatant, consisting as it does of euphemisms for sex and danger. His work, at least until the publication of his *Poems and Ballads,* more overtly sensual, remained within the outer limits of Victorian respectability.

To some extent this assured his commercial success. Curiously, though he exhibited almost not at all, his work commanded a wide and admiring audience. He was constantly beseiged for replicas of his major paintings. He was also frequently asked for photographs of his work, and herein may lie one clue to the growth of his reputation. Several famous photographers were among his close friends: William Stillman, Barbara Bodichon, Lewis Carroll, Julia Cameron. Charles Eliot Norton and George Eliot (who was his neighbor on Cheyne Walk in Chelea) both purchased photographs of his paintings.[63] In other words, photographic reproductions may have been one means through which possible patrons and other artists became familiar with Rossetti's work. For instance, the correspondence between Rossetti's *Lady Lilith* and Courbet's *Portrait of Jo,* Whistler's mistress (fig. 35), has produced the suggestion that Courbet might have seen a photograph of Rossetti's painting.[64]

In any event, Rossetti's style deeply affected his contemporaries, as also did Swinburne's. Whether Swinburne was encouraged to see fatality in Woman by Rossetti's visual images, or whether Rossetti was encouraged to "fatalize" his painted women by Swinburne's poetic Woman as Dreadful Destiny is in the long run less important than the double impact of their work on their time. As in a *folie a deux,* the imagination of each seems to have stimulated the other to even greater flights of fancy. The convergence of their imagery linked them in the public mind

in a single school of thought, criticized as both "fleshly" and "aesthetic."

John Morley used the word "fleshly" in his condemantion of Swinburne's poetry in 1866. He was followed by Robert Buchanan in 1871, who, writing first under the pseudonym, Thomas Maitland, attacked both Swinburne and Rossetti in "The Fleshly School of Poetry" published first in *Contemporary Review,* and later as a pamphlet under his own name. "We get very tired," wrote "Maitland,"

> of this protracted hankering after a person of the other sex; it seems meat, drink, thought, sinew, religion for the fleshly school . . . whether he is writing of the holy Damozel or of the Virgin herself, or of Lilith, or Helen, or of Dante, or of Jenny the streetwalker, he [Rossetti] is fleshly all over, from the roots of his hair to the tips of his toes; never a true lover merging his identity into that of the beloved one; never spiritual, never tender; always self-conscious and *aesthetic.* "Nothing," says a modern writer, "in human life is so utterly remorseless—not hate, not love, not ambition, not vanity—as the artistic or aesthetic instinct morbidly developed to the suppression of conscience and feeling.[65]

Buchanan's identification of the "fleshly" portrayal of the "sensual" woman in poetry or painting with immoral aestheticism is total. As in Rossetti's poetry, so in his painting:

> There is the same thinness and transparency of design, the same combination of the simple and the grotesque, the same morbid deviation from healthy forms of life, the same sense of weary, wasting, yet exquisite sensuality; nothing virile, nothing tender, nothing completely sane; a superfluity of extreme sensibility, of delight in beautiful forms, hues, and tints. . . .[66]

From these statements we may assume that for Buchanan, insistence on the "beautiful" at the expense of other qualities is "morbid" and destroys the art. "Fleshliness. . . ," he stated, "is a quality which becomes unwholesome when there is no moral or intellectual quality to temper and control it."

Buchanan went on to explain fully the manner in which the fleshly and the aesthetic are bound together:

> . . . The fleshly gentlemen have bound themselves by solemn league
> and covenant to extol fleshliness as the distinct and supreme end
> of poetic and pictorial art; to aver that poetic expression is greater
> than poetic thought, and by inference that the body is greater
> than the soul, and sound superior to sense; and that the poet,
> properly to develop his poetic faculty, must be an intellectual
> hermaphrodite, to whom the very facts of day and night are lost
> in a whirl of aesthetic terminology.[67]

In this passage Buchanan used "fleshly" and "aesthetic" as
though they were nearly synonymous in meaning. Further, the
"fleshly school" had but one subject, the sensual woman, and
that subject one no "good" poet would dwell on, since "good"
poetry should forever be based on "profound meaning," by
which we may assume he meant a moral. He condemned particu-
larly such poems as Rossetti's "Eden Bower," which "contained
not one scrap of imagination; a clever grotesque. . . ."

> No good poet would have wrought into a poem the absurd tradi-
> tion about Lilith; Goethe was content to glance at it merely,
> with grim smile, in the great scene in the Brocken. We may remark
> here that poems of this unnatural and morbid kind are tolerable
> only when they embody a profound meaning.[68]

Lilith, at any rate in Rossetti's version, seems to have been
born out of the remorseless "aesthetic" instinct, devoid of con-
science; that is, virtue.

Buchanan purported in his essay to defend the national
morality from that "fever-cloud generated first in Italy (by
Aretino) and then blown westward, sucking up on its way all
that was most unwholesome from the soil of France."[69] His
sweeping denunciation included not only nearly all Italian and
French literature, the poetry of Swinburne and Rossetti, but
also much of Tennyson, Browning, and William Morris—as well
as their followers. He may have had a personal as well as critical
ax to grind. Swinburne, William Rossetti, and others of their
circle, had been unanimous in their denigration of Buchanan's
poetic product for some years preceding the pamphlet. The
opinions expressed, and the anonymous form of the first publi-
cation of the review, evoked a wide-spread exchange of printed
epithets that lasted for some years.[70]

The merit—or source—of Buchanan's argument in favor of morality in art aside, he offered it in support of contemporary mores. His attitude therefore represents the feelings of the lay public of his time. However some poets and painters may have disagreed, Buchanan expressed the conventional wisdom: the fleshly school and the aesthetic movement were one and the same, and the primary product of its adherents was Lilith—the quintessential femme fatale.

The English version of the full-fledged femme fatale, in other words, is part of an overall shift of artistic theory that took place in the wake of the Pre-Raphaelite movement. Rossetti, Swinburne, Morris and Burne-Jones extricated themselves first from academic restriction on subject matter and then from Ruskin's—and Hunt's—insistence on "nature" as controlling source of art. These men all contributed to the shift of the predominant theory of art from the definition of art as imitation, in the classic sense of *mimesis,* with all of its didactic overtones, to the Aesthetic ideal of "art for arts's sake." They shared a mood in which they began to portray more and more an inner rather than an outer landscape. The growing squalor of the exterior world helped substantially to stimulate this refocusing of vision, and the rapid industrialization of Europe in the nineteenth century bore a major responsibility for the nostalgic evocation of a fabled past so characteristic of most Romantic art.

Some artists, like Turner, used the remaining visible landscape as a replacement for the civic ideal of classic art. That is, the lessons of ethics and heroism inherent in history painting and sculpture based on the classic ideal were preached instead by mountains, waterfalls, and ultimately a single perfect blossom or leaf of grass. Ruskin, more than most, was an articulate exponent of this point of view. An avid draughtsman, he eulogized the wonders of nature in meticulous renderings of scenery ranging from panoramic views to details of tiny clumps of vegetation. In his letters and diaries he wrote at length about the experience that comes to every art student—the marvelous moment, after much struggle, of "getting it right," the moment when the drawing "works." For Ruskin, the moment was far more than one of mere technical achievement. It was one of mystic revelation, of connection with the "source of sublimity" in Nature.[71]

The Wordsworthian accents of such attitudes are unmistake-able, and are descended from Edmund Burke's celebration of the Sublime, Uvedale Price's description of the *picturesque* Sublime. Rossetti, working first with Ford Madox Brown, then with Hunt, finally becoming Ruskin's protogee, was initially as enamored as they with the pursuit of the "natural," as distinct from the con-ventional artifices of academic painting. As he matured, how-ever, he moved from his mentors' compulsory observation of nature increasingly to observation of his own inner life.

He never moved completely away from the observed to the imaginary subject. His titles, settings, and space are those of the world of dreams, but the bodies, clothing, jewels and flowers of his compositions were based on detailed observation of objects in front of him. This disconcerting combination, with the sym-bolism so prominent in his work, gives his work the atmosphere of Mannerist "emblem" painting, and was the feature that in-duced the later Aesthetes to champion him as leader. That cham-pionship is perhaps best demonstrated by the famous story of Oscar Wilde traversing the streets of London with a Rossettian lily in his hand.

Rossetti himself repudiated the Aesthetic label.[72] On the other hand, he espoused no very clear aesthetic theory of his own. His friend Hall Caine recalled the artist lying on a couch and ruminating for hours at a stretch, and in explanation com-menting that art was based on "fundamental brainwork."[73] One can only suppose the artist planned his work in his head before taking up pen or brush. This sort of preoccupation is of course common among creative people, but hardly constitutes a theory of art. Precisely the absence of any coherent doctrine made Rossetti claimable, so to speak, as leader by any number of wildly different creative people—as for instance, Swinburne, Morris, and Burne-Jones.

Rossetti found it impossible to follow Ruskin's insistence on the moral basis of the arts, and this divergence undoubtedly contributed to the flagging of their friendship. At no point, how-ever, did Rossetti openly espouse an Aesthetic position as ex-treme as Swinburne's, that which so greatly distressed Ruskin in later life. Swinburne's position, expressed first in his *Notes on Old Masters,* then in his rebuttal to Morley in 1866, came to full

fruition in his *Essay on Blake.*

> Art is not like fire or water, a good servant and bad master; rather the reverse. She will help in nothing. . . . Her business is not to do good on other grounds, but to be good on her own. . . . The contingent result of having good art about you and living in a time of noble writing or painting may no doubt be this: that the spirit and mind of men then living will receive on some points a certain exaltation and insight . . . which of course implies . . . advantages of a sort you may call moral or spiritual. . . . But if the artist does his work with an eye to such results, he will too probably fail even of them. Art for art's sake first of all, and afterwards we may suppose all the rest shall be added to her (or if not she need hardly be overmuch concerned). . . .[74]

The rejection of traditional moral or didactic purpose in art inherent in this passage forms the heart of the Aesthetic theory, and resulted directly from the ideas that Swinburne shared with—or possibly learned from—Poe, Gautier, and Baudelaire. Proper Victorians, as well as artists who shared Ruskin's views, found it profoundly offensive. Buchanan obviously was of their number.

Swinburne published his poetry several years before Rossetti, and was the first to be condemned as fleshly. His work therefore bears the initial responsibility for the definition of the sensual or seductive female as both immoral and fatal. His "Hermaphroditus" may have produced some of the public's confusion of hermaphrodite with femme fatale, as witness Buchanan's comments that her makers were intellectual hermaphrodites. Since their names were linked in both literary and lay circles, Rossetti also was charged with the responsibility of "fleshly" art. The "Pre-Raphaelite woman" whose iconography he established became the standard visual image of flesh—and fatality.

Rossetti's great outpouring of portraits of women with legendary names is usually understood as the result of an extraordinary obsession on the part of the painter. He may indeed have made his art out of profound psychological need. But in spite of critical opprobrium, and almost no public exhibition, Rossetti made a great deal of money as a painter. His work was

distinctly popular. That very popularity raises the clear proba-
bility that, far from being isolated in a deep-seated neurosis,
Rossetti merely expressed a central psychological conflict of his
time. It was one he shared, if not with most men, certainly with
his patrons. If making his art was therapeutic for him, contem-
plating it was therapeutic for his buyers.

So much has been written about the devastating effect of
Victorian morality on sexual and psychological health in the in-
dividual that it is hardly necessary to dwell on it here. Suffice
it to say that Rossetti paid obeisance in his painting to the shib-
boleths of his patrons by avoiding explicit nudity, or even em-
phasis on seductive dress. He did skirt perilously close to the
edge of propriety by painting women with expressions and pos-
tures of moderately explicit erotic invitation. He managed, that
is, to respect his buyers' inhibitions at that same time that he
titillated them—and possibly himself. His work pleased his
patrons in one of the murkier areas of their souls—and he shared
that pleasure, which in turn bears no small measures of responsi-
bility for the earnestness and conviction of his work. Unlike
some forms of erotic art, his was not produced tongue in cheek.
Rossetti, like the women he painted, saw no humor in his sub-
ject.

One of Rossetti's biographers did not find Praz's "Fatal
Lady" in Rossetti's work, since the more extreme perversities
were inapplicable to him, and his primary sexual interests were
"really quite ordinary."[75] Most authors would disagree with
this analysis of the content of Rossetti's art, but this is an other-
wise important point. Leaving aside the definition of "ordi-
nary," Rossetti's sexual attitudes were certainly *usual* for his
time.

Multiple replicas of such compositions as *Beata Beatrix,*
based on drawings of his dead wife, and of *Proserpina,* for which
Jane Morris modeled, give weight to the opinion that Rossetti
was neurotically obsessed with the women he loved. The half-
dozen versions of *Beata Beatrix* in particular lend credence to
this view, especially given the sensational character of Elizabeth's
Siddall's death. There is no doubt that he dearly loved his Lizzie,
and mourned her deeply. But there is considerable evidence
that he was far from crippled emotionally by her death, or

haunted by her memory. Rather than being inactive, he began a period of great productivity not much more than a year after she died. Poetry, paintings, replicas of paintings, all flowed briskly from his hand from 1863 until his breakdown in 1871.

The half-dozen versions of *Beata Beatrix,* produced over a period of some years, far from being the result of his own initiative, were each started at the behest of someone else. Rossetti took up the first version in 1863, at the urging of Howell, then his agent. Howell had found the unfinished painting of Lizzie, evidently started some time before her death, in a battered and dirty condition in Rossetti's studio. First Howell refurbished the canvas, and then undertook to persuade the artist to take it up once more.[76]

Coaxed to do so, Rossetti immediately sct about to find a buyer—*before* beginning work on the canvas. His letters suggcst that this was in accordance with his established procedure. He invariably wrote to several patrons to describe drawings and suggest their purchase or a commission for a painting of the subject. Each of the replicas was commissioned by a favored patron; the implication is that Rossetti responded to the marketplace in his choice of subject at least as much as to his own psychological needs.

As with *Beata Beatrix,* so also with *Proserpina* (fig. 36), often described as a work expressing Rossetti's longing for Jane Morris, whom he loved, and from whom he was frequently separated for long stretches of time. The first studies of the work, which also exists in several versions, are dated 1871, and William remarked that the subject was originally intended to be Eve holding the apple—a favorite subject for Rossetti, "converted by afterthought" into Proserpina.[77] Possibly Swinburne's poems, "Hymn to Proserpina," and "Garden of Proserpina," included in his 1866 volume of poetry, inspired Rossetti to emulation; Rossetti wrote a sonnet for this as for others of his paintings. But, as he began work on one replica of *Proserpina,* he wrote his brother that it was "very well started, and I fully expect to finish it soon and bag the tin." "Tin," from his youth on, was his favorite word for money.[78]

Rossetti's marketplace mentality existed in relation to

many of his paintings, those that are unique as well as those that
exist in replicas. When he wrote his mother in 1866 that he had
"been working chiefly on the Toilette picture," he added that he
had "engaged [it] some time ago to a Mr. Leyland of Liverpool
for 450 guineas, and hope to send it to him by the end of Sep-
tember."[79] The sale obviously preceded the work. He followed
the fine old-fashioned practice of extricating payment for work
in progress from prospective buyers and shared their Victorian
mercantile delight in money.

 This is not to say that he was wholly and unremittingly
venal in regard to his painting, but that the businesslike manner
in which he accumulated a substantial quantity of worldly goods
has not generally been brought into perspective with the nature
of his work. By shortly after 1860, his income reached more
than comfortable proportions, and his work was much sought
after, often by several buyers at a time. This casts a wholly dif-
ferent light on his subject matter than the details of his biogra-
phy. If he was painting for the market, so to speak, he was pro-
ducing works that pleased the upright conventional mill-owners
and business men who were his patrons—not to mention their
wives and children. Clearly he had to respect their views.

 Nor was he more crassly commercial than other artists of
the day. Oppé has pointed out that the number of replicas pro-
duced by academicians—in the interest of increasing their stan-
dard of living—during the middle decades of the nineteenth cen-
tury had reached the proportions of a "scandal." If Rossetti
seemed more concentrated on his income than others, it was
merely because "he had not the traditional English reserve in
speaking of matters of money."[80] He produced replicas, ac-
cording to his brother, because as a "non-exhibiting artist," he
had "necessarily to rely on a small and close circle of purchasers:
and . . . these purchasers were in general more anxious to secure
such specimens of his art [his half-length females] than to com-
mission work of any other class."[81]

 Rossetti took pains to protect himself from charges of
participating or lending approval to whatever the respectable
world might consider immoral. When Swinburne's *Poems and
Ballads* was published in 1866, reports circulated that Tennyson
believed Swinburne's less attractive proclivities were a product

of his "intimacy" with Rossetti. The latter immediately wrote to Tennyson to disabuse him of the notion. "As no one delights more keenly in his genius than I do," he said, "I have also a right to say that no one has more strenuously combated its wayward exercises in certain instances."[82] For a man whose subject matter in painting was almost entirely limited to enticing women, and whose poetry was focused on the delights of love, he was remarkably averse to others' celebration of similar delights. His prudery was not limited to disavowal of responsibility for Swinburne's "waywardness"—he also "detested" what in his day was called "Ettyism"—paintings of idealized nudes.[83]

Rossetti's paintings, poems, letters produce a picture of someone beset with multiple conflicts. He welcomed, and when young needed, the championship of a man like Ruskin, but could not long tolerate Ruskin's authoritarian temperament. During his youth he was revolutionary and rebellious, instrumental in creating a new direction in English art. But in later years he referred to the Pre-Raphaelite Brotherhood as the result of "the visionary vanities of half a dozen boys."[84] On the rare occasions when he thought in terms of politics, his instincts were conservative. For example, in 1848 he wrote a burlesque epic on the Chartist march on London, called *The English Revolution of 1848*—never published. Late in his life, when his brother William composed sonnets defending Irish democratic revolutionaries, Rossetti became profoundly anxious. He wrote to Lucy, William's wife:

> the consequences are absolutely and very perilously uncertain when an official of a monarchical government allows himself such unbridled license of public speech . . . [he brings upon himself] the clear possibility of absolute ruin. . . .

And to William he remarked, "I cannot see the force in your arguments."[85]

This is not to say Rossetti was not serious about his art or deeply committed to conveying his feelings and ideals to his audience. But over-emphasis on the "ideal" quality of his work obscures his commercial success and moreover the extent to which Rossetti in his social, sexual and political values, was a quite ordinary man—an average Victorian gentleman. His

brother, in fact, called him a "typical John Bull."[86]

Her certainly shared contemporary attitudes toward the female of the species. In 1870, in reply to a question from his friend and fellow poet, Thomas Hake, Rossetti wrote:

> You ask me about Lilith—I suppose referring to the picture-sonnet. The picture is called *Lady Lilith* by rights . . . and represents a *Modern Lilith* combing out her abundant golden hair and gazing on herself with that self-absorption by whose strange fascination such natures draw others within their own circle. The idea which you indicate (viz: of the perilous principle in the world being female from the first) is about the most essential notion of the sonnet.[87]

Note that Hake is the one who suggested the all peril resides in the female; Rossetti has simply agreed.

Rossetti's fantasies of women and sex are embedded in his work, and illustrate quite clearly that he adhered to an inhibiting Victorian sexual code every bit as much as the more prosaic persons around him. The very restrictions of "middle class morality" evoked in his psyche as in others, a familiar circular syndrome: the conflict of prohibition and desire. He created a body of work in which the erotic elements are implied rather than direct, in what must have been conscious respect for contemporaneous ideas of decency. In doing so he invented a visual iconography which more and more emphasized woman as sex object, and because she was "forbidden," she became ever more dangerous and mysterious.

Rossetti's adherence to conventional morality glimmers through his *Stealthy School of Criticism*, written in response to Buchanan's attack. Swinburne, rebutting criticism years earlier, had been at pains to uphold his right to follow wherever his Muse led, without concern for whether or not his verse was fit for maidens:

> the office of adult art is neither puerile nor feminine, but virile; its purity is not that of the cloister or the harem; all things are good in its sight, out of which good work may be produced.[88]

Rossetti, in defending his work against charges of immorality, did not bring forward a claim to artistic freedom; he maintained, rather, that his poetry *was moral.*

The sonnet "Nuptial Sleep" had roused Buchanan's particular ire. Said the critic:

> Here is a full-grown man, presumably intelligent and cultivated, putting on record for other full-grown men to read, the most secret mysteries of sexual connection, and that with so sickening a desire to reproduce the sensual mood, so careful a choice of epithet to convey mere animal sensations, that we merely shudder at the animal nakedness.[89]

This charge most deeply wounded Rossetti as poet. In his rebuttal he condemned the cowardly "pseudonymous" form of Buchanan's review in a few short sentences, and then leaped immediately to his major concern: demolishing the accusation that he confused body with soul, and extolled sensual delight as equal to spiritual. "Nuptial Sleep," he said, was not a "whole poem" but a sonnet-stanza, the whole poem being *The House of Life.* Anyone, he said, reading the other sonnets, would know immediately that:

> one charge it would be impossible to maintain against the writer of the series . . . that is, the wish on his part to assert that the body is greater than the soul. For here all the passionate and just delights of the body are declared—somewhat figuratively, it is true, but unmistakeably—to be as naught if not ennobled by the concurrence of the soul at all times.[90]

This exchange casts on important light on the essential agreement between poet and critic on a major point: body and soul *are* separate, and unmitigated sensuality is, in Buchanan's words, "simply nasty."

Rossetti, in other words, was far more hostage to the value system of his time than Swinburne, less inclined to declare artistic or personal freedom from it. Swinburne labored under no such inner compulsion to respect the sacred cows of his environs and compatriots. His 1866 volume of poems was a deliberate confrontation with Victorian mores. He had certainly been

advised and warned of the probable result by most of his friends, not the least of whom was Rossetti.

But, like Rossetti, he always struggled to behave as the proper English gentleman. Stung by the report that he had had the temerity to introduce himself when young to the "famous" Rossetti, he denied it vehemently in later years. That, he said, was something he never would have done, especially in his "nonage." He was *properly introduced* by a mutual friend. Remember this, wrote Lafourcade, and be aware that "Swinburne's Muse will always preserve a vine-leaf of respectability."[9][1] Swinburne and Rossetti, like Gautier and Baudelaire, were unconventional men, producing novel forms of art, while preserving conventional social attitudes. They succeeded in highlighting and accentuating Eve as a symbol of temptation and sin, and adding to her the deadly threat of Lilith, Helen, Cleopatra. All four concentrated on the female as "the perilous principle in the world." This was concomitant with their espousal to a greater or lesser degree (with Gautier at one pole and Rossetti at the other) of the principle that Art justified any subject. Their subject and theory combined to lead to an identification of the deadly female with the "Aesthetic" idea.

These men established the *type* of the femme fatale. The femme fatale as stereotype entered the arts in their wake, in the enormous flowering of Art Nouveau, Decadence, and Symbolism. The stereotyping began almost as soon as the form itself was established.

NOTES

[1] John H. Cassidy, *Algernon C. Swinburne* (New York: Twayne Publishers, 1964), p. 39.

[2] Cecil Y. Lang, ed., *The Swinburne Letters,* 5 vols. (New Haven: Yale University Press, 1959), vol. 1, p. 53.

[3] Evelyn Waugh, *Rossetti* (London: Duckworth, 1928), p. 119f.

[4] Lang, *Swinburne Letters,* Introduction, p. xxxvi f.

[5] Georges Lafourcade, *Swinburne, a Literary Biography* (New York: Russell and Russell, 1932), pp. 54-55.

[6] *Ibid.,* p. 70.

[7] Henry Treffrey Dunn, *Recollections of Dante Gabriel Rossetti and His Circle,* edited and introduction by Gale Pedrick [1904] (London: New York: AMS Press, 1971), p. 23. Rossetti seems to have been in error since no such volume is known.

[8] Thomas V. Moore, "A Study in Sadism: The Life of Algernon Charles Swinburne," *Character and Personality* 6 (1937), p. 6.

[9] W. M. Rossetti, *Rossetti Papers,* p. 206.

[10] John Morley, "Mr. Swinburne's New Poems," *Saturday Review,* August 4, 1866, no. 562, vol. 22, p. 145.

[11] *Ibid.,* p. 145.

[12] Algernon C. Swinburne, *Poems and Ballads,* Third Series (London: Chatto and Windus, 1889), p. 175. All quotations from Swinburne's poetry from this edition.

[13] *Ibid.,* p. 177.

[14] *Ibid.,* p. 191.

[15] *Ibid.,* p. 192.

[16] *Ibid.,* pp. 185-186.

[17] Morse Peckham, in the introduction to Swinburne's *Poems and Ballads* (Indianapolis and New York: Bobbs-Merrill, 1870), pp. xxviii, xxix.

[18] Morley, p.

[19] Swinburne, "Notes on Poems and Reviews," (London: John

Camden Hotten, 1866), p. 12.

[20] Swinburne, *Letters,* vol. 1, p. 12.

[21] Swinburne, *Poems and Ballads,* pp. 88, 89, 119f.

[22] Swinburne, "Notes on Poems and Reviews," p. 10.

[23] Swinburne, *Poems and Ballads,* p. 89.

[24] *Ibid.,* p. 90.

[25] Swinburne, "Notes on Poems and Reviews," p. 14.

[26] Swinburne, *Poems and Ballads,* p. 263.

[27] Algernon C. Swinburne, "Notes on Old Masters at Florence," *Essays and Studies,* 3rd ed. (London: Chatto and Windus, 1888), p. 316.

[28] *Ibid.,* pp. 319-320.

[29] *Ibid.,* p. 353.

[30] *Ibid.,* p. 354.

[31] D. G. Rossetti, *Letters,* vol. 2, p. 529.

[32] Lafourcade, pp. 112, 193.

[33] D. G. R., *Collected Works,* vol. 1, p. 288.

[34] Quoted in Surtees, vol. 1, p. 92.

[35] D. G. R., *Collected Works,* vol. 2, p. 281.

[36] *Ibid.,* vol. 1, p. 216.

[37] D. G. R., *Letters,* vol. 2, p. 656.

[38] William Rossetti and Algernon Swinburne, *Notes on the Royal Academy Exhibition* (London: John Camden Hotten, Piccadilly, 1868), p. 46.

[39] D. G. R., *Collected Works*, vol. 1, p. 215.

[40] W. M. R., *Designer and Writer*, p. 56.

[41] Ronald W. Johnson, "Dante Rossetti's *Beata Beatrix* and the *New Life*," *Art Bulletin* 57, no. 4 (December 1975), p. 549.

[42] *Ibid.*, p. 556.

[43] Baum, *House of Life*, p. 27.

[44] David Sonstroem, *Rossetti and the Fair Lady* (Middleton, Connecticut: Wesleyan University Press, 1970), p. 86.

[45] D. G. R., *Letters*, vol. 2, pp. 643, 647.

[46] D. G. R., *Collected Works*, vol. 1, p. 357.

[47] F. L. Fennell, Jr., *The Rossetti-Leyland Letters* (Athens, Ohio: Ohio University Press, 1978), p. 7.

[48] D. G. R., *Letters*, vol. 2, p. 602.

[49] A. E. Street, "George Price Boyce R. W. S.," *Architectural Review*, vol. 151 (1899), p. 52.

[50] D. G. R., *Collected Works*, vol. 2, p. 469.

[51] R. Elzea, *The Samuel and Mary Bancroft and Related Pre-Raphaelite Collections* (Wilmington: Delaware Art Museum, 1978), p. 112. Quoted from a letter written by Fairfax Murray to Samuel Bancroft, September 6, 1893. Their correspondence at the time of the Metropolitan Museum's purchase of the small replica makes interesting reading. Bancroft was outraged that the Metropolitan staff considered its example superior. See E. Carey, "The New Rossetti Watercolor in The Metropolitan Museum," *The International Studio*, 135:125-130, 1909; and R. Ross, "Rossetti, An Observation," *Metropolitan Museum Bulletin*, 1908, for opposing viewpoints.

[52] See for instance the *Illustrated London News*, Saturday, July 9, 1864, p. 48; February 16, 1864, p. 154; February 20, 1864, p. 194; October 29, 1864, p. 571.

[53] W. M. R., *Designer and Writer*, p. 52.

[54] *Ibid.*, p. 22.

[55] D. G. R., *Collected Works*, vol. 1, p. 360.

[56] Surtees, vol. 1, p. 92.

[57] D. G. R., *Collected Works*, vol. 1, p. 306.

[58] *Ibid.*, vol. 1, p. 308f.

[59] Frederick G. Stephens, *Dante Gabriel Rossetti*, Portfolio Monographs (London: Seeley & Company, Ltd.; New York: Macmillan Company, 1894), p. 67.

[60] *Ibid.*, p. 67.

[61] John Kitto, D. D., F. S. A., *A Cyclopedia of Biblical Literature*, 3rd ed. enlarged and improved, ed. William Lindsay Alexander, D. D., F. S. A., etc. (Edinburgh: Adam and Charles Black, 1864), pp. 834-835.

[62] Swinburne, *Poems and Ballads*, p. 218.

[63] W. M. R., *Designer and Writer*, p. 523.

[64] Alistair Grieve, "Whistler and the Pre-Raphaelites," *Art Quarterly* (Summer, 1971), pp. 220-223.

[65] Robert Buchanan, "The Fleshly School of Poetry," *The Contemporary Review*, vol. xviii, August-November, 1871 (October, 1871), p. 343. (Under the pseudonym of Thomas Maitland.)

[66] *Ibid.*, p. 336.

[67] *Ibid.*, pp. 334-335.

[68] *Ibid.*, p. 349.

[69] *Ibid.*, p. 334.

[70] D. S. R. Welland, in his anthology: *The Pre-Raphaelites in Litera-*

ture and Art [1953] (Freeport, New York: Books for Libraries Press, 1969), offers excerpts and a bibliography of the decade long controversy. See in particular pp. 207-208.

[71] See John Ruskin, *The Diaries of John Ruskin: 1848-1873,* ed. Joan Evans and John Howard Whitehouse (Oxford: Clarendon Press, 1958), especially vol. 2.

[72] Helen Rossetti Angeli, *Dante Gabriel Rossetti* (London: Hamish Hamilton, 1941), p. xx.

[73] Caine, *Recollections.*

[74] Algernon Swinburne, *William Blake: A Critical Essay* (London: John Camden Hotten, 1868), p. 91.

[75] Sonstroem, p. 203.

[76] Surtees, vol. 1, pp. 152-153.

[77] W. M. R., *Designer and Writer,* p. 80.

[78] D. G. R., *Letters,* vol. 3, p. 1092.

[79] *Ibid.,* vol. 2, p. 602.

[80] A. Paul Opee, "Art," *Early Victorian England,* pp. 101-170, vol. 2 (London: Oxford University Press, 1934), p. 127.

[81] W. M. R., *Designer and Writer,* p. 70.

[82] D. G. R., *Letters,* vol. 2, p. 607.

[83] Waugh, p. 136.

[84] Caine, *Recollections,* p. 81.

[85] D. G. R., *Letters,* vol. 4, pp. 1864-1865.

[86] W. M. R., *Designer and Writer,* p. 135.

[87] D. G. R., *Letters,* vol. 2, p. 850.

[88]Swinburne, *Notes on Poems and Reviews,* p. 4.

[89]Buchanan, p. 338.

[90]D. G. R., *Collected Works,* vol. 1, pp. 481-482.

[91]Lafourcade, p. 67.

CHAPTER 7

THE BIRTH OF A STEREOTYPE
GUSTAVE MOREAU AND EDWARD BURNE-JONES

While Eve was metamorphosing into Lilith in London, she was being transformed into Salome in Paris by the painter Gustave Moreau. Put differently, the rise—or descent—of the "fatal figure of the woman" to the level of stereotypical femme fatale took place at the hands of those labeled "aesthetic" in England, and, eventually, "decadent" in France. Both words were in vogue well before the coalescence of art movements that acquired the words as titles. As the word "aesthetic" was being attached to writers like Swinburne in during the 1860's, the word "decadent" was beginning to circulate widely in Paris.

The pervasive notion of a culture in decline gained literary and artistic impetus in France from the upheaval of the 1848 revolution, perceived by many of the creative community as a disaster. Even earlier, Thomas Couture's famous painting *Romans of the Decadence* (1847), a scene of classic orgy, was well received, and generally understood to reflect current French society.[1] Defenders of classicism condemned as decadent such writers as Baudelaire, who retaliated in kind. He called them "unenigmatic sphinxes who keep watch before the doors of classical Aesthetics," and championed Poe as a practitioner of "Decadent literature."[2] Gautier, in turn, considered Baudelaire's poetry to be a superb example of the "style of the decadence," which was an essential style under contemporary conditions:

> The final stage is reached when language is required to express everything and is stretched to the ultimate point of tension. One may recall, in connection with it, the Latin of the lower empire, gamy and already blotched with the greenish hues of decomposition, and the intricate refinements of the Byzantine school, the ultimate form taken by Greek art after it had fallen into de-

liquescence; but such is truly the inevitable and necessary idiom of those nations and civilizations in which artificial life has superseded natural life.[3]

The comparison of Baudelaire's language with that of Byzantium must have struck Moreau's mind with some force. His painting, usually described as the visual counterpart of Flaubert's novels, can just as readily be interpreted as analogue to Baudelaire—or, for that matter, Gautier. Moreau's work seems almost to illustrate Baudelaire's theory of correspondence, to create a synaesthetic experience for the viewer: shapes and colors that have sound and scent as well as visibility. The layered detail, the shimmering surfaces and the proliferating symbolism of his paintings were constructed, as Praz would have it, out of the "aesthetics of Baudelaire and the music of Wagner."[4]

Moreau occupies a peculiar middle position between the uncompromising academicism of some of his contemporaries and the eventual complete rejection of academic dictates espoused by others such as Degas. Until recently he was considered a relatively obscure and insignificant figure in the rapidly changing field of the visual arts in the Paris of his day. He was born in 1826 to a family of means, who encouraged his devotion to the arts, and was not hindered in his career by the necessity to make a living. His primary importance has long been considered to be that, late in life—in 1892, just six years before his death—he became a teacher at the Ecole des Beaux-Arts, and numbered major figures such as Matisse and Rouault among his students.

Moreau's praise and favor were given to the grand tradition of didactic history painting, his scorn to genre subjects. As a teacher, he told his students:

> Do not forget that art must uplift, ennoble, improve moral standards. Whatever Gautier may say, art can lead to religion (I refer here to no particular orthodoxy) and to true religion, the only kind to deserve the name, which uplifts the soul and guides its workings towards an ideal of beauty and perfection.[5]

Indeed the track of Renaissance and Baroque classicizing models in his work is one of its more salient—and curious— components. His debt to Poussin as well as Delacroix, to Raphael as

well Leonardo, Mantegna, and Botticelli, is reflected in his drawings and subjects. He traveled to Italy and drew after the masters in time-honored fashion; the titles of his paintings are often those typical of Salon contributions, drawn from the Bible, classical myth, and literature. The classicizing contrapposta is the basic element of his figure composition, and the immoble structure in most of his work illustrates his intention to create the "stille Grosse und edle Einfalt" that Winckelmann praised in ancient art.

Yet his most famous paintings, those of Salome beginning in 1876, are a nearly total departure from the principles of classicism. The traditional Christian subject, the perspective system, and even in some instances the symmetrical balance of classical art, are contradicted by scale and surface. Instead of a receding series of planes behind the principles figures, scaled to the viewer, the architecture towers above them, creating a gloomy and mysterious atmosphere not unlike a Piranesi prison. Moreau's surfaces are bejewelled and bespangled with sharp contrasts of color, lighting and decorative detail, abrogating the dictates of simplicity and clarity of surface, volume and gesture prescribed by theoreticians from Alberti forward.

The disconcerting effect these paintings have on the average viewer results largely from this eccentric union of classicizing composition and anti-classic decoration. Add to this the frozen trance of the figures, locked into place by static lines of structure, barely discernible beneath the jewels, and the overall scenes are ones from which the life has not merely been drained, but deliberately banished. For instance, in *Salome Dancing Before Herod* in oil (fig. 1), and *The Apparition* in watercolor (fig. 9), both exhibited in the Salon of 1876, the background is composed of repeated horizontals and verticles, which enclose and lock the space into complete stillness. The same compositional structure was used in an oil replica of *The Apparition* (fig. 37). Though the arms and drapery of Salome, in both, create diagonal lines, these are in balanced opposition, forming a rigid architectonic equilibrium.

Des Esseintes, in Huysmans' novel *A Rebours*, likened Salome in the Dance to an idol, the "goddess of Immortal hysteria," belonging to the "ancient theogonies of the Far East."

She was inhuman, outside feeling, outside time itself. But Salome in *The Apparition* is less of an idol, more of a woman. The goddess has merged into the courtesan, and is "perhaps even more troubling to the senses."

> In this, she was altogether more feminine, obedient to her tempera-
> ment of a passionate cruel woman; . . . awakening more powerfully
> the sleeping passions of man; bewitching, subjugating more surely
> his will, with her unholy charm as of a great flower of concupis-
> cence. . . .[6]

Truth to tell, however, both Salomes, either confronted with the severed head of the saint, or dancing to win that head, are iconic, remote, immeasurably beyond attainable womanhood for the man viewing the pictures, and perhaps for that reason all the more alluring. Either before or after the beheading of John, the figure of Salome retains her absolute distinction from the common run of women.

Moreau's reputation must be credited to Huysmans more than to anyone else. After a mild early success in the Salons from 1864 to 1869, a year in which he was severely attacked by critics, he did not enter again until 1876, when these two paintings were among those exhibited. He first caught Huysmans' admiring eye in 1880, but never again submitted work to the Salon. So it was largely through the enthusiasm expressed in Huysmans' novel, published in 1884, that Moreau became the idol of the Symbolist poets.

Huysmans and others, such as Sâr Peladan, who founded the Salons of the Rose and the Cross in 1892,[7] championed Moreau as the ultimate in fashioner of Symbolist Woman. They already had an interior image of the woman who best exemplified their dark view of sexuality in the Decadence by the time they saw Moreau's work. They seized upon his paintings as the perfect pictorial expression of ideas already widely current. Moreau's work of the 1870's marks a peak, a culminating point at which the idea of the femme fatale had become widespread. The concept of Woman embedded in these works began to appear to some extent in Moreau's paintings of 1864 and several years following, those with which he achieved his first successes in the academic salons. *Oedipus and the Sphinx* (1864), *The*

Young Man and Death (1865), *Jason* (1865) and *Orpheus* (1866) most clearly demonstrate the beginnings of an oeuvre in which the female is threatening, the figures androgynous, and the somewhat Mannerist composition and space begin to separate Moreau's work from the technical conventions of salon painting at the time.

Oedipus and the Sphinx was painted in emulation of Ingres' earlier famous version of the subject, and possibly for that reason found the most favor with public and critics alike.[8] Both artists composed the subject of two figures, Oedipus at the right, Sphinx at the left, in the foreground of a rocky landscape. But Ingres' Oedipus is muscular, leaning forward thrusting his face challengingly toward a Sphinx who is shrouded by the rock edges of the opening of her cavern. He is aggressive and powerful, clearly anticipating victory in the encounter. Moreau's Oedipus is epicene, languid, leaning back, and the focus of the composition is the Sphinx, clinging to the young man's torso like a cat, claws grinding into his chest. *Her* chin is thrust out aggressively, *her* posture is strong and threatening.

In *Young Man and Death* (fig. 38), a memorial to Theodore Chasserieu, whom Moreau greatly admired, the idealized figure of the dead painter is again epicene—or, as is frequently said, androgynous. Instead of the figure of a skeleton that Moreau had initially planned to personify Death, the background is occupied by the languid, suggestive body of a woman, head bowed, crowned with poppies and asphodels, holding an hourglass in her hand.[9] Critics compared this figure of Death to various figures in Asian Indian art, then becoming familiar to Europeans through the importing of Indian miniatures.[10] If this is Atropos, Daughter of Night, as is also sometimes said, she is more closely related to sources nearer home. She bears a striking resemblance to many of Primaticcio's stucco figures decorating Fontainebleu. Her remote source is of course Michelangelo's Ignudi, adorning the celing of the Sistine Chapel. Her closest relative is Michelangelo's *Night,* in the Medici tomb at San Lorenzo in Florence. There can be no question that Moreau was familiar with all of these, since he had only recently returned from Italy when he painted this work. From the time he first saw the originals in 1857, the Ignudi were a life-long source of fascination for him. Years later he was still musing on the

somnambulistic quality that he saw in all Michelangelo's work. He considered this compositional device sublime, and the state of sleep-walking to be ideal. The figures seemed to him to be "arrested" in transit to another world.[11] The painting's atmosphere of not merely arrested motion, but arrested life, must have been born out of this admiring interpretation of the work of Michelangelo.

But if Moreau derived the dream state in which his figures exist, and some of their postures, from Michelangelo, the quality called androgyny that they possess had some other source. Michelangelo's "androgyny" is heavily muscular, and most of his figures appear more male than female to the average viewer. The smooth surfaces of the bodies of both male and female figures in Moreau's art, seemingly not only without muscle but also without bone, produced men and women in much of his work that are easy to confuse with one another. Whether one refers to his figures as androgynous for sexless, their relative lack of secondary sex characteristics actually serves to emphasize their sexuality, and distort it from what is conventionally considered the norm.

The work of Leonardo, represented lavishly in the Louvre, is also frequently cited as a source for the sexual ambiguity of so many of Moreau's figures, and an idex to the nature of his own sexuality. He apparently owned a reproduction of Leonardo's *John the Baptist* that hung in his home.[12] As a student he copied much of Leonardo's work, and many of the landscape backgrounds of his pictures utilize the rock formations, haze, and dreamy distance found in some of Leonardo's work. Certainly the face of the central figure in *Young Man and Death* is cast in a mold that can be called "Leonardesque."

This painting offers an interesting reversal of a popular late Gothic and early Renaissance theme: "Death and the Maiden." The subject had its most probable origin in the popular fifteenth century "Dance of Death," in which each member of society is invited into the dance, and was rendered in drawings, woodcuts, engravings and paintings by a wide variety of French, Flemish and German artists, among them Nicolas Manuel-Deutsch, Hans Baldung-Grien, and Dürer, not to mention Holbein, in his masterful *Dance of Death.* Many of these are perversely erotic in con-

tent, showing Death as a skeletal seducer, caressing the Maiden. In Moreau's painting, the sexes are reversed, and the act of seduction absent, but the eroticism, implicit in the sensual treatment of the flesh, remains. Other interesting elements demonstrate the extraordinary range of Moreau's erudition and experience; the cherub who holds the lamp is obviously a reference to the standard personification of Death in Hellenistic tomb sculpture: the youth with an inverted lamp.[13]

Apart from a revealing glimpse of Moreau's art-historical experience and information, the most intriguing facet of this work is the impulse that lay behind the artist's personification of Death as woman. The traditional depiction of Death, from the classic, is male, with the attributes of Saturn: the scythe; or of Cronus: the hourglass. In this painting, Moreau produced an early version of woman as the, not merely perilous, but *fatal* principle in the world, one that became more increasingly marked in his Salomes, Delilahs, Messalinas a few years later.

In *Jason* (fig. 39), also exhibited in 1865, Moreau's prototype was less antique, and his symbolism somewhat less obvious. He owed more than a little to Mantegna for this work. The figure of Jason is reminiscent of several figures in Mantegna's *Parnassus,* in the Louvre since 1801 (fig. 40). Moreau's Jason stands in a manner similar to that of Mercury, on the far right in *Parnassus.* Mantegna's Venus and Mars, on the promontory of rock toward the center top of his work, provide a particularly interesting comparison to Moreau's group of Jason and Medea. It is as though Moreau has given Jason the character of Venus, and Medea that of Mars.

The moment of the myth that he chose, according to Moreau's own commentary on the picture, is the point at which Jason seizes the fleece.[14] Ovid, in the *Metamorphoses,* described Medea—behind Jason in the painting—as additional spoils for the conquering hero. Medea, as depicted by Moreau, is ambiguous in the extreme. Her posture is that of Eve, her genitals hidden by flowers and foliage, traditional in many Gothic and Renaissance renditions, and she has the snake of Eve coiled on her arm. She is both seductive and dangerous, and if she is part of the victor's spoils, she is a dubious gift.

Orpheus, exhibited in the Salon of 1866, portrays the static figure of a standing woman, head bent over the lyre on which rests the head of Orpheus the Bard (fig. 41). The overall atmosphere conveys something of the effect of a Greek funerary stele, in which the deceased and mourners are bent, grave, and remote, frozen in the postures of melancholy rather than grief. But the subtitle of the painting, "Thracian girl carrying the head of Orpheus," implies the aftermath of a Bacchanale. The woman's stance is classicizing, but the setting, with rock formations like those of Mantegna's *Parnassus,* hints at a primeval landscape. Moreau did at least six versions of this work, in both watercolor and oil, and repeated the theme in a similar composition called *Salome with the Head of John the Baptist* in 1876.[15] Years before, Gautier had foreseen the potential of the Thracian girl with Orpheus' head for translation into the Biblical story of the Baptist. The head of Orpheus, he wrote in *Le Moniteur,* reviewing Moreau's painting in 1866, is "like John the Baptist's head on a silver platter in the hands of Herodias."[16]

The story of Salome on which Moreau based his paintings is not Biblical, but rather a complex narrative with multiple sources, some in folklore, some in poetry, and some in the visual arts. In the Biblical story, Salome has no name at all, but is simply referred to as the Daughter of Herodias, and neither of the two women is afflicted with lust for the Baptist. Herodias' daughter functions merely as the passive instrument of her mother's revenge on John, who had condemned her marriage to Herod as unlawful (Mathew 14:1-12). The first alteration of the Biblical story into its nineteenth century form was one in which Herodias, not Salome, became inflicted with lust for John the Baptist. One undoubted source for Herodias' passion was Heinrich Heine's poem "Atta Troll," published in the French edition of his *Poems et Legendes.* Moreau, it is said, possessed an 1874 edition of this work.[17] But the idea was available and popular earlier, since Heine's works were collected in a French edition of his *Oeuvres complets* between 1852 and 1868. Perhaps Heine's story struck a spark with Gautier when he saw Moreau's painting of the Thracian girl. A number of French poets were enchanted with Heine's imagery, and utilized it both before and after the dates of Moreau's paintings.[18]

In Heine's poem, Herodias' appearance is brief and non-

Biblical. She is described as afflicted with "bloody love" for the Baptist, and she carries his bodiless head about with her after the execution, kissing and caressing it, tossing it in the air like a toy.[19] A long tradition of interchangeability of the names of Herodias and Salome led first to the application of "Herodias" to the dancer, and then to inserting her lust into her daughter's —Salome's—character. In other words, the transformation of Salome from obedient daughter to principal actor in the story resulted from a fusion of the identities of Herodias and Salome.

A passing reference in Browning's "Fra Lippo Lippi," published in *Men and Women* in 1855, illustrates the fusion. The prior of the abbey, looking at Lippi's painting of Salome and the head of John, tells the painter:

> Oh, that white smallish female with the breasts,
> She's just my niece . . . Herodias, I would say,—
> Who went and danced and got Men's heads cut off!
> Have it all out![20]

The prior does not like the painting, needless to say, and Browning goes on to put words of rebuttal in the artist's mouth. The fusion is one that marries an iconographic tradition of Renaissance painting with a nineteenth century literary theme.[21] In Italian painting she who danced was always Salome; in literature she who lusted was Herodias. Here they are one and the same.

Praz suggested that a popular German folk tale inspired Heine.[22] This tradition may also have induced Fuseli to interpret Salome as Bacchante; in addition Moreau quite probably saw Fuseli's drawing—which was made for a French edition of Lavater's writings on physiognomy. These were still popular in the 1860's. Swinburne referred to them, in passing, as did Baudelaire in his *Intimate Journal*. One of his maxims on Love gives instructions on selecting a lover:

> Your mistress, the woman of your paradise, will be sufficiently indicated to you by your natural sympathies, verified by Lavater and by a study of painting and statuary.[23]

And Swinburne, like Gautier, had already begun to perceive the

fatal nature of Salome in Florentine paintings—whether intended or not.

These paintings by Moreau are then more of a culmination of a long development than they are an innovation. He pulled together a series of ideas that were current, and created an image that synthesizes the sin of Eve, the blood lust of Herodias, and the ideal beauty of the Androgyne that is hieratic in posture and setting.

The hermaphroditic, androgynous, or sexless nature of both the male and female figures in Moreau's art has given rise to a vast amount of speculation as to the nature of his sexuality. If he was homosexual, as is often suggested, the evidence was well concealed during his lifetime. Some evidence does exist to suggest that he may have had a relationship of many years with at least one woman.[24] However, he clearly considered the "feminine" male figure to represent an ideal; and possibly, also the converse, the "masculine" female. The poet, for him, was invariably youthful, "of an antique beauty." For one of his male figures he wrote: "This figure must be completely draped and very feminine. It is almost a woman, who alone can understand the self-sacrifice and suffering of the poet."[25]

It should be clear that that terms: feminine, masculine, androgynous—were being used according to the nineteenth century understandings of those words, and not those in vogue today. Winckelmann's celebration of the adolescent of either gender (or both), the nineteenth century fashion for abundant flesh in women, and the polarized roles and appearance of men and women that were held to be correct, were all measures applied to any image, literary or visual. In an era during which emphatic gender characteristics were in general prized, bodies without them would automatically be seen as childlike—desirable to such as Gautier, sexless, or androgynous.

Slender lines and "dubious" gender characterize nearly all of Moreau's women; few are even as conventionally female in appearance as his Medea, who seems barely beyond puberty by nineteenth century standards. Only an occasional female approaches the opulence of the siren in his *Poet and Siren,* a late work of 1893, which perhaps most clearly expresses the sexual

attitudes of a whole generation of men. The monumental figure of the woman, surrounded by her cloak of hair, gazes with concentrated menace on the poet at her feet, who seems to be drawing his last breath. Around them both, his cloak, and strange toxic-looking plants, are splashed on the canvas surface in broad heavy strokes of brilliant red paint as though they were smears of blood.

Moreau may have agreed with Baudelaire that "fat" women are the joy of schoolboys: "leave these falsehoods," said the poet, "to the neophytes of the pseudo-romantic school. If the fat woman is sometimes a charming caprice, the thin woman is a well of sombre delights."[26] Moreau certainly agreed with Baudelaire that women had no business in the creative professions, once remarking that "the serious intrusion of women into art would be an irremediable disaster."[27] In his extensive commentary for his unfinished canvas *The Chimeras,* he wrote that woman is:

> in her primal essence, an unthinking creature, mad on mystery and the unknown, smitten with evil in the form of perverse and diabolical seduction. . . . Dark, terrible, deadly chimeras, the chimeras of space, of the waters, of mystery, of darkness and dream.[28]

He never married, apparently convinced that an artist should be committed to his calling as to the priesthood, and remain alone, perhaps celibate. But like many of his contemporaries, he was at once repelled and fascinated by Woman. His recorded remarks and commentaries on his paintings have laid him open, like Baudelaire, to charges of the most profound misogyny.

His work has a close parallel in that of Edward Burne-Jones, coming into public prominence at almost exactly the same date. Burne-Jones' *Beguiling of Merlin* (fig. 41), shown first at the Grosvenor Gallery in London in 1877, was one of several he exhibited in Paris at the Exposition Universelle in 1878, and marked the beginning of the growth of his French reputation.[29] The painting was not popular with the public, but received wide critical acclaim, and by the time another decade had passed, he was championed with Moreau by the poets of the Symbolist movement as one of the "masters of symbolic representation."[30]

The surface of this painting, unlike the typical brushwork of Moreau, has an enamel-like polish. The artist placed his emphasis on the sinuous line that locks the composition into place. But like Moreau, he has used the contrapposta, an embellished setting, and intensity of gaze between the protagonists to create a close, still, almost airless atmosphere. The sway of Nimue's body, the curving branches of the hawthorn tree, evoke an initial impression of movement greater than any in Moreau's paintings, but the foliage lines circle and confine the composition, so that the movement is only on the surface. The figures are imprisoned and immobilized, just as Merlin was enchanted, forever, by the siren's song. Burne-Jones, apparently, adhered to principles of design quite like those of Moreau's inevitably quoted "necessary richness" and "beauty of inertia."

The parallel ideas of these two men make the viewer wonder if they might have been familiar with each other's work before the 1880's, by which time Burne-Jones was widely popular in France. Further, how well-known the Pre-Raphaelites were in general in Paris is an intriguing question. Phillippe Julian implied that they may have had considerable effect quite early on. The Moxon edition of Tennyson's poems, he said, carried the style right across the European continent.[31]

To a great extent, however, the parallels between Burne-Jones and Moreau seem to have arisen from their interest in similar ideas and their adherence to similar artistic values. The most important influence on Burne-Jones was Rossetti; his mutated version of Pre-Raphaelite ideals was the core of Burne-Jones' style from first to last.

Ned, as his friends called him, had been intended, like Swinburne, for the profession of clergyman. He was drawn to the visual arts first by his friendship with William Morris, and then by his hero-worship of Rossetti. The structure and content of his early drawings and paintings are strikingly close to Rossetti's style—paint surface, figure and composition, in most of his work, is nearly identical to that of his mentor. His subject matter—Malory, Tennyson, Arthurian legend—owes much to his inclusion in the second generation Pre-Raphaelite group. He also shared their delight in the Gothic novel. A pair of early gouache paintings entitled *Sidonia and Clara von Bork* (1860) illustrate

his debt to the latter both in style and content. The paintings portray standing female figures in interiors reminiscent of Rossetti's, beholden to Flemish art. The figures fill the canvas, and the gowns are richly decorated in a Italianate pattern.[32]

The subject is a familiar one: paired paintings illustrating the dual nature of Woman. The figures are two sisters from Meinhold's *Sidonia the Sorceress*, published in 1849, long a favorite with Rossetti. Clara was virtuous, destroyed by her sister Sidonia, who was evil. Meinhold's character was based on the biography of a seventeenth century noblewoman, accused in legend of witchcraft, convicted, beheaded and burned. Sidonia, according to the tale, desirous of marrying the Prince of Pomerania, vowed revenge when he married another. She "caused sterility in many families," and the death of the "whole reigning family of Pomerania."[33]

Possibly Meinhold's description of portraits of Sidonia from the "school of Kranach" inspired not only Burne-Jones but many another artist painting fatal women:

> . . . a gold net is drawn over her almost golden yellow hair, and her neck, arms and hands are profusely covered with jewels. The bodice of bright purple is trimmed with costly fur, and the robe is of azure velvet . . . [she is very beautiful, but] not pleasing in the mouth, particularly, one can discover an expression of cold malignity.[34]

By no means all of Burne-Jones' work concentrated on such subjects, but evil women did crop up with a fair degree of regularity. Nimue, who bewitched Merlin, and Morgan le Fay, appear among his early water colors, side by side with victims: Fair Rosamund, Cinderella, Ariadne.

By the end of the decade of the 1860's Burne-Jones had shifted to a more classical interest in subject, though not in style. In 1869 he exhibited *The Wine of Circe* at the Old Water Colour Society, an event that marked the beginning of his independent reputation and success. The work was castigated by the *Art Journal,* but greeted with delight by Burne-Jones' fellow artists, in particular Rossetti, who wrote a sonnet for it.[35] More significant, the work marked the beginning of the association of

this artist with the Aesthetic Movement. Frederick Leyland, the wealthy ship-owner who was patron of all the Pre-Raphaelites, in particular Rossetti, purchased the painting, which became an important element in what is described as an "aesthetic" interior being planned for the home of its collector/owner.[36]

Among the more remarkable of Burne-Jones' femmes fatales is the figure of Phyllis in *Phyllis and Demophoön,* exhibited at the Old Water Colour Society in 1870 (fig. 43). The threat to the male is not part of the story illustrated by the painting, but is rather implied in the postures and expressions of the principal actors. The story comes from Ovid, and relates that Phyllis, suffering from an unrequited love for Demophoön, was turned into an almond tree through the pity of the gods. When Demophoön discovered this, he embraced the tree, which then suddenly blossomed.

In the painting, Phyllis emerges from the tree in an almost exact reversal of the fate of Daphne in the story of Apollo and Daphne: the bark has split, and Phyllis is growing out of the trunk, her hair extending from the branches and leaves. Rather than sharing a joyful embrace with her, Demophoön turns away as she leans forward, almost as though he were struggling to get free. His face shows apprehension and grief, mixed with a tinge of resignation.

This particular work was the object of an anonymous complaint to the Society when it was exhibited, and Burne-Jones was asked to remove it and replace it with something more suitable, one suspects, for family viewing. The source of agitation was the full frontal nudity of Demophoön, which provides a sharp contrast to the modestly draped figure of Phyllis. Burne-Jones, outraged, withdrew the work and sent his formal letter of resignation to the Society, saying:

> The conviction that my work is antagonistic to yours has grown in my mind for some years past, and cannot have been felt only on my side—therefore I accept your desertion of me this year as the result of so complete a want of sympathy between us in matters of Art, that it is useless for my name to be enrolled amongst yours any longer. . . . In as grave a matter as this I cannot allow any feeling except the necessity for absolute freedom in my work to move me.[37]

His position has a surprisingly modern ring, carrying all the earmarks of a contemporary rejection of censorship in the arts. He did not sustain so intense a level of defiance. Something over ten years later, he repeated the subject in 1882 on a larger scale in an oil called *The Tree of Forgiveness* (fig. 44). In this work, Phyllis is nude, Demophoön sports a coy knot of drapery over his genitals, and his expression has moved from apprehension to terror. Most intriguing is the absence of genitalia in the figure of Phyllis. She is as though carved from marble, and truly representative of one variety of the "androgyny" prized by the Symbolists.

For the figure composition of both these paintings, Burne-Jones may have had recourse to Botticelli. The group of Phyllis and Demophoön is almost a mirror image of Zephyr and the nymph on the viewer's right in Botticelli's famous *Primavera*, seen by Burne-Jones on several occasions, during his trips to Italy. The painting in the National Gallery in London entitled *Apollo and Daphne* would also have been familiar to him; this was frequently attributed to Botticelli in the past, but is now more usually accepted as by Pollaiuolo.[38] Botticelli was on Burne-Jones' list of favorite artists, together with Michelangelo, Mantegna, Andrea del Sarto, and after his third trip to Italy in 1871, Orcagna, Uccello, and Piero della Francesca.[39]

The *Beguiling of Merlin*, begun in 1872 but not completed until 1877, was one of eight works of his included in the opening exhibition of the Grosvenor Gallery in May of 1877. The Gallery, established by Sir Coutts Lindsay, was deliberately intended to provide exhibition space for artists disdained by the Royal Academy. The first exhibit has been called an opening gun of the Aesthetic Movement;[40] but this had in fact been discussed at least as early as Buchanan's review in 1871.

Though not intended to compete directly with the Academy, the gallery did so with great success, adding immeasurably to the standing of the artists who exhibited there. The paintings by Burne-Jones were particularly noticed, and after the first exhibition his wife wrote: "From that day he belonged to the world in a sense of that he had never done before, for his existence became widely known and his name famous."[41]

Nimue, occupying the foreground of *The Beguiling of Merlin,* is more overtly fatal than is usual in Burne-Jones' work. Snakes twist in her hair, which flows across her shoulder; the twisted bark of the tree behind her repeats the writing line. At the left rear, an aged Merlin seems slowly to subside earthward, sinking into his permanent trance. While the subject is medieval, the style is not. The figures, the line, the enchanted atmosphere, place Burne-Jones firmly among a group known as the "quattro-centists" associated with the Grovesnor. From this point forward the name of Botticelli was reiterated over and over in connection with Burne-Jones. When the Grosvenor Gallery opened, wrote one scholar, "the Botticelli cult was in full swing," begun by Swinburne and Rossetti, and "encouraged" by Ruskin and Pater.[42]

Botticelli's imaginative settings and elegant line were the elements of his art that evoked Burne-Jones' emulation of him as well as others like Mantegna. But his focus on these traits rather than the "natural" and "simple" characteristics of Quattrocento art admired by Ruskin evoked that gentleman's displeasure. Years earlier, as benefactor, Ruskin had tried to turn his protogee's eye and hand to a different approach to study. According to Lady Burne-Jones:

> Ruskin was distressed by Edward's plan of work, which did not include the kind of study he considered essential; whilst imagination —Edward's life-breath—he mistrusted and looked at as a thing which could be used or laid down at pleasure. An object must be copied exactly by a student, no matter what it was, and good was to come of the copying.[43]

In the early phases of their friendship, Burne-Jones struggled to please Ruskin, but frequently, as his wife commented, the "rebel revealed itself in his pupil." Burne-Jones, even more than his mentor Rossetti, whose influence on him Ruskin distrusted, turned more and more to the inner world of imagination, and the expressive power of line and color, rather than the virtuous truth of nature (as Ruskin saw it).

The shadowed eyes and hollow cheeks of both male and female figures that characterize much of Burne-Jones' work may have been one cause of disquiet for Ruskin. They did not appear

before 1862, but were frequent thereafter. During that year, Edward made his second trip to Italy under Ruskin's patronage, and made a number of copies of Italian paintings at Ruskin's request. Among them were works of Tintoretto, in particular the head of Bacchus in *Bacchus and Ariadne.* Possibly this, as has been said, was one source for Burne-Jones,[44] but Octave Mirbeau did not think so:

> Those bruised eyes are unique in art, one cannot tell whether they are the result of onanism, saphism, natural love or tuberculosis![45]

Bacchus, or Dionysus, is an androgynous deity, often depicted as such in Renaissance art. Ruskin's request that Edward pay particular attention to this picture might have aroused his interest in pictorial representation of that type. Their growing differences of opinion, however, probably diminished Ruskin's influence on Burne-Jones. As Burne-Jones' own native bent asserted itself, those differences precipitated an open break between them. The occasion was Ruskin's lecture on Michelangelo in 1870. Ruskin attacked Michelangelo on moral as well as artistic grounds, and also attacked those who admired him. He read the lecture out loud to Edward before delivering the address, and years later the artist was still hurt:

> He read it to me just after he had written it, and as I went home I wanted to drown myself in the Surrey Canal or get drunk in a tavern—it didn't seem worth while to strive any more if he could think it or write it.[46]

Though their friendship was eventually patched up, it never again became close. To some extent this quarrel marks Burne-Jones' ever-increasing independence from the earlier models that had aided in forming his style.

Swinburne's poetry was a source much closer to home than Italy for arousing Burne-Jones' interest in pictorial representation of androgyny. They were life-long close friends after they met at Oxford in 1857. Undoubtedly the painter knew all of the poet's work, essays as well as verse. And Swinburne, as we know, found Hermaphroditus representative of the highest beauty. In 1866, defending his four sonnets on the subject, he wrote:

It is incredible that the meanest of men should derive from it any
other than the sense of high and grateful pleasure. Odor and
colour and music are not more pure. How favorite and frequent
among the Greeks was this union of the sexes in one body of per-
fect beauty, none need be told.[47]

In a footnote to his quotation from Shelley's *Witch of Atlas,*
he elaborated ironically the notion that only the dirty-minded
find lasciviousness in the image:

It is well for us that we have teachers (reviewers) able to enlighten
our darkness, or heaven knows into what error such as he [Shelley]
or I might fall. We might even, in time, come to think it possible
to enjoy the naked beauty of a statue or picture without any virtu-
ous vision behind it of a filthy fancy; which would be immoral.[48]

In this passage and this attitude, Burne-Jones would have
found encouragement to incorporate the Greek, and therefore
classic, ideal in his figure style, and to vindicate it from charges
of immorality. In most of his work after 1870, he favored
slender figures in which emphatically female or male characteris-
tics were absent, giving them, like Moreau's, the label of
Androgyne.

An additional source for this kind of ambiguity may have
been, also like Moreau's, the work of Leonardo da Vinci. In
Burne-Jones' *Depths of the Sea* (1886), the lethal mermaid who
drags the drowning man to the ocean floor has a face that is an
amalgam of Leonardo's *John the Baptist* with a *Mona Lisa*
smile (fig. 45). The face is also like that of the Virgin in the
famous cartoon of *The Virgin and St. Anne,* now in the collec-
tion of the National Gallery in London. This work, though not
acquired by the museum until 1962, was in the possession of the
Royal Academy from 1779, and therefore available for anyone
to see in London.[49] Today, the drawing is displayed alone in
its own gallery, facing a row of benches where the viewer may sit
to contemplate the work in reverence, as though in a church pew.

Burne-Jones' interest in ambiguity in the human form
stemmed less from disturbed or unusual sexual proclivities than
from a deliberate espousal of the principle of Beauty. He never
clearly defined what he meant by Beauty, though he often ex-

tolled it. "Two things," wrote his wife, "had tremendous power over him—beauty and misfortune—and far he would go to serve either; Beauty, so much rarer than misfortune, he was quick to recognize in spiritual form as well as physical."[50] His life-long wish, rarely fulfilled, was to paint "in situ" on the grand scale, and to realize immense schemes of decoration in order for "the common people to see them and say "Oh!—Oh!"[51] He always had in mind "large schemes of work, "huge cloudy symbols of a high romance" that included "The Chariot of Love," "The Sirens," the "beginning of the world, with Pan and Echo and the sylvan gods," the whole story of Troy, and the Four Ages of the universe.[52]

He found the beauty that he aspired to create in the imagination, and for him, as for Baudelaire, it was always strange. It existed in a world designed with architectural firmness and peopled with silent souls held in place by contours sometimes resembling the armature of stained glass. The firmness of design and line may have evolved out of his nearly life-long exposure to the technical demands of designing glass, book engravings, and tapestries for the firm established by William Morris. The subject matter, he himself said more than once, was an extension of the ideas of Rossetti. "Georgie" Burne-Jones, remarking on her husband's loneliness in his work during the last ten years of his life, quoted him as saying:

> The worst of it is I've no longer Rossetti at my back—he has left me more to do than I've the strength for, the carrying on of his work all by myself.[53]

That work seems to have been, at least in part, the preservation of that elusive thing we call Beauty in art.

Burne-Jones thus forged a unique and highly personal style out of a series of strong influences on his development. To the tilted heads and languid air of Rossetti's women, the curvilinear design of Blake's drawings, were added the clarity of design of Florence and something of the color of Venice. The abundant foliate and floral backgrounds of his works owe much to medieval woodcuts and *mille fleur* tapestries.

His work derives its characteristic atmosphere from his use

of the time-honored concept of "invention" as well as from his own celebration of imagination. His invention consisted of the special blend of glowing color with line, stable structure, and decorative surfaces that, combined, flatten his space and create the sense of suspended animation that came to such a high point in his *Briar Rose* series. While his subjects, and the essentials of his technique, are quite different from Moreau's, the general effect of the works of the two men is quite similar. Robert Ironside has quite accurately called the art of both "conceptual," an art in which the forms are vehicles of interior visions.[54]

The closest affinity of such mannered work is of course Mannerist. Like the sixteenth century Mannerists, both artists —as well as Rossetti—combined multi-faceted symbols to form works of esoteric meaning, verging on the complexity of sixteenth century emblem paintings. For the casual viewer the works offer an uncomplicated sensual delight in decoration, but for the more curious they offer a mystery that piques curiosity and commands analysis—an opportunity for intellectual games as well as a vision of a poetic personal world. This is the element most attractive to the Symbolists.

Within a few months of each other, Moreau had produced two of his Salome paintings, Burne-Jones had exhibited his *Beguiling of Merlin,* and Rossetti had completed his *Astarte Syriaca.* Together they comprise a definitive lexicon of the visual traits of the femme fatale, who might be said at this point to have reached her full maturity in the visual arts. In each case the lady had by this date made many appearances in the art of all three men, and remained a major component of their work. Within a short time, the lethal lady they produced became one of the most widely reiterated subjects in art.

The years from 1866 to 1870 have been called the "cradle" of the Symbolist movement, and the middle years of the 1880's their "flowering." A comprehensive list of periodicals devoted to the critical essays and poetry of the Symbolists shows the most important ones beginning to appear from 1881 on, among them *Le Chat Noir* (1882), *La Revue Independent* (1884), *Le Decadent* (1886) and *Le Symboliste* (1886).[55] These were the years when the art of Burne-Jones and Moreau reached great prominence among Symbolists, being championed as visual

counterparts of their poetry. But by this date, the femme fatale was already something of a cliche.

One avenue by means of which the femme fatale reached the proportions of a stereotype can be found in inexpensive and popular jewelry favored by women during the nineteenth century. In tracing the transition of cameo imagery from one popular image to another, Dora Janson found that the types moved from Medusa early in the century, through typical "sweet" faces, to a flowering of "Bacchante" types between 1860 and 1870. These were widely copied in cheap glass brooches.[56] A Bacchante, of course, tore off the head of Orpheus the Bard, and was Fuseli's contribution to the gestation of the femme fatale.

Walter Pater's *Studies in the Renaissance* (1873) offers the best-known synthesis of the ideas underlying the imagery developed during the 1860's and purveyed throughout Europe during the following decade. The volume includes his essay on Leonardo, first published in 1869, and his essay on Botticelli, first published in 1870, both in the *Fortnightly Review.* In his essay on Leonardo he wrote that the painting of the Medusa in the Uffizzi, hallowed in Shelley's poem, was a masterful "interfusion of beauty and terror." She was one of several examples of the type of "womanly beauty"—the "Daughters of Herodias"—that Pater said Leonardo favored.[57] The essay on Leonardo reaches its climax with the description of *La Gioconda,* that figure who is "older than the grave." About Botticelli, Pater remarked that the artist never painted the "Goddess of Pleasure . . . without some shadow of death in the grey flesh and wan flowers."[58] (What the artists in question would have thought of this characterization beggars the imagination!)

Pater himself acknowledged a heavy debt to Swinburne for both his ideas and his style.[59] To some extent he owed an equal debt to Rossetti, whose paintings seem to have conditioned him to perceive a monumental fatality in almost any portrait of a woman. Some years later, in his volume of *Appreciations,* he included a laudatory essay on Rossetti, whom he described as "in the words of Merimée, se passionnent pour le passion—one of love's lovers."[60] Rossetti, he said, created "a new order of phenomena . . . a new idea."[61] By 1880, to reiterate, the "enigmatic," dangerous smile of the Gioconda was part of the

fashionable demeanor of the *femme du monde*. Whether Pre-
Raphaelite or Gioconda-esque, it was chic to wear trailing gar-
ments, to appear fated, fateful, or fatal, to be, as Gautier said in
his reminiscences,"pale and greenish-looking; to seem consumed
by the effects of passion and remorse; to talk sadly and fanci-
fully of death."[62] The Romantic love affair with Death, it
would seem, was a necessary pre-condition for the evolution of
the femme fatale.

Even more than fashion or seriously intended art criticism,
satire aided in the growth of the idea as stereotype. George Du
Maurier, one of the best-known of *Punch* cartoonists, began his
campaign against the Pre-Raphaelites in 1866. In a series called
The Legend of Camelot he parodied the style, content, and com-
position of Hunt, Millais, Burne-Jones, and Morris, but above all,
Rossetti, using the illustrations of the Moxon edition of Tenny-
son's poems as his chief source.[63] One of the more important
results of public parody is, of course, a much wider dissemination
of the ideas and style of the original than might ordinarily have
occurred. The chief actress in Du Maurier's cartoons is clad in
loose flowing costume, long hair swirling, head tipped back with
arched neck, and the obligatory somber, soulful gaze: the Pre-
Raphaelite/Aesthetic woman.

Du Maurier followed this with his "Ballad of Blunders,"
satirizing Swinburne's newly published and vilified "Ballad of
Burdens," included in *Poems and Ballads*.[64] Both of these paro-
dies, beginning during the summer and fall of 1866, were evident-
ly inspired by the critical flap over Swinburne's poetry. About
three weeks before Du Maurier published his ballad, an anony-
mous squib was printed in *Punch,* under the headline: "Calling
a thing its Right Name":

> Having read MR. SWINBURNE'S defense of his prurient poetics,
> *Punch* hereby gives him royal license to change his name to what is
> evidently its true form—SWINE-BORN.[65]

Du Maurier's long campaign against the Aesthetic movement
emerged quietly in 1873, with a series featuring the Misses
Bilderbogie, dressed in anti-establishment trailing robes. Other
cartoonists, before and after, were also lampooning these cos-
tumes, and by 1881, Gilbert and Sullivan had joined the club;

their musical satire of Aetheticism, *Patience*, was produced that year. So extended an examination of an attitude and mood in the fine arts, in such popular forms, was instrumental in spreading the very ideas it attacked.

Walter Hamilton, collector of literary parodies, published a defense of the Aesthetic movement in 1882. Though the Aesthetes had their sillier moments, he maintained, they were to be admired for instituting a general improvement in the design of of homes, household items, and "Taste" overall. This, to him, was far more important than one of the things for which Aesthetic art was criticized: being "most peculiar" in its "portrayal of female beauty." He implied that the derision of "philistines" for ladies who imitated the ideal of the "pale distraught lady" with "matted masses" of "auburn hair, . . . emanciated cheeks . . . and long crane neck" was perhaps deserved.[66] Such a description ob-viously reflects an ill-tempered view of a Rossetti or Burne-Jones heroine. Burne-Jones, with Swinburne, received his own knocks at the hands of cartoonists in 1881 and 1882—one production copied his *Tree of Forgiveness*, and another created flowers out of his and Swinburne's heads, twin blossoms of a single plant—Flowers of "Culture."[67] Perhaps the author of this cartoon was alluding to Baudelaire's equally cultivated (unnatural) flowers.

A delightful verse quoted by Hamilton makes clear that the "Pre-Raphaelite woman" was considered lethal no matter what her guise:

A Female Aesthete

Maiden of the sallow brow
Listen, whilst my love I vow!
By thy kisses which consume;
By thy spikenard-like perfume;
By thy hollow parboiled eyes;
By thy heart-devouring sighs;
By thy sudden, pasty cheek;
By thy poses, from the Greek;
By thy tongue, like asp which stings;
By thy dress of stewed-sage green;
By thy idiotic mien;-
By these signs, O Aesthete mine
Thou shalt be my valentine.[68]

The consuming kisses and stinging, poisonous tongue of the vampire (snake) form of the femme fatale are as obvious as the sting of ridicule, and in this poem, the confluence of Pre-Raphaelitism, Aestheticism, and fatality, is complete. The fashion implied—to be clothed and seen "a la Grecque"—reigned in Paris as it did in London, and was equally parodied.[69]

Since Burne-Jones was decorator as much as painter, designing extensively for the firm established by his friend Morris (and Rossetti), the figure style he shared with Moreau became a staple of the arts and crafts movement. Through the medium of painted furniture, clothing, jewelry, the fundamental visual elements of the femme fatale became an international type. In advertising posters by Mucha and jewelry by Lalique, she survived well past the turn of the century.

The contributions of Morris' firm to the process are difficult to overestimate. His stimulation of the whole field of design and contributions to the general European style of Art Nouveau are only recently beginning to be understood. Through this medium, the "women and flowers" that Rossetti came to consider the only things worth painting were transmogrified into women who *were* flowers—lethal and seductive, as was Rappaccini's daughter. Hawthorne's Beatrice, however, did not *intend* to be fatal to her lover. The *will* to be fatal was added to the Woman by Pre-Raphaelites and Aesthetes.

The impact of the idea of the fatal woman on the most unlikely people shows quite well in a late painting by William Holman Hunt. For *The Lady of Shallot* (fig. 46) he resurrected a design he had used earlier in the Moxon edition of Tennyson's poems, and vastly increased the lethal emphasis. True to his own moral nature, however, he has made sure the lady is caught in her own toils. She is wound around and trapped in her yarn, which vibrates through the composition in an echo of her hair. The strands swirl behind her to encircle Adam, who reaches for the apple, in a medallion at the rear, about to Fall once again.

NOTES

[1] Kenneth Cormell, *The Symbolist Movement* (New Haven: Yale University Press, 1951), p. 212.

[2] Charles Baudelaire, "New Notes on Edgar Allan Poe," *Selected Critical Studies,* ed. D. Parmee (Cambridge: University Press, 1949), p. 117.

[3] Gautier, *Baudelaire,* translated by Guy Thorne, p. 19-20.

[4] Praz, p. 290.

[5] Quoted in Pierre-Louis Mathieu, *Gustave Moreau,* translated by James Emmons (Boston: New York Graphic Society, 1976), p. 219.

[6] Huysmans, pp. 52, 56.

[7] Milner, p. 72.

[8] Lucie-Smith, p. 63.

[9] Mathieu, pp. 91-92.

[10] *Ibid.,* p. 92. Possibly later critics were influenced by Huysmans, who likened Death in Moreau's work to Asian Indian examples.

[11] *Ibid.,* p. 58.

[12] *Ibid.,* p. 167.

[13] The chief source for the symbolism of death is Erwin Panofsky's *Tomb Sculpture* (New York, 1964). Other sources include Wilpert's Catalogue of Sarcophgi: *I Sarcofagi christani antiki* (1929-1930), and J. M. Clark, *The Dance of Death.* The earliest printed book of the poem is Guyot Marchant's *La Danse Macabre* (1486), available in a facsimile edition (Paris, 1925).

[14]Mathieu, p. 94.

[15]*Ibid.*, pp. 306-307, 323.

[16]*Ibid.*, p. 98.

[17]*Ibid.*, p. 126.

[18]Praz, pp. 300-301.

[19]Heinrich Heine, "Atta Troll," *Complete Poems of Heine,* translated by E. A. Bowring (London: George Bell & Sons, 1884), pp. 267-325.

[20]Robert Browning, *Men and Women* (Boston: Houghton-Miflin, 1886), p. 32.

[21]C. S. Vogel, "Browning's Salome: An Allusion in 'Fra Lippo Lippi'," *Victorian Poetry* 14 (Winter 1976), p. 348.

[22]Praz, p. 299.

[23]Baudelaire, *Intimate Journals*, p. 116.

[24]Mathieu, p. 163.

[25]*Ibid.*, p. 165.

[26]Baudelaire, *Intimate Journals*, p. 118.

[27]Mathieu, p. 164.

[28]*Ibid.*, p. 159.

[29]Edward Burne-Jones, *Paintings, Graphic and Decorative Work: 1833-1898,* Catalogue of the Exhibit, Arts Council of Great Britain, London, 1975, p. 51.

[30]Cormell, p. 142.

[31]Julian, p. 55.

[32]Burne-Jones, *Paintings*, p. 26.

[33] William Meinhold, *Sidonia the Sorceress,* 2 vols. (London: Simms and McIntyre, 1849), pp. viii-ix.

[34] *Ibid.,* p. ix.

[35] D. G. R., *Letters,* vol. 2, p. 816.

[36] Burne-Jones, *Paintings,* Catalogue, p. 44.

[37] Georgiana Burne-Jones, *Memorials,* vol. 2, p. 12.

[38] Michael Levey, *A Room-To-Room Guide To the National Gallery* (London, The National Gallery, 1972), p. 33.

[39] Georgiana Burne-Jones, *Memorials,* vol. 2, p. 26.

[40] Barrie Bullen, "The Palace of Art: Sir Coutts Lindsay and the Grosvenor Gallery," *Apollo* 102, no. 165 (November 1975), p. 355.

[41] Georgiana Burne-Jones, *Memorials,* vol. 2, p. 75.

[42] Bullen, p. 356.

[43] Georgiana Burne-Jones, *Memorials,* vol. 2, p. 18.

[44] John Gordon Christian, "Burne-Jones' Second Italian Journey," *Apollo* 102, no. 165 (November 1975): 334-337.

[45] Milner, p. 20.

[46] Georgiana Burne-Jones, *Memorials,* vol. 2, p. 18.

[47] Swinburne, "Notes on Poems and Reviews," p. 12.

[48] *Ibid.,* p. 12.

[49] Levey, p. 13.

[50] Georgiana Burne-Jones, *Memorials,* vol. 1, p. 309.

[51] *Ibid.,* vol. 2, p. 13.

[52] *Ibid.,* vol. 1, p. 308.

[53] *Ibid.,* vol. 2, p. 190.

[54] Robert Ironside, "Gustave Moreau and Edward Burne-Jones," *Apollo* 101, no. 107 (March 1975), p. 178.

[55] Cormell, p. 201ff.

[56] Dora Jane Janson, "From Slave to Siren," *Art News* 70, no. 3 (May 1971), pp. 49-51.

[57] Pater, *The Renaissance,* p. 135.

[58] *Ibid.,* p. 65.

[59] Swinburne *Letters,* Lang, in introduction, p. xvii; also vol. 2, p. 58.

[60] Walter Pater, *Appreciations, With an Essay on Style* (London: Macmillan Company, 1891), p. 235.

[61] *Ibid.,* p. 242.

[62] Quoted in Bruce, "Vamp's Progress," p. 355.

[63] Leonee Ormond, *George du Maurier* (London: Routledge & Kegan Paul, 1969), p. 176, Plates pp. 177-180.

[64] *Punch,* December 1, 1866, vol. 51, p. 227.

[65] *Ibid.,* vol. 51, p. 189.

[66] Walter Hamilton, *The Aesthetic Movement in England* (London: Reeves and Turner, 1882), pp. 24-25, 127.

[67] See *Punch's Fancy Portraits, Punch* (London, 1882).

[68] Hamilton, p. 25.

[69] Quoted in many sources; e.g., Praz's remark in reference to the Gioconda.

CHAPTER 8

THE LAST WORD

No one person "invented" the femme fatale, unless it was Goethe, who resurrected the half-forgotten figure of Lilith from ancient and medieval legend for the temptation of *Faust*. The concept gradually gathered momentum and glamor through the work of a series of artists, poets and critics who were the inheritors of a Faustian world-view. Eve, accruing an enormously intensified erotic and lethal power, might be said to have transmuted over several decades into Lilith—consort no longer of Adam, but of Satan. From inventing Original Sin, and the wages of sin—Death—she determined to seduce men into death.

Apart from the psychology of those who created her, a number of practical reasons for the rapid spread of idea and imagery existed in the middle years of the nineteenth century. One was the rapid growth of the field of design. Not only Burne-Jones contributed to the firm of William Morris; Rossetti filled many of its commissions. Another was the phenomenal growth of the publishing industry, not to mention photography, as part of the more general industrialization of Europe. The new technology, then as now, offered a means of rapid spread of any idea not possible in an earlier century. Far from the least contribution to the popularity of the femme fatale is the common human conviction that evil is always more *fun* than virtue.

All of the men who contributed so much to the compound imagery owed a considerable debt to the glimpse of Lilith offered to them by Goethe. Gautier, fascinated in equal parts by the East, the Germans, and the refinements of eighteenth century cultivated life, created a body of literature that was a well of ideas and a short-cut to the past for both his French and English contemporaries. Rossetti, of immeasurable importance in familiarizing his world with the work of Blake and Botticelli,

invented a visual iconography of compelling power. Two channels of tradition, extending through Gautier and Baudelaire in France, through Rossetti and Swinburne in England, mixed and intermingled in the works of Burne-Jones and Moreau to produce images of erotic evil of a new kind in the history of European art.

In many examples, the sharpened contrasts of unnatural brightness and darkness, intense colors, detail and movement, suggest a variety of states of altered awareness. They resemble, to a remarkable extent, the appearance of the environment to people in the changed perceptual condition of intense sexual arousal. The overall erotic meaning of the works portraying the femme fatale to their makers could hardly be more explicit. Whether in paint, poetry, or novel, in art forms made primarily by men for men, the lady exists only to fulfill her sexual destiny. The end result is an "iconic" image of Woman, who, in most of her forms, is as immobile and silent, as utterly remote, as the Sphinx she so often resembles. The artists who created her succeeded in creating also a vast distance between the image and the viewer. One is bound to wonder if the distance is not also the result of a need to create a wide separation between themselves and living women. Dead women, exotic women, embody a fierce and total rejection of living women.

The femme fatale is usually thought of as a primary product of Symbolists and Decadents, but as we have seen she was already a stereotype by the 1880's when the Symbolist movement was approaching its apogee. Visual images of the femme fatale from the last decades of the nineteenth century can be found in England, France, Germany, Austria, Scandinavia—and in some form of art at all times during the last century or more. The femme fatale appeared above all on the stage and in opera: Carmen, Salome, Venus. Sarah Bernhardt staged Wilde's *Salome;* Lilith entered the literary tradition. "Der Jüngling von Säis" wrote a verse history of the legends surrounding her in 1867; Edouard Rod, in 1889, created a modern Lilith in the guise of an English governess who resembled a Burne-Jones painting, and who stole the young French hero's soul.[1] George Macdonald, friend of the Pre-Raphaelites, published a novel entitled *Lilith* in 1895, and Paul Heyse included a novella of the same title with his short stories in 1898.[2] The femme fatale survived past the turn of the century to become the vamp of cinema, embodied in

such actresses as Theda Bara, who attempted to carry the impersonation into her private life.[3] Martha Kingsbury cited the appearance of the femme fatale in an extraordinary variety of popular advertising graphics during the *fin de siecle* and later, ranging from Gibson Girls to sheet music.[4]

The Cinema "vamp," short for vampire, entered the language at least as early as the phrase "femme fatale." The *Oxford English Dictionary* (1955) records its use in England by 1918, as a "woman who sets out to charm or captivate others from dishonest or disreputable motives by an unscrupulous use of sexual attractiveness." "Vampire," from which vamp is derived, may have entered the English language in 1734 from central Europe by way of Germany, in the wake of a rising tide of interest in folklore studies in German universities.[5] Vamp, either as vampire or femme fatale, or both, was in use in England before the given dictionary date; G. B. Shaw used it in his Preface to *Mrs. Warren's Profession,* published in 1902.[6] Evidently Shaw was sure that most readers would understand what he meant. The identification of vamp with femme fatale is quite clear from the dictionary definition: a vamp, obviously, is a femme fatale for beginners.

Dorothy Sayers offers one more morsel of evidence for the stereotypical nature of the femme fatale. In *Strong Poison* (1930) Lord Peter Wimsey first encounters Harriet Vane and falls in love with her, while she is on trial for the murder of an earlier lover. He undertakes to clear her of the crime, and at one point during the investigation, is exposed to the opinion his peers hold of the accused woman. The scene is a society luncheon givey by his mother, the Dowager Duchess:

> Captain Bates: "I mean to say, this woman, with no morals at all. . . ."
>
> Mrs. Dimsowrthy: "I thought she had rather a nice voice. . . ."
>
> Mrs. Featherstone: "Nice voice, Freakie? Oh no . . . I should have called it sinister. It absolutely thrilled me, I got shudders all the way down my spine. A genuine *frisson.* And I think she would be quite attractive, with those queer smudgy eyes, if she were properly dressed. A sort of *femme fatale,* you know. Does she try to hypnotize you, Peter?"[7]

Here, quite clearly, is a Burne-Jones painting brought to literary life. But a study of the development of the visual imagery of the femme fatale and her literary counterparts and sources does not answer the question posed by her enormous popularity and longevity. The image itself opens a series of Pandora's boxes out of which fly endless question about the sexual psychology of the individuals who created it and the culture in which they lived. Julian maintained that there is a close relationship between the flood of late nineteenth century images depicting the "erotic chimera," the "belle dame sans merci," and the then new publication of Krafft-Ebing's *Psychopathia Sexualis* (1886). Others might prefer—indeed have preferred—Freud, and described the femme fatale as an expression of male castration fears.[8]

Especially the repetitious element of the imprisoning, strangling hair of the femme fatale raises questions about the nature of the sexuality of the men who depicted it. That image reached the proportions of international male fetish by 1900. Hair, according to Krafft-Ebing, is one of the most common of sexual fetishes among men.[9] His monumental work helped to prolong the existence of the nineteenth century denial of normal female sexuality. However, he did attempt to reduce the prejudice against what was construed as sexual deviation in his day by describing it as pathology, rather than wilful sin.

Among his case studies is a group to whom he refers as "Hair Despoilers." According to his description a number of disturbed men attacked women in public with scissors, and ravished their hair instead of their bodies, in a manner reminiscent of Pope's *Rape of the Lock*.[10] Charles Berg, a more recent Freudian analyst, has offered an explanation of the underlying motive for such "rape." He published a lengthy book on the significance of hair in sexual pathology, maintaining that the hair of the head represents, on the unconscious level, the genitalia. The physiognomists of earlier times, he pointed out, considered thick, abundant hair in a woman to be a sign of the "wanton." Quoting Freud, he said that the "basis of fetishism is aversion to real female genitals."[11]

This variety of commentary would lend credence—may, in fact, have produced—the opinion that much of the art of the

second half of the nineteenth century was formed in the crucible of sexual obsession and pathology. The analysis implies that the work was produced by men afflicted with contradictory desires and oppressions. One might assume, as yet another psychiatrist, Wittels, has stated, that they suffer from the "Lilith neurosis." He explained:

> The existence of the feminine component and the wish to externalize this component, can well account for the popularity and success of the "vamp" or loose woman. Men who adore such types are consciously afraid of their feminine tendencies. . . . Often they fall an easy victim to a girl, who, through former marriages or public notices of her conduct in the tabloids, betrayed clearly her unwillingness to accept the role as housewife. Women who had poisoned, strangled, or in some other way murdered their husbands or lovers, were permitted to go scotfree and were thereafter inundated with proposals of marriage from every direction.[12]

Shades of Harriet Vane! The "wish to externalize the feminine component" might account, one supposes, for the Androgyne, for bisexual Madeleine/Theodore, for the "masculine" conquering Goddess or Siren, as in Rossetti's *Astarte* or Moreau's *Salome*. Wittel's analysis is loaded with implications; one idea among many being that the femme fatale (Lilith) is indeed the Jungian anima, that portion of the male psyche that is feminine, unacknowledged, threatening, and desirable.

The men discussed in these pages did, for the most part, share an "aversion to the female genitals" that might result in sexual conflict: the dread and longing that Horney detailed in such blunt terms. Rossetti's distaste for the exposed female body, Baudelaire's "horror" over "natural" woman, Gautier's disdain of erotic activity, the misogyny expressed by Swinburne and Moreau, even finds an echo in Burne-Jones, a much less flamboyant man. He seems to have shared his father's dismay over women who were "overfat or masculine."[13] He wanted his women always to be childlike, always "beautiful," and, like Ruskin, as he aged, preferred children to adults.

They were all, to put it differently, gifted and unusual men who shared feelings and ideas about women. The feelings may have been neurotic in origin, but the ideas permeated the society

in which they lived, and sprang from ancient tradition. In their art they were innovators, but in their social attitudes they participated in conservative opinion: the standard view of "woman's place." They did not like the "new woman," and were all variously alarmed, disapproving, scornful, condemning, of women who departed from the conventional ladylike docility prescribed by polite society. Rossetti, whose wife struggled to become an artist, and whose sister was a poet, might at first glance be expected to have had more tolerance for ambitious and independent women. But even he shared the conventional wisdom, reproving his sister Christina for occasional inappropriate masculinity, a "falsetto muscularity," in her poems.[14]

Swinburne, Moreau, Baudelaire, are all reported as expressing strong disapproval of "masculine" women, or women who engaged in "masculine" activities: writing, painting, other professions. Gautier had hardly any opinion of women whatsoever, reserving his admiration for dancers—the ballet. This, he believed, was truly and solely a *female* profession.[15] The separation of the spheres of masculine and feminine, for all of these men, was absolute.

But if one is to say they were sexually distrubed, even neurotic, then one is forced to say that a major aspect of the culture of Europe was equally neurotic. If they created an image based on neurotic sexual fantasy, that fantasy was nearly universal in Europe. The "icon" they made was so sought after and so cogent for their contemporaries that its label entered the language. And they shared their culture's values.

Explanation for the lasting popularity of the femme fatale must be sought in a wider arena than the individual psychology or sexuality of the artist. That the icon had social meaning and derivation is highlighted by the fact that it found great favor with many women as well as men. Women imitating the Gioconda smile, women attiring themselves in Pre-Raphaelite robes, women wearing the costume jewelry that gave them the air of Egypt, harem, sorceress, siren, and death were clearly responding to an attractive role model. Jane Burden Morris was photographed in the role (fig. 47); Sarah Bernhardt portrayed herself as fatal sphinx atop her own inkwell (fig. 48).

Possibly one might interpret the enormous popularity of the image among women as produced by a condition in which women were "co-opted" by a male value structure. While this may have contributed something to the popularity, I think one must assume rather more entered into it. Women adopted the appearance and demeanor of the femme fatale without necessarily adopting the lethal attitude. They were aspiring as much to the icon's independence as to her erotic power. She offered one of the few role models for women in the nineteenth century that combined freedom with fascination and erotic intrigue. By imitating the femme fatale, women could imagine that they acquired more than her attractions: her freedom, her sexual independence—and considerable enjoyment. Put another way, she offered a focus of sexual fantasy for women as well as men.

That need for independence clearly indicates that the development of the imagery of the femme fatale was associated with the nineteenth century growth of femininism. The years during which the femme fatale acquired her essential attributes were also the years during which the female emancipation movement gathered strength. The femme fatale, independent of male control, and threatening men, reflects the fears of generations of social thinkers. She was produced by men who felt threatened by the escape of some actual women from male dominance.

The capacity of feminists to foment rebellion among all kinds of women was noticed in a number of quarters quite early, in popular as well as serious literature. In 1848 a new ballet entitled *Les Amazons* was produced in London, with one Mademoiselle Plunkett in the lead. The Amazons in the story were discovered on an island in the New World by Columbus. They proceed, Circe-like, to entice and command his sailors. Said the reviewer:

> It is fortunate, in these days of asserting the rights of women, that they [the Amazons] are not nearer neighbors, or there is no telling what grand domestic revolutions they might not give rise to.[16]

Emancipation interests were attributed to women who wore Aesthetic dress. Existing costume, with its confining lines, bustles, heavy corsets, seemed to Aesthetes to be above all ugly,

but women who espoused the fashion for Aesthetic gowns were more interested in good health and physical freedom in their dress than in their claim to fashion. One of the better known, Lady Haberton, was described as belonging to "the great revolt," and a member of a group to whom "conventional costume was . . . a sign of female bondage."[17] Aesthetes themselves, that is, may or may not have had any interest in female emancipation, but the rest of the population was convinced that Aesthetic—originally Pre-Raphaelite—garb was part of a general rebellion against the social order.

On October 20, 1866, *Punch* advised Rossetti's friend and patron Madame Barbara Bodichon, together with Dr. Mary Walker, though they ably defended the "cause of womanhood suffrage," that they had better be prepared to exercise other political functions, such as "enrolling themselves in regiments of Amazonian volunteers" and assuming the responsibility for defending their country.[18] Responding to John Stuart Mill a few months later, after he introduced a womanhood suffrage bill in Parliament in 1867, "Judy" ("Mrs. Punch") refused to enlist under his banner unless it was a *crinoline*—not "MISS MARY WALKER'S costume," which "is a cross between the masculine and feminine garb; an anomalous and unbecoming combination of farthingale and unmentionable's."[19] She was equating Pre-Raphaelite (Aesthetic) costume with Androgyny, and was possibly conditioned to do so by the paintings in which it was featured. Clearly, female emancipation and "androgynous" clothing were closely connected in the public mind.

The Androgyne is more often than not considered to be a reflection of the homosexual interests of its creators. Few of its admirers and creators, however, were homosexual. Moreau and Swinburne may have been; Shelley, Burne-Jones, Gautier, and the majority of Symbolists who followed them decidedly were not. The urge to depict and celebrate androgyny in their work may have originated elsewhere. The interpretation of the Androgyne as adolescent may have provided one impulse. The adult in relation to the adolescent is authority, and the Androgyne is therefore pliable and manageable, obedient to the adult (male) in ways few grown women remain, unless they retain an adolescent mentality. And, naturally, minimizing gender characteristics serves to call attention to them—to sexuality itself.

On the other hand, if the Androgyne is understood to be a woman with male attributes—as she was so often painted—she is instantly seen as the independent woman, since no "true" woman in the nineteenth century aspired to escape cloistered dependence on her menfolk. The Androgyne may be an object of desire for bisexual or homosexual individuals, but even more she/he may be a reflection of what men a century ago understood, consciously or unconsciously, to exist in some women.

In other words, the androgyny of the femme fatale can be seen as arising in part from the nineteenth century conviction the personal independence and freedom were *masculine* in nature. Consequently, if a woman behaved in a "masculine" way, obviously she would have a slightly "masculine" appearance. That this was considered attractive is a result of the championship of the Hellenistic Hermaphrodite, and one aspect of the survival of the classic tradition. Even more, the androgyne is Baudelaire's *femme damnée,* who has rejected the male altogether, and by doing so has completely escaped male dominance.

Shaw's comment that Don Juan had become Doña Juaña and left the Doll's House illuminates the connection between feminism and the femme fatale. Don Juan, of course, loved, deserted, and sometimes destroyed his women, and one must assume that Shaw's "Doña Juaña" did likewise. Wittels, in his analysis of the "Lilith neurosis," made a similar comment. In the poetry and drama of the nineteenth century, he found two "antithetical types of women." One was "Das Süsse Mädel"—The Sweet Girl—and the other was Nora, Ibsen's heroine, who became ancestor to the modern Lilith: Wilde's Salome, Wedekind's Lulu and Delilah. By the time of the First World War, he said, "Delilahs, Helens, Salomes, Cleopatras could be seen in the streets of all large cities."[20] Most people today would not put Nora in the same category as Lilith. Wittels, in 1932, did. He was evidently convinced that the dual nature of the Eternal Feminine was real.

The evil in the dark half of the Eternal Feminine was emphasized by the femme fatale's rejection of maternity. The years when she came to maturity were marked by the first significant birth control campaigns as well as the female emancipation movement. These were inextricably intertwined with one another in

the public mind—and with the femme fatale. She is after all barren, and the refusal of a woman to bear a man's child is an extreme form of destruction of the male: deprivation of his posterity, his immortality. She represents the ultimate in female independence: total escape from control of her sexuality and from conventional morality. The outcry of "decent" people against propagation of information concerning efficacious methods of family limitation was—and is—at a high decibel level. To refuse to be a mother is of course one dimension of women's liberation, and understood by many as immoral.

The 1860's were seen by some as a period of female "flight from maternity" that took place in both France and England under growing advocacy for for new methods of family planning.[21] The practice of contraception was opposed then, as now, by the church, "respectable people," and even members of the medical profession. It was characterized by a flood of tracts maintaining that only the mother was moral,[22] similar to the one written by Charlotte Tonna.

The birth control movement was underway in France before 1800, and a drop in the birth rate is recorded in urban France steadily from before the Revolution right through the early decades of the nineteenth century, well before any wide discussion of contraceptive methods took place. In England, advocates of contraception began publishing pamphlets as early as 1820; Drysdale's massive two volume *Elements of Social Science* appeared in 1855, and included thorough discussion of all known contraceptive methods, recommending specific means of family limitation on the grounds of health.[23] The work provoked a storm of controversy, and by the 1870's, a proponents of family planning, either identified with the feminist movement or distinct from it, were on trial for immorality.[24]

Opponents of women's emancipation and suffrage connected these movements in England with a dropping birth rate, to the ultimate damage of the nation. While statistically it appears that the birth rate had in fact not dropped in most economic classes, it was matter of firm belief at the time that it had.[25] Conservatives thought women, decent and otherwise, were being seduced by the Devil to use contraceptives, and that feminism was his means of seduction. The subject was evoking clamorous

argument in London by the 1860's, and produced a series of articles in every variety of periodical. The *Athenaeum, Tinsley's Magazine, The Westminster Review,* attacked and defended the principles in one issue after another. By 1868 the *Saturday Review* had collected enough articles on the subject to anthologize them in book form.[26] Several authors in this volume remarked that educated women are usually unable to nurse their children, if, indeed, they are willing to have them at all. Some, wrote one author, will refuse to do their duty to England—that of bearing babies. In one article, the author made an angry and concerted attack on the "deterioration" of the British matron and maid who wish to limit childbearing. "We turn a little sickened," said the writer, "from the woman stripped of all that is womanly"—e.g., stripped of docile consent to unlimited childbearing.[27] By the closing years of the century, the practice of contraception was believed to "degrade the finest moral instincts of both men and women, especially, of course, the latter; in them it cannot have any other effect than to bring about a bestial sensuality and indifference to all morality."[28]

Such vituperation supports the idea that images of femmes fatales illustrate a male "backlash," and reflect male fantasies of both fear and desire. Certainly dangerous women are infinitely more interesting and exciting than domestic ones, and Victorian insistence on the saccharine sweetness of the docile maiden no doubt produced in some people a degree of sexual ennui bordering on nausea. But, to reiterate, the popularity of the image was dependent not only on men but on women who hastened to model themselves on the image. Some women still do, offering confirmation to radical feminists that they have been "co-opted" by a male value system like their Victorian sisters. In this instance it is perhaps fair to say that women have absorbed the erotic implications of the femme fatale as a role model without understanding the implications of her independence. Certainly some feminists saw the femme fatale as a symbol of the limitation of any woman to mere sexual symbol; a group of them vandalized Rossetti's *Astarte Syriaca* during a suffragist demonstration in Manchester in 1913.[29] One must agree that the "total woman" movement, complete with boots and black lace panties, is a degrading reduction of woman to nothing but pure sex. More and more popular arts—women selling cars scantily clad, lying on tiger skins, rock groups advertising their wares with

record jackets covered with chains and whips, imply more than the use of sex for sales. They imply an attitude towards sexual freedom, and female freedom from male sexual dominance, that is quite frightening. Stated differently, the battle of the sexes has become not only bitter but savagely brutal.

The central issue embodied in images of the femme fatale is precisely the issue of male sexual dominance. The femme fatale is not only free from control of her behavior, from child-bearing, not only self motivating and independent—she has complete control of her own sexuality. This is the element of her character that makes her lethal. The femme fatale destroys not only her lovers but their progeny, and attacks the very foundation of patriarchal society. By destroying not only the male, but his posterity, his hope of immortality, she becomes an image of conflict: desire and fear—for both men and women, since the sexual freedom she represents both attracts and repels, and flies in the face of established social norms.

It is appropriate that one of her major forms is Lilith. In going through Rossetti's papers after his death, his brother William found a letter dated November 18, 1869, addressed to the *Athenaeum,* signed by one Ponsonby A. Lyons. Rossetti's friend Stephens, one of the original Pre-Raphaelites, was then an editor of the periodical. Perhaps Rossetti, at the time composing his ballad "Eden Bower," applied to his old friend for more information about legendary Lilith, and this letter was one outcome. The letter opens:

> Lilith, about whom you ask for information, was evidently the first strong-minded woman and the original advocate of women's rights. At present she is queen of the demons.

He went on to offer several versions of the story of Lilith, pointing out that Lilith "refused to obey Adam, saying they were both quite equal," and that she had been created to "injure infants."[30] There are many legends attached to Lilith, but these are her salient characteristics. They highlight the overwhelming power that many men ascribe to women who claim their freedom, and to the magic net of Lilith's hair.

Perhaps the last word belongs to Ponsonby Lyons. Though,

"According to the Talmud," he said, "Lilith has long hair and wings," the real demon does not resemble the modern poetic version:

> . . . for the sake of poetical and picturesque feeling, I grieve to be obliged to record in your valuable columns, on the high authority of the book Zohar, that, when devils do appear to men in the human form, they have no hair on their heads.[31]

NOTES

[1] Der Jungling Von Sais, *Lilith: Die Losung des Weltrathfels* (Hamburg: M. H. W. Luhrsen, 1867); Edouard Rod, "Lilith," *Scenes de la vie Cosmopolité* (Paris: Perrin et cie., 1890).

[2] Paul Heyse, "Lilith," *Neue Märchen,* dritte Auslage (Verlag von Wilhelm Herke, 1899); George MacDonald, *Phantastes and Lilith* [1895] (Grand Rapids, Michigan: William B. Eerdman's Publishing Company, 1964).

[3] Marjorie Rosen, *Popcorn Venus* (New York: Avon Books, 1973).

[4] Kingsbury, "The Femme Fatale and her Sisters," and also Jan Thompson, "The Role of Woman in The Iconography of Art Nouveau," *Art Journal* 31 (Winter 1971-1972): 158.

[5] Anthony Masters, *The Natural History of the Vampire* (New York: G. P. Putnam's Sons, 1972), p. 196.

[6] Shaw, *Nine Plays,* p. 8.

[7] Dorothy Sayers, *Strong Poison* (New York: Harper and Row, 1930), p. 100.

[8] Lucie-Smith, p. 69.

[9] Krafft-Ebing, p. 49.

[10] *Ibid.,* p. 267f.

[11] Charles Berg, *The Unconscious Significance of Hair* (London: George Allen & Union Ltd., 1951), pp. 30, 59.

[12] Fritz, Wittels, "The Lilith Neurosis," *Psychoanalytical Review* 19, no. 3 (July 1932): 251.

[13] Georgiana Burne-Jones, *Memorials,* vol. 1, p. 137.

[14] Quoted in B. Fass, "Christina Rossetti and St. Agnes Eve," *Victorian Poetry* 14 (Spring 1976): 43.

[15] Theophile Gautier, *The Romantic Ballet;* reviews collected and translated by Cyril W. Beaumont (New York: *Dance Horizons,* 1932).

[16] Unsigned Article, "A New ballet at Covent Garden Theatre," *Illustrated London News,* October 14, 1848, vol. 13, no. 339.

[17] Ormond, p. 268.

[18] Unsigned Article, "The Way to Womanhood Suffrage," *Punch,* October 20, 1866, vol. 51, p. 159.

[19] "Judy," "A Certain 'person' to Mr. Mill, *Punch,* June 1, 1867, vol. 52, p. 224.

[20] Wittells, pp. 241, 245.

[21] J. A. Banks and Olive Banks, *Feminism and Family Planning in Victorian England* (New York: Schocken Books, 1964), pp. 53-54.

[22] *Ibid.,* pp. 22, 58.

[23] George Drysdale, *The Elements of Social Science,* 3rd edition (London: 1859).

[24] Banks and Banks, p. 82.

[25] *Ibid.,* Introduction.

[26]Mrs. L. G. Calhoun, ed., *Modern Women: and What Is Said of Them.* A reprint of Articles from the *Saturday Review* (New York: J. S. Redfield, Pub., 1868), original publication in London.

[27]*Ibid.,* p. 100.

[28]Richard Ussher, *Neo-Malthusianism* (London: Gibbings & Company, Ltd., 1898), p. 78.

[29]Curatorial Files, Manchester Art Gallery, Manchester, England.

[30]W. M. R., *Rossetti Papers*, p. 483.

[31]*Ibid.,* p. 485.

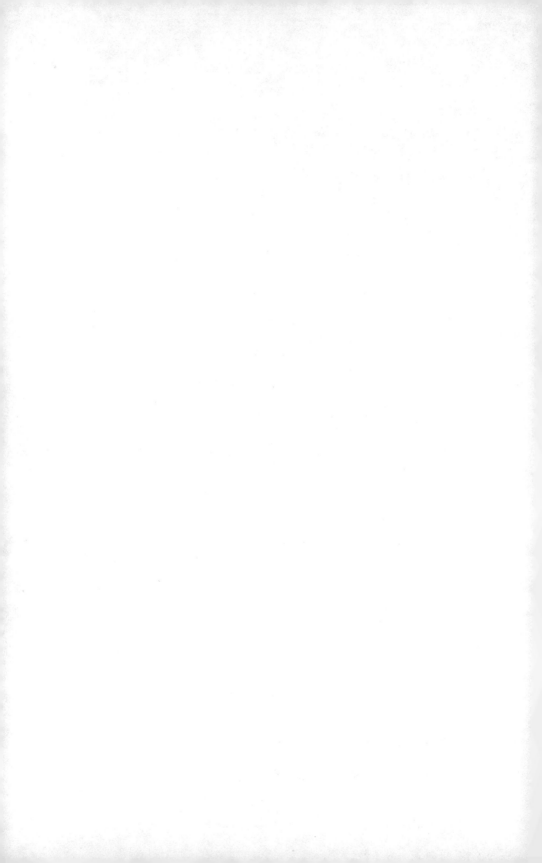

INDEX

ILLUSTRATIONS

Salome
Gustave Moreau
Courtesy of the Armand Hammer Foundation, Los Angeles, California

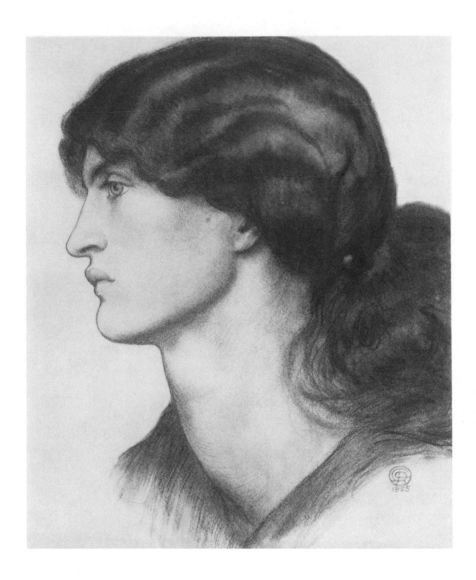

Mrs. William Morris
Dante Gabriel Rossetti
Courtesy of the Fogg Art Museum, Harvard University,
Cambridge, Massachusetts

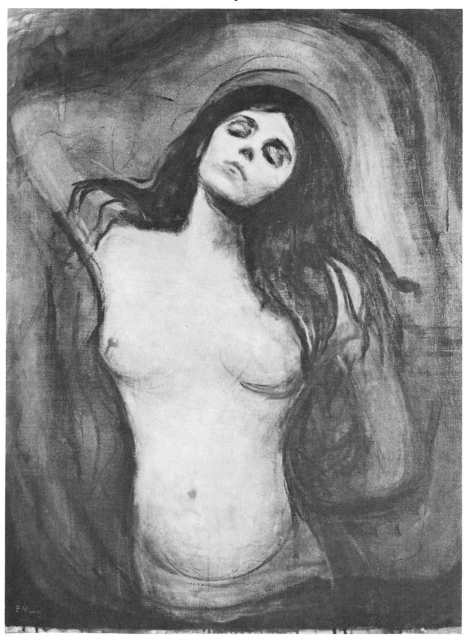

Madonna
Edvard Munch
Courtesy of the Nasjonalgalleriet, Oslo, Norway

4

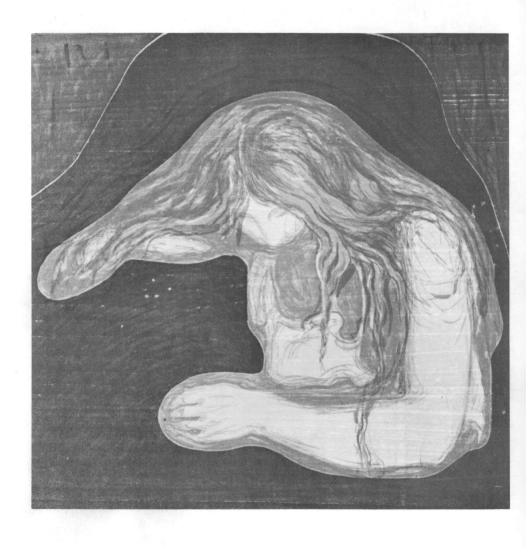

The Vampire
Edvard Munch
Courtesy of the Munch-Museet, Oslo, Norway

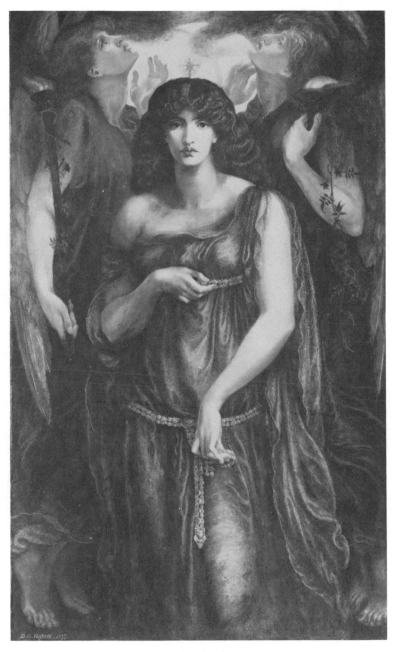

Astarte Syriaca
Dante Gabriel Rossetti
Courtesy of the City Art Gallery, Manchester, England

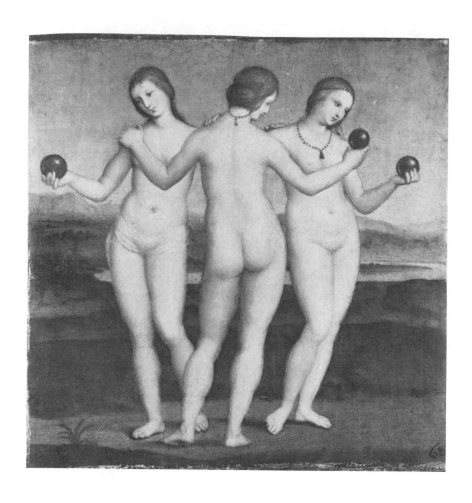

The Three Graces
Raphael
Courtesy Lauros-Giraudon

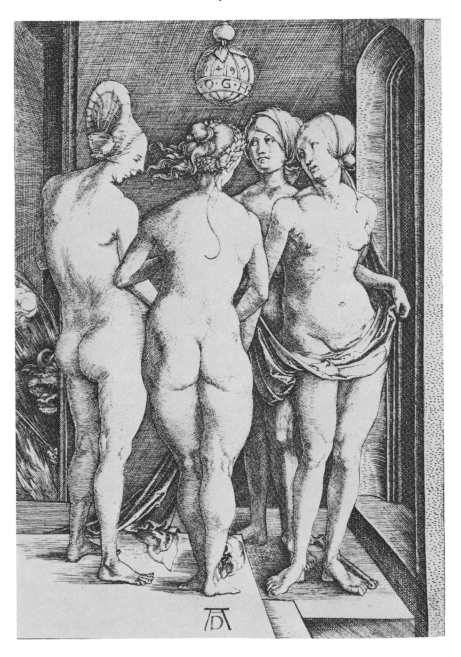

The Four Witches
Albrecht Dürer
Courtesy Dover Publications

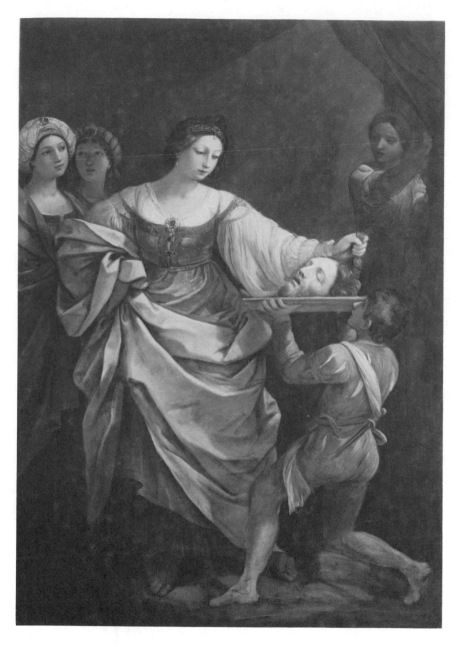

Salome with the Head of John the Baptist
Guido Reni
Courtesy of The Art Institute of Chicago

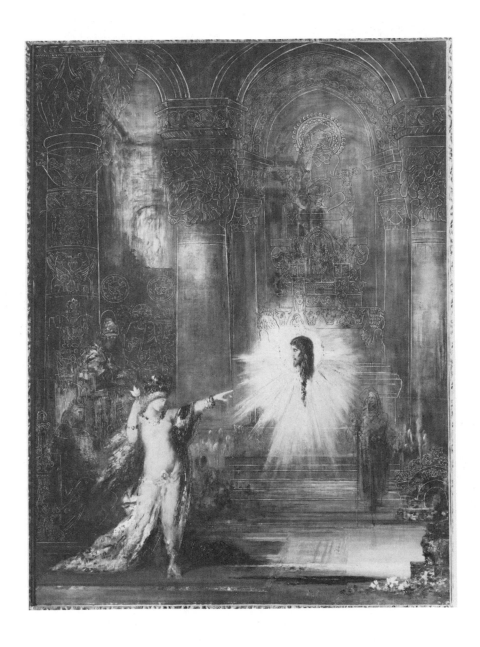

The Apparition
Gustave Moreau
Courtesy of the Musees Nationaux

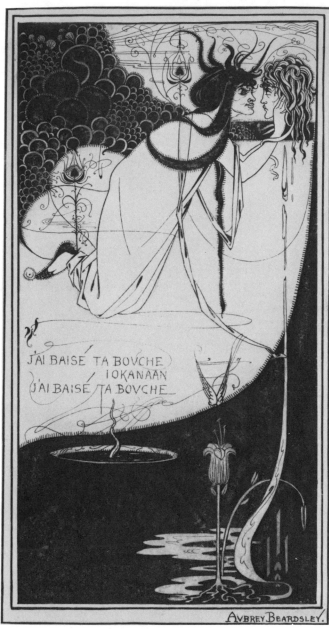

J'ai Baisé Ta Bouche Iokanaan
Aubrey Beardsley
Courtesy of the Gallatin Beardsley Collection,
Princeton University Library, Princeton, New Jersey

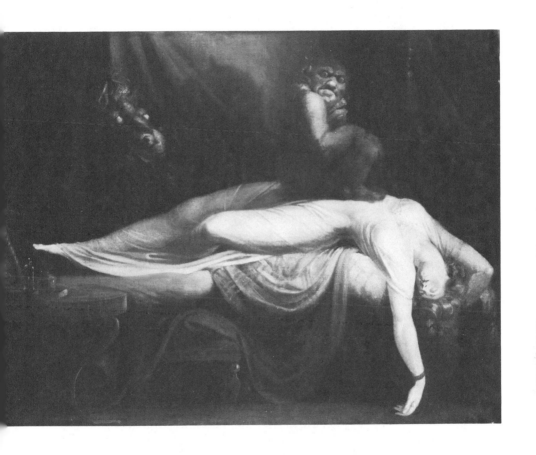

The Nightmare (recto)
Henry Fuseli
Courtesy of the Detroit Institute of Arts, Detroit, Michigan

The Nightmare (verso)
Henry Fuseli
Courtesy of the Detroit Institute of Arts, Detroit, Michigan

The Daughter of Herodias with the Head of John the Baptist
Henry Fuseli
Courtesy of the Rare Book and Manuscript Library,
Columbia University, New York

Lady Macbeth Sleepwalking
Henry Fuseli
Courtesy of the British Museum, London

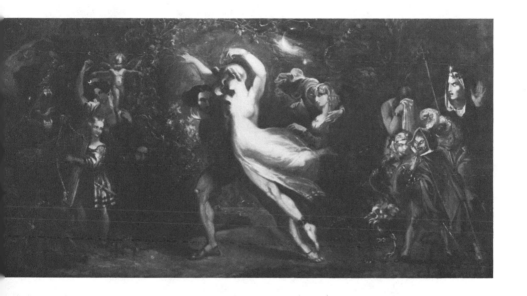

A Scene From Goethe's Faust
Theodore von Holst
Private Collection, New York

Borghese Hermaphrodite
Courtesy of the Musees Nationaux

The Girlhood of Mary Virgin
Dante Gabriel Rossetti
Courtesy of the Tate Gallery, London

Ecce Ancilla Domini
Dante Gabriel Rossetti
Courtesy of the Tate Gallery, London

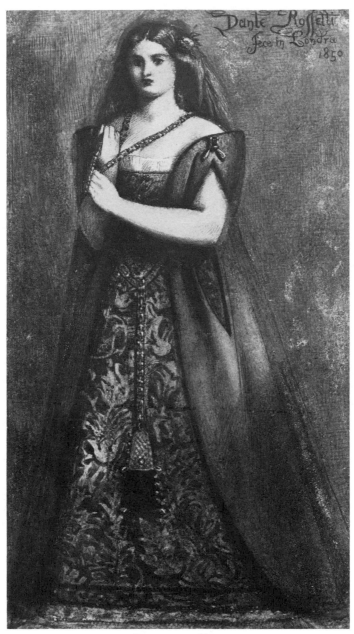

Rossovestita
Dante Gabriel Rossetti
Courtesy of the Birmingham Museum and Art Gallery,
Birmingham, England

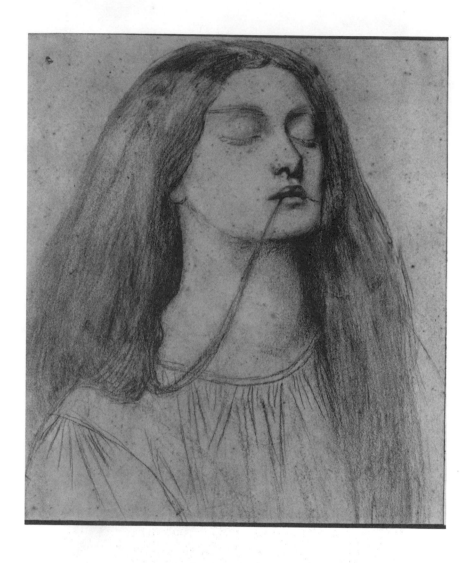

Miss Siddall with Strand of Hair in her Mouth
Dante Gabriel Rossetti
Courtesy of the Fitzwilliam Museum, Cambridge, England

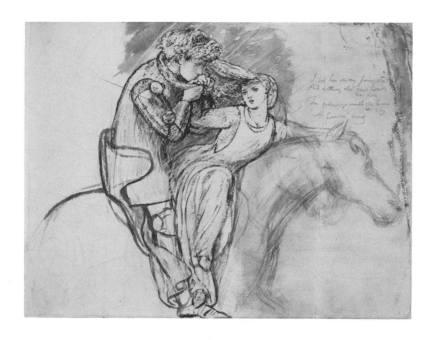

La Belle Dame sans Merci
Dante Gabriel Rossetti
Courtesy of the British Museum, London

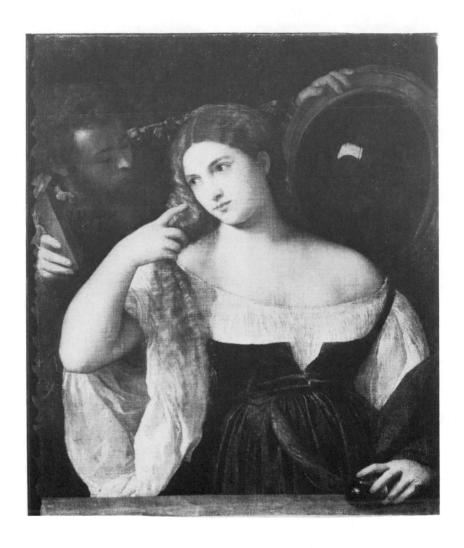

Lady at her Toilette
Titian
Courtesy of the Musees Nationaux

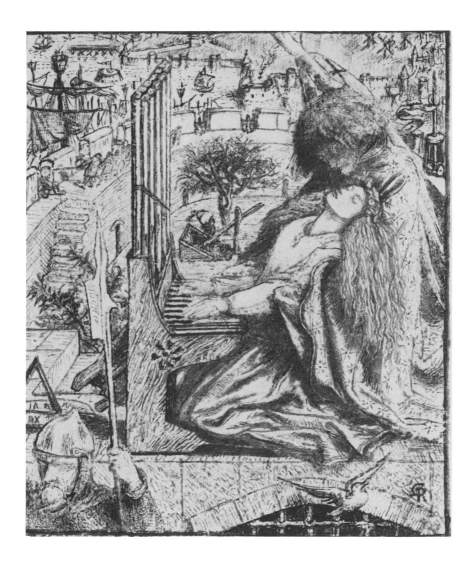

St. Cecilia
Dante Gabriel Rossetti
Courtesy of the Birmingham Museum and Art Gallery,
Birmingham, England

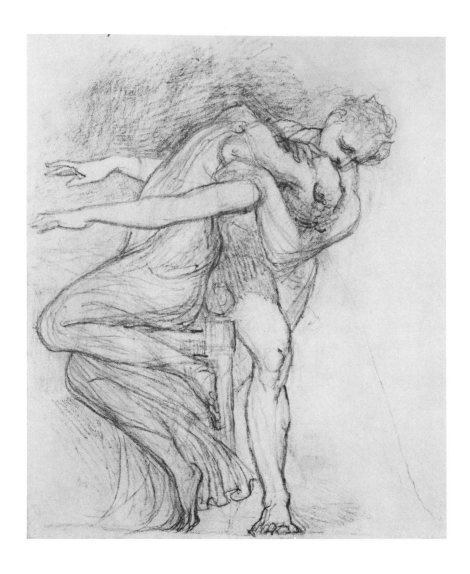

Young Man Kissing a Young Woman at a Spinet
Henry Fuseli
Courtesy of the Kunsthaus, Zurich

Sir Lancelot and the San Grael
Dante Gabriel Rossetti
Courtesy of the Ashmolean Museum, Oxford, England

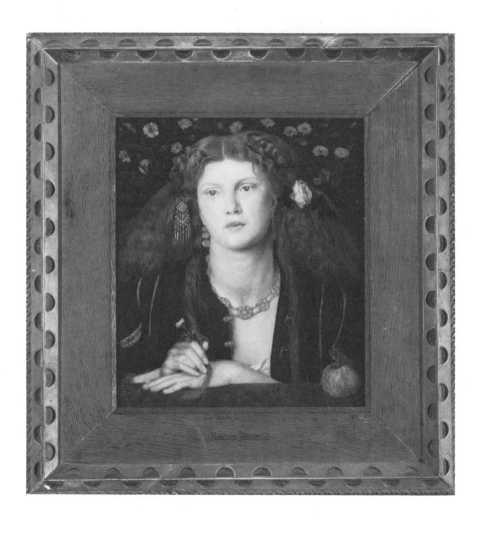

La Bocca Baciata
Dante Gabriel Rossetti
Courtesy, Museum of Fine Arts, Boston

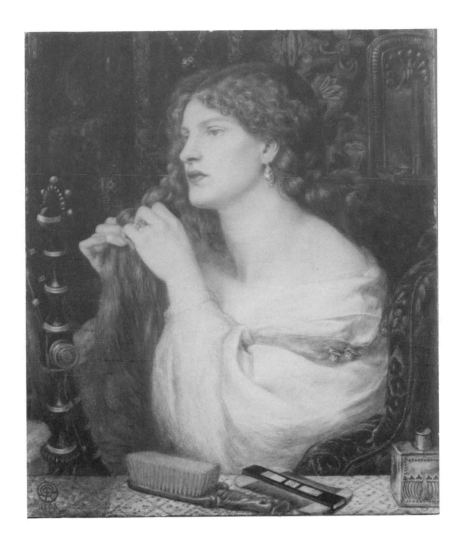

Aurelia (Fazio's Mistress)
Dante Gabriel Rossetti
Courtesy of the Tate Gallery, London

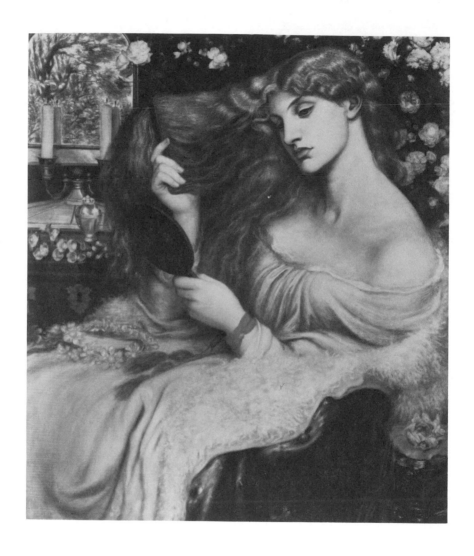

Lady Lilith
Dante Gabriel Rossetti
Courtesy of the Delaware Art Museum

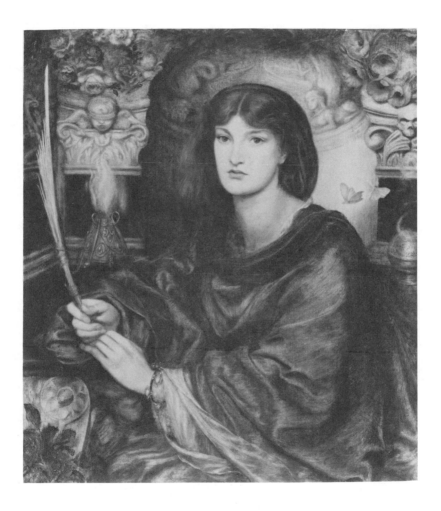

Sibylla Palmifera
Dante Gabriel Rossetti
Courtesy of the Walker Art Gallery, Liverpool, England

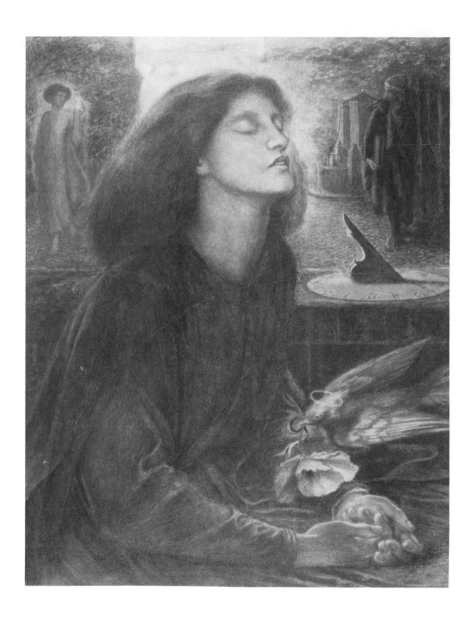

Beata Beatrix
Dante Gabriel Rossetti
Courtesy of The Fogg Art Museum, Harvard University,
Cambridge, Massachusetts

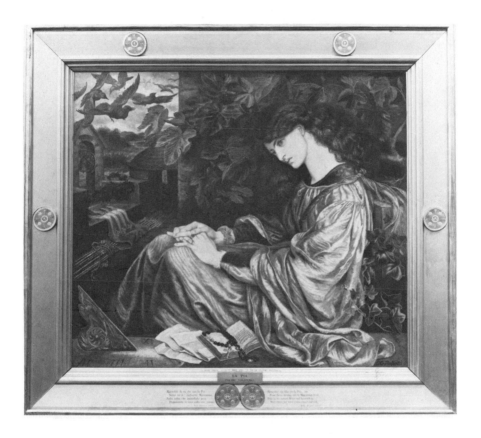

La Pia de'Tolomei
Dante Gabriel Rossetti
Courtesy of Helen Foresman Spencer Museum of Art,
The University of Kansas, Lawrence, Kansas

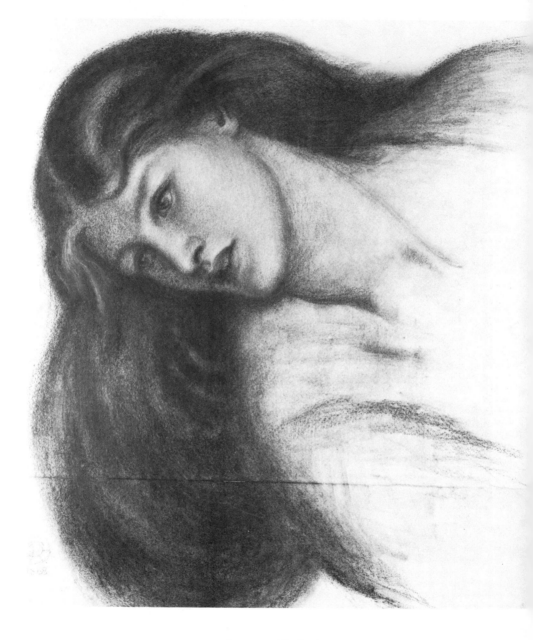

Aspecta Medusa
Dante Gabriel Rossetti
Courtesy of the National Arts Library,
Victoria and Albert Museum, London

Lady Lilith
Dante Gabriel Rossetti
Courtesy of The Metropolitan Museum of Art

Venus Verticordia
Dante Gabriel Rossetti
Courtesy of the Russell-Cotes Art Gallery and Museum,
Bournemouth, England

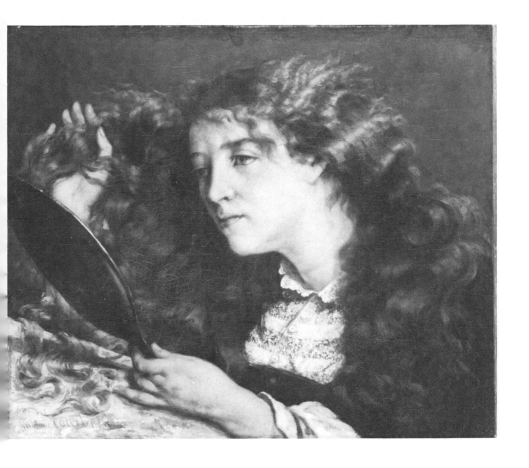

Portrait of Jo (La Belle Irlandaise)
Gustave Courbet
Courtesy of the Metropolitan Museum, New York

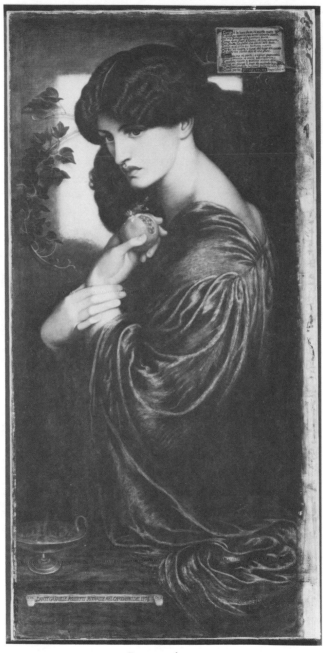

Proserpine
Dante Gabriel Rossetti
Courtesy of the Tate Gallery

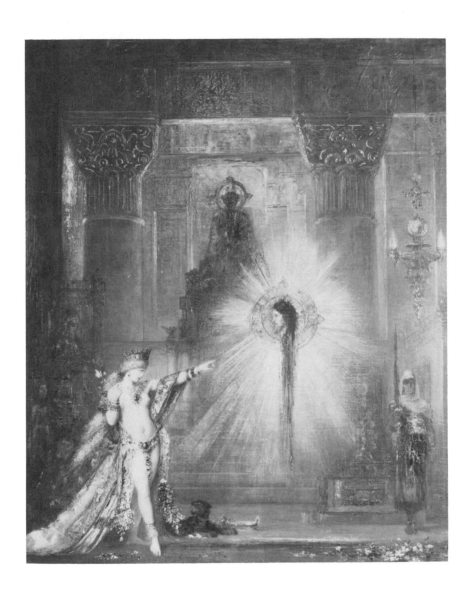

The Apparition
Gustave Moreau
Courtesy of the Fogg Museum, Harvard University,
Cambridge, Massachusetts

The Young Man and Death
Gustave Moreau
Courtesy of the Fogg Art Museum, Harvard University,
Cambridge, Massachusetts

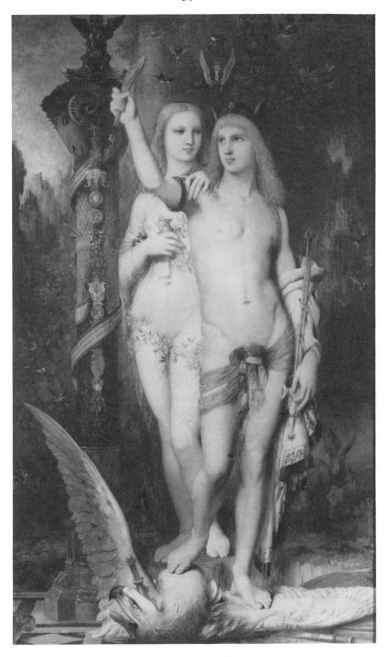

Jason and Medea
Gustave Moreau
Courtesy of the Musees Nationaux

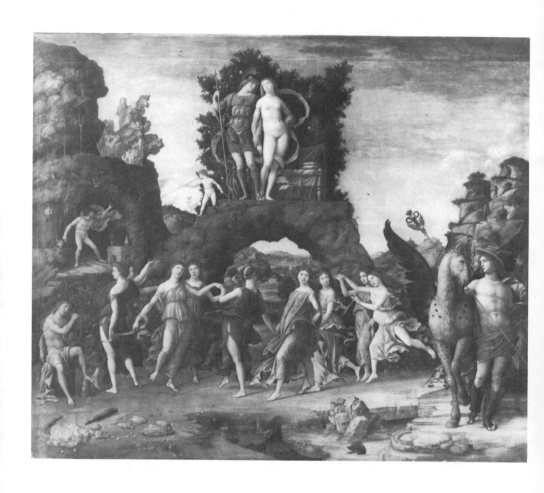

Parnassus
Mantegna
Courtesy of the Musees Nationaux

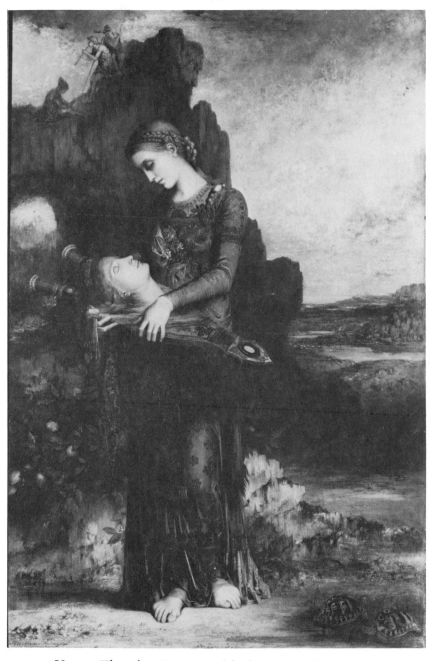

Young Thracian Woman with the Head of Orpheus
Gustave Moreau
Courtesy of the Musees Nationaux

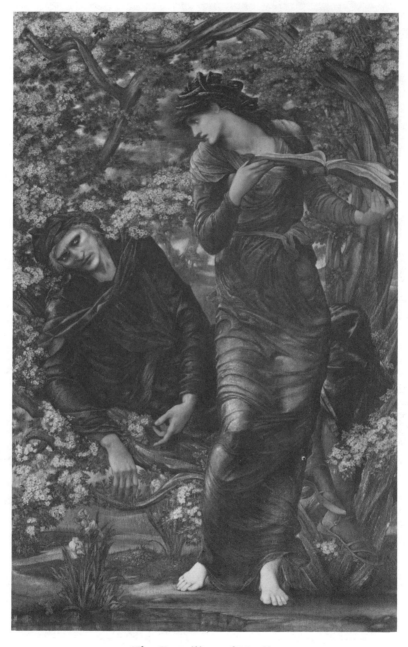

The Beguiling of Merlin
Edward Burne-Jones
Courtesy of Walker Art Gallery, Liverpool, England

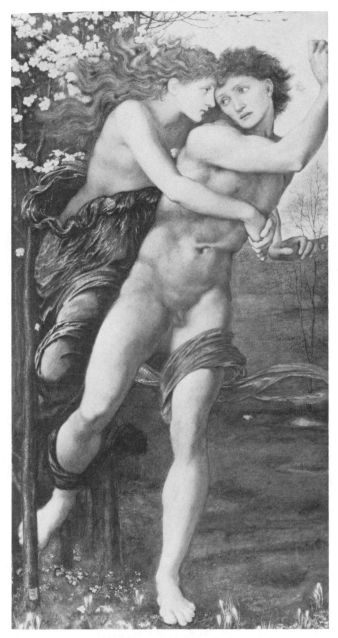

Phyllis and Demophoön
Edward Burne-Jones
Courtesy of the Birmingham Museum and Art Gallery,
Birmingham, England

The Tree of Forgiveness
Edward Burne-Jones
Courtesy of the Walker Art Gallery, Liverpool, England

The Depths of the Sea
Edward Burne-Jones
Courtesy of the Fogg Art Museum, Harvard University,
Cambridge, Massachusetts

The Lady of Shallott
William Holman Hunt
Courtesy of the Wadsworth Atheneum, Hartford

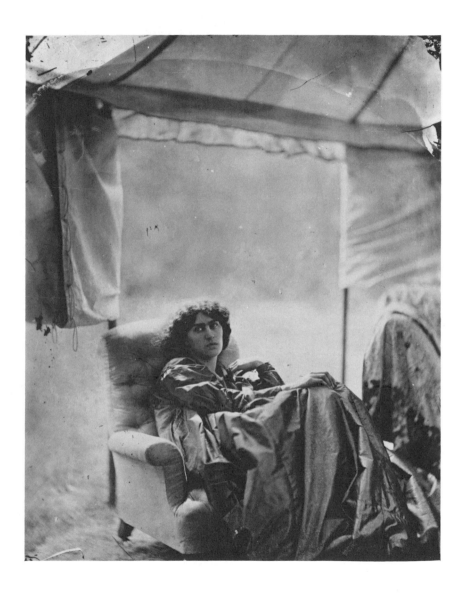

Posed by Rossetti
Mrs. Jane Morris
Courtesy of the National Arts Library,
Victoria and Albert Museum, London

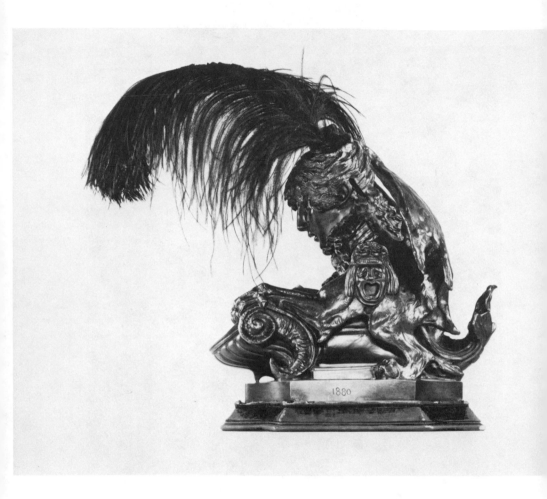

Self-Portrait as Sphinx
Sarah Bernhardt
Courtesy, Museum of Fine Arts, Boston